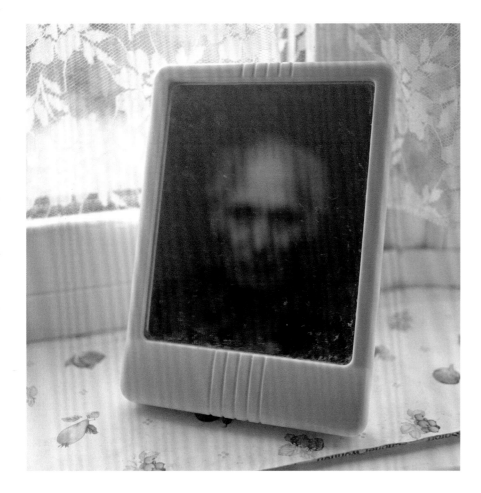

Family

Photography

Now

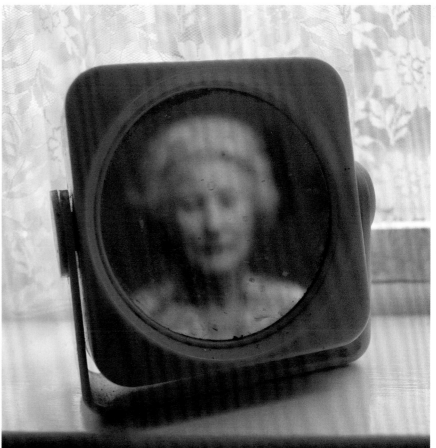

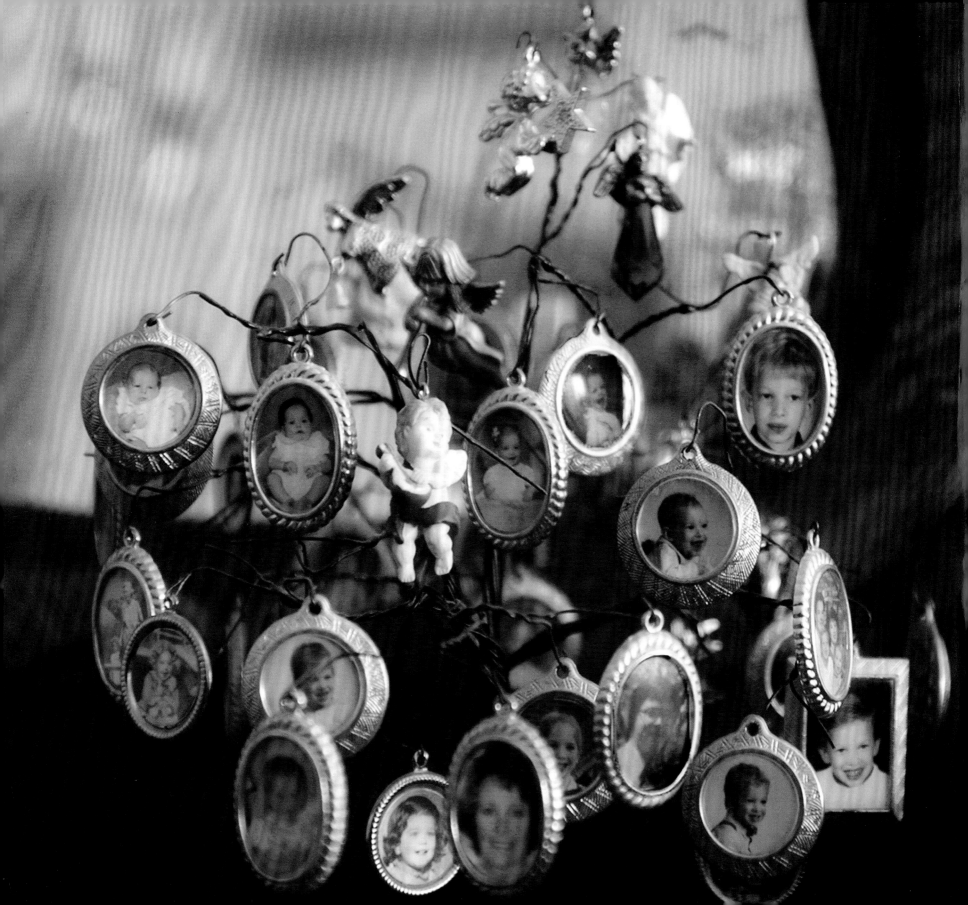

Sophie Howarth and Stephen McLaren

Family
Photography
Now

over 320 photographs in color

and black and white

 Thames & Hudson

PAGE 1 Photographs by Colin Gray
(see also p. 50).
PAGE 2 'Irene's most prized possession,
her family' by Donna Rosser.
RIGHT Photograph by Cecilia Reynoso
(see also p. 44).

First published in 2016 in the United States
of America by Thames & Hudson Inc.,
500 Fifth Avenue, New York, New York 10110

thamesandhudsonusa.com

Library of Congress Catalog Card Number
2015941295

ISBN 978-0-500-54453-2

Printed and bound in China by C&C Offset
Printing Co. Ltd

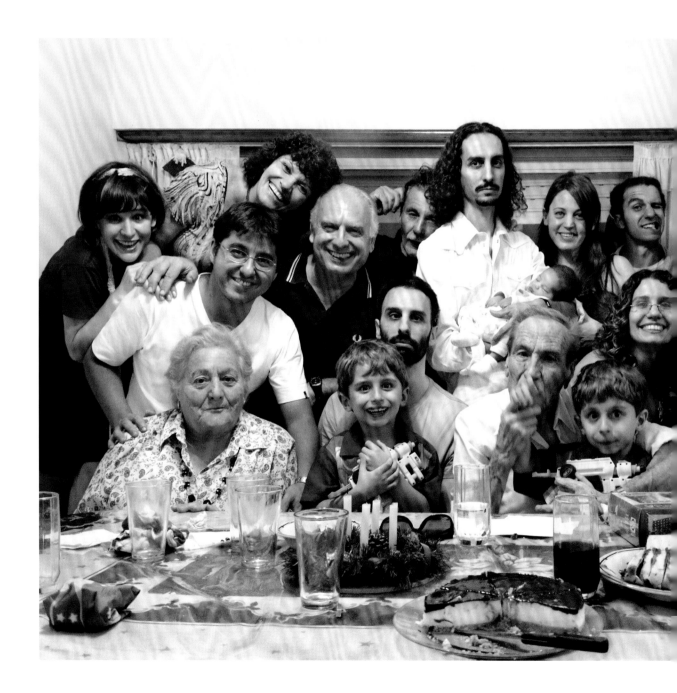

Contents

Is my family normal? Sophie Howarth

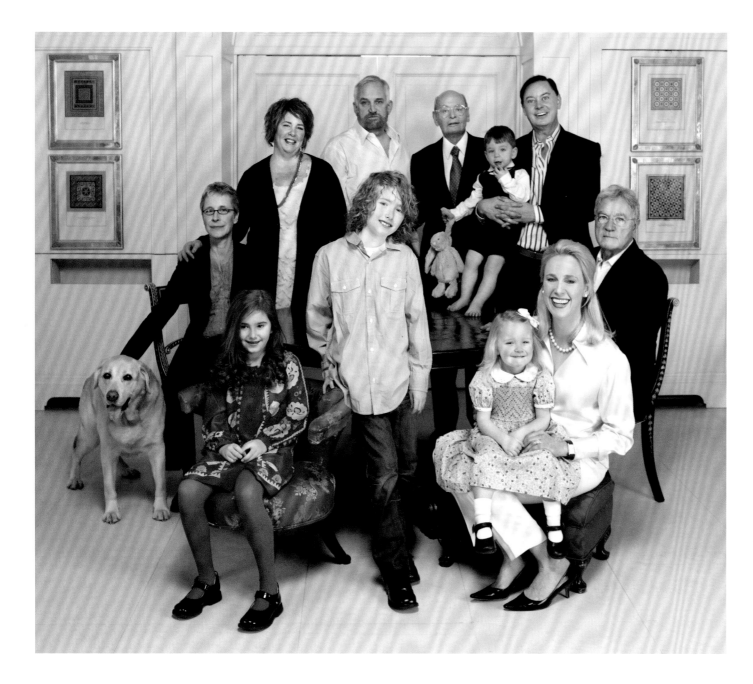

In January 2015, the Japanese camera company Nikon asked Kordale Lewis and Caleb Anthony, two gay dads from Atlanta, to be part of a new advertising campaign. The couple had shot to internet fame a year earlier when a photo from their family Instagram stream went viral. The 'selfie', showing the two dads brushing their daughters' hair, attracted over 50,000 likes, along with a heavy dose of homophobic hate. In a world where all publicity is good publicity, that level of attention made 'Kordale and Kaleb' hot property from Nikon's point of view. The ad campaign, titled 'I Am Generation Image', involved giving cameras to seven people who might have 'something to say'. What Kordale and Kaleb had to say turned out to be surprisingly banal: 'We just want people to know that, hey, we're normal.' To prove it, they documented themselves engaged in a bunch of everyday family activities: cuddling up on the sofa, doing household chores, making silly faces. Nikon shot a short film showing the family getting ready for school, playing with the dog, visiting the grandparents. It was exactly the kind of wholesome portrait of family life that photographic companies have been peddling for generations, given an LGBT twist to demonstrate that Nikon embraces all kinds of contemporary family.

'Look at us! So loving, so happy, so normal.' That has been the basic message of family photography for decades. Today's families may strike more informal poses than their Victorian counterparts, and assemble their images on digital walls rather than in physical albums, but the domestic photograph is still, largely, a tool for promotion. The internet is awash with articles offering tips and techniques for taking great family photos: keep everyone close together but avoid placing people in a straight line; stagger head heights for a nice rise-and-fall rhythm; show the special relationship between Mum and Dad that glues everyone together; hold hands, high five or all jump for joy at the same time. As the photographer Martin Parr has commented: 'Most family albums are a form of propaganda, where the family looks perfect and everyone is smiling.'

The more unusual your family circumstances, the more important it seems to be to show yourselves as 'normal'. Politicians are the masters of the carefully crafted but exquisitely banal family portrait: it's off with the suits and on with the chinos for the annual Christmas card snap at the White House or 10 Downing Street. Occasionally there's a spanner in the spin. When Scott Brison, Canada's first gay MP in a same-sex marriage, sent out a Christmas card showing himself, his husband and their golden retriever out walking together in a glowing landscape, he received a torrent of abuse from more conservative members of the public. Brison reacted to the furore with the cool and accurate observation that 'I'm not the first politician to have a family picture on a Christmas card'.

Political family branding plummeted to a new low when the Syrian presidency joined Instagram in 2013 and started streaming pictures of Bashar and Asma al-Assad and their three children blowing out candles on a birthday cake, playing football in the park and riding their bikes by the coast. What the Syrian spin doctors hadn't accounted for was that by joining the social media scrum, the First Family were opening themselves up to anyone who wanted to comment. 'I love ur designer clothes and shoes ... paid for by the blood of your people!' wrote one user. 'You could be Hitler's brother,' wrote another. The account administrators were soon fighting the backlash, policing the comments sections and taking down pictures judged to be most offensive. While there is still a steady stream of photos showing Asma al-Assad visiting schools and tending to the sick, all family pictures have now disappeared.

This book isn't a collection of idyllic family portraits because the truth is that real families aren't often idyllic. They come together, but they also fall apart. They love and protect their different members, but they also reject and confine them. Families are containers for both loyalty and cruelty, altruism and selfishness: in short, for all our best and worst characteristics. In putting this book together, we wanted to tackle the emotional rollercoaster of family life with the honesty it deserves, cutting through the glut of smiling snapshots and tightly choreographed nuclear units to show how much more photography can be than just a tool for advertising domestic bliss.

James Joyce believed that 'in the particular lies the universal'. That principle has guided our selection of work. Like opening someone else's diary and discovering your own secrets, we hope that engaging with the particular relationships illuminated through the

RIGHT Bashar al-Assad, his wife and three children, blowing out candles on a birthday cake. Photograph Camera Press London.

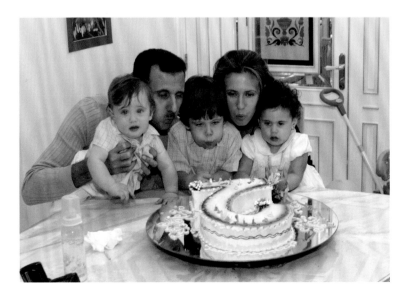

photographs in this book will help you reflect on your own family ties. We didn't want to create a book in which readers could easily identify, or aspire to identify, with all those photographed. Instead we wanted to appeal to a more generous concept of empathy, by showing work that enlarges our capacity to be touched by lives often very different from our own.

We have been moved and humbled by the photographers who have allowed us to include work that explores particularly complex relationships with family members: Christopher Capozziello's portrait of his twin brother (see p. 74), Timothy Archibald's collaboration with his son (p. 34) and Sian Davey's photographs of her daughter (pp. 15 and 128) are among those that stand out. Equally courageous, though in a different way, are those photographers who immerse themselves in the emotional reality of families very different from their own: Liz Hingley's portrait of the Jones family (p. 154), Birte Kaufmann's documentation of Irish travellers (p. 160) and Annalisa Brambilla's tender observation of the Habib-Robinson family (p. 198), to name just three.

All the photographers included in this book accept that families are contradictory beasts, rarely comprehensible to their own members, let alone to outsiders. All recognize that when it comes to interpreting internal family dynamics, perspective is everything, but everyone's is different. What feels like a loveless marriage to one spouse can feel like an emotional lifeline to another; teenagers who act like tyrants often see themselves as victims. Those who take the most photographs often wield more than their fair share of power in constructing the family narrative. Mindful of this, we have found ourselves attracted to photographers who approach their subjects with humility, curiosity and respect, using their camera as an emotionally bonding rather than divisive technology. Martine Fougeron's record of her sons' adolescence (p. 86), Nadia Sablin's portrait of her aunts (p. 114) and Maja Daniels's study of identical twins Mady and Monette Malroux (p. 174) are all examples.

The way we take, edit and share family photographs has been transformed by changes in technology, but their social and emotional function has remained fairly constant: they are essentially a means of establishing connection and belonging. During the 19th century, when photography was still an expensive and cumbersome medium, even families who could afford to visit photographers' studios would generally only do so to mark important occasions such as christenings, marriages or deaths. In 1900, Kodak launched the Box Brownie camera, priced at $1 and pre-loaded with film, after

which more and more families began taking their own pictures. First smiles, first steps, birthdays and holidays made up the vast majority of the so-called 'Kodak moments' of the 20th century. Most middle-class families around the world owned some kind of point-and-shoot camera by the end of the 20th century, but it was the combined influence of digital photography and mobile phone technology at the start of the 21st century that almost universalized access to the medium. Today the United Nations estimate that six of the world's seven billion people have mobile phones, and at least 80% of those have cameras. The vast majority of people taking pictures now have only ever done so on a phone, and they use photography to keep in touch with family and friends moment to moment, rather than to lay down memories for posterity. By the time you read this page, more than half a million photographs will have been uploaded to Snapchat, currently the world's most popular photo-messaging application. By the time you turn over, they will all have been deleted, since Snapchat only keeps each photo for a maximum of 10 seconds. It is easy to carp at such ephemerality but 'photo chat' arguably serves the function of keeping families connected better than its analogue ancestor.

Aleks Krotoski, an expert in psychology and digital technology, has championed the emotional benefits of new photographic technologies for globally dispersed families. As she summarizes:

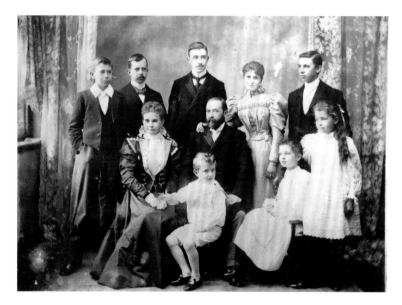

ABOVE A formal photograph taken on a glass negative, c. 1895, showing the family of William Lee, founder in the late 19th century of a successful clothing business, Kay & Lee Ltd, in Manchester, England

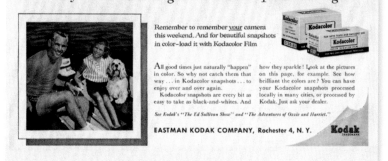

'We live in an increasingly transient world, where the need to make a living has given rise to mass migration to urban centres in every country. Children are separated from parents, siblings from one another and the web has provided us with the devices that make it easy to stay in touch.' She notes that her own family is scattered around the globe, but 'we mean the same thing to one another as we always have.... [We] used to sit around the slide projector and tell the same old stories until we laughed so hard we cried'. Now, thanks to Flickr, Facebook and the many other online photo-sharing sites, 'We don't have to be co-present to feel like we're taking part in each other's lives. I look at my mum's photos online and we then laugh about her travel exploits. Dad sends snaps of his orchids and his travels. But those are their experiences, rather than the shared ones that exist from particular moments of our lives. I get a sense of them as individuals by having access to their photo stories. And we get a sense of us together – whatever that family arrangement might be – when we look at photos of us together.'

Family photography isn't so much about documenting as shaping our family narratives. We organize our albums, whether physical or digital, to tell the story we want to believe about our lives. We photograph our relatives when they bring us the most joy, and often return to those photographs when that joy seems to elude us. Curator Val Williams has described family photographs acting like 'a talisman against the real', suggesting they offer a kind of magical protection from the troubling reality of our everyday lives. It is, after all, so much easier to feel affection for the smiling baby on a screensaver than the same child screaming because they don't want to go to sleep, or for the man or woman gazing into our eyes in a soft-edged wedding photograph on the mantelpiece than the person whose infidelity we've just discovered.

Donna Rosser's photograph of a table-top ornament made from over twenty miniature framed portraits of different family members (p. 2) beautifully captures the comfort and reassurance photographs can offer us at moments of vulnerability. 'I took it in my mother-in-law's home, on our last visit to see her prior to her move to an assisted living situation,' Rosser explains. 'The portrait charms on the tree are family: my family and children, my husband's siblings and children, and small angel charms collected by my mother-in-law. My father-in-law, rather crafty, made the tree by twisting wire and creating a flat heavy base. It reminds me how much she valued family even if we were not close to her geographically. We were always in her thoughts.'

In 2014, wedding videographer and documentary maker Doug Block made a film called *112 Weddings*, which involved going back to interview some of the 224 people whose big day he had originally filmed. 'I had a lot of questions for them but at the core it all came down to two basic ones: What did you enter marriage thinking it would be? And what did it turn out to be?' Not surprisingly, Block found that 'I do' was one thing to say, another to stick with. Mental and physical illness, the drain of having or not having children, differences of opinion, changes in financial circumstances, demanding jobs, lack of jobs – these were just some of the struggles the couples he interviewed had experienced. Some marriages had survived, others had not. 'Weddings aren't just about one couple getting married, they're about two families merging, with each bringing their own complicated histories to the mix,' Block observed. 'Happy ever after

BELOW Photograph by Cai Xianmin of the Wangs, aged 66 and 63, posing for a new wedding photo 32 years after their original wedding photos were taken at the Renmin Photo Studio, Shanghai. Image courtesy of Global Times China.

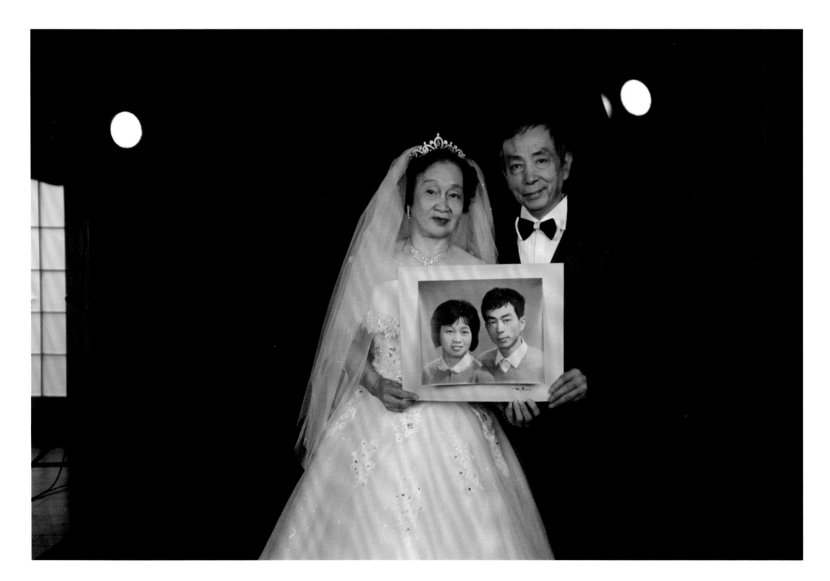

is complicated. All you can do is work at it, be there for each other and hopefully get through it together.'

There is something immensely touching about photographs of couples whose love has stood the test of time: Colin Gray's documentation of his parents' long marriage (pp. 1 and 50) and Sarker Protick's portrait of his elderly grandparents (p. 104) are two examples. Only the hardest of hearts couldn't be moved by Cai Xianmin's image of a couple revisiting the Renmin Photo Studio in Shanghai 32 years after having gone there for their original wedding photographs. They proudly hold up one of the black and white images taken on March 5, 1981, as if to imply the photograph itself has helped sustain their commitment to one another.

Nowhere is the emotional crutch of a photograph more evident than when it comes to a loved one we have lost. For the Victorians it was common practice to photograph the dead. Quicker and cheaper than commissioning a painting, a photograph offered the bereaved something to remember the deceased by. In the 19th century, when infant mortality was high and photography still expensive, a mourning portrait could often be both the first and last photograph taken of a child.

In 2005, Cheryl Haggard's son Maddux was born unable to breathe or move on his own. Unlike most new mothers, Cheryl didn't rush to get her phone out and post images of her newborn on Facebook. But, after making the heartbreaking decision to take him off life support, she did ask a photographer friend to take pictures of her cradling her son. 'My photographs of him are my world. I left the hospital that night with a broken heart and empty arms. Besides his blue blanket and some blurry memories, these photographs are all I have.' Haggard went on to found Now I Lay Me Down to Sleep, a non-profit organization that arranges for volunteer photographers to support parents suffering infant loss by taking pictures of them with their newborns. 'Photographs are one of the most precious and tangible mementoes that a parent can have, showing the love and bond that was given and shared with their baby. These portraits will last for generations, and will honor and remember a tiny life that is forever loved and cherished.'

'To photograph is to squeeze into little squares or rectangles moments, salvaged from the clutter of life, or from the chaos of one's family,' photographer Sylvia Plachy has said. At moments of uncertainty, these fragments of memory become all the more resonant. After Hurricane Katrina hit New Orleans in 2005, photojournalists Dave Ellis and Becky Sell set up Operation Photo Rescue,

ABOVE In remembrance of baby Logan: a professional portrait by Julie Williams of a family who have experienced infant loss, supported by the agency Now I Lay Me Down to Sleep

ABOVE Munemasa Takahashi's 'Salvage Memory' project involves cleaning, restoring and digitizing photographs such as this one, from the Japanese natural disaster in 2011

a non-profit network of hundreds of volunteers around the globe who restore family photos for survivors of natural disasters. 'Following family and pets, photos are the next most cherished possession, as the memories captured in photos are all that remain after a natural disaster,' they explain. Japanese artist Munemasa Takahashi concurs. She led a team of volunteers in the nationwide 'Salvage Memory' project, recovering, cleaning and digitizing more than three quarters of a million photographs after the 2011 earthquake and tsunami, and reuniting almost half with their original owners. 'The first thing the people who lost their loved ones and houses came to look for was their photographs. Only humans take moments to look back at their pasts, and I believe photographs play a big part in that.'

Most photographs can be judged for quality on the basis of technical competence and aesthetic qualities – whether they are well lit, well framed, in focus and so forth. Family photographs are different. We treasure them when they bring us comfort and delight, confirming our emotional ties and reassuring us of our place in the social network.

At the time of writing there is an internet trend for re-creating childhood photographs, then showing past and present side by side. The pictures are often awkward and almost always absurd: fully grown siblings cuddled together in bed, crammed into a bath, or wearing fancy dress. They make us laugh but they also touch us. The Luxton brothers' 'Then and Now' blog is typical: two bearded men re-enact learning to ride a bike, blowing out candles, or making dens. The brothers originally made the photos as a gift for their mother, a form of gratitude for the happy childhood she had given them, and testimony to the deep affection they continue to feel for her and each other.

Psychiatrist and philosopher Neil Burton explains the role nostalgia plays in our lives: 'Our everyday is humdrum, often even absurd. Nostalgia can lend us much-needed context, perspective, and direction, reminding and reassuring us that our life (and that of others) is not as banal as it may seem, that it is rooted in a narrative, and that there have been – and will once again be – meaningful moments and experiences.'

As we have assembled this book, it has struck us time and again how resilient most families are. Every one has its struggles – with misunderstandings, betrayals, disappointments, insecurities and tragedies. And yet they find ways to flex and adapt, constantly reworking themselves around their capacity to connect and com-

mit. As the writer Andrew Solomon, whose own family consists of five adults and four children living across three states, comments: 'It is not true that "love is not love which alters when it alteration finds." Love alters all the time; it is fluid, in perpetual flux, an evolving business across a lifetime.' Photographs have become an increasingly important tool for navigating this flux.

Whether bound together by blood, love, duty or a cryptic combination of all three, all families seem more intriguing the more you try and understand them. If there is one thing we became sure of in making this book, it's that when you scratch beneath the surface there is no such thing as a 'normal' family.

RIGHT The Luxton brothers' humorous recreations of childhood moments have spread through social media

This is my life

Photographers documenting their own families

The view from within a family unit is never clear or settled. All families involve tangled webs of relationships that change over time. The photographers in this section are embedded, committed participants in their own domestic dramas, using their cameras as wayfinders through a thicket of emotional intensity.

'Family likeness has often a deep sadness in it. Nature, that great

tragic dramatist, knits us together by bone and muscle, and divides us

by the subtler web of our brains; blends yearning and repulsion; and ties

us by our heart-strings to the beings that jar us at every movement.'

George Eliot, Adam Bede

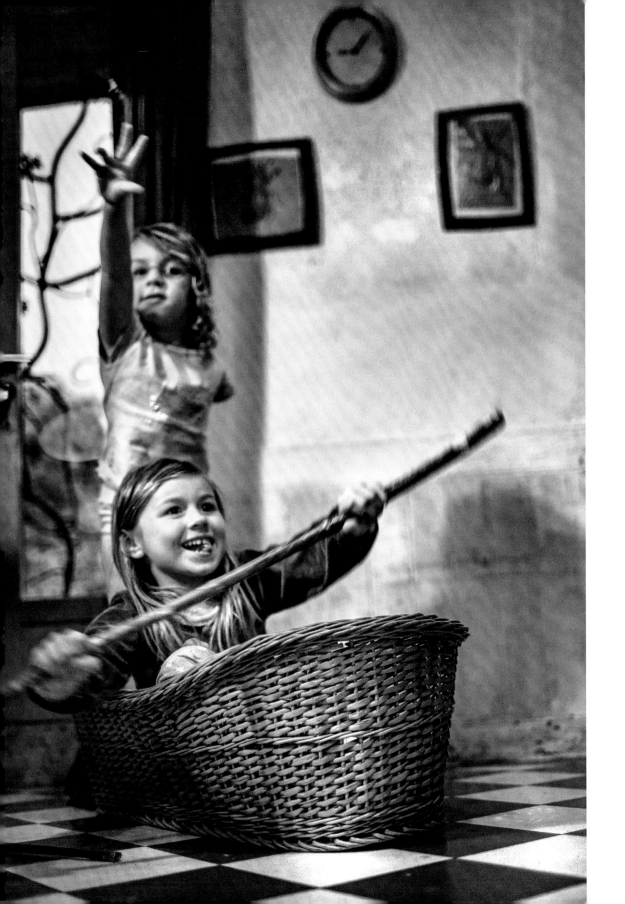

ALAIN LABOILE

born 1968, France

*Spontaneous and joyful photographs
of an idyllic childhood in rural France*

In a small village in the southwest of
France, in an old house surrounded by
bamboo forest and bordered by a small
stream, a realm exists that appears
almost untouched by modern life. 'We
think of ourselves as living at the edge
of the world, in a universe of our own,'
explains Alain Laboile.

He has been photographing his six
children, Eliott, Olyana, Luna, Merlin,
Dune and Nil, almost every day since
2004. He documents them climbing
trees and making dens, swinging from
ropes and chasing shadows. They dress
up and play with imaginary friends,
they undress, have water fights and coat
themselves in mud. They play endless
games of hide and seek, do piggy back
and wheelbarrow races, and make
broomsticks and wings from branches.
They collect frogs and lizards, chase
birds and cats, and even bring a baby
deer to live with them for a few weeks.

No doubt they have the same
showdowns over chores and homework
that all other children do, and between
the six of them they surely experience
regular eruptions of sibling rivalry,
but Laboile does not show us that side
of life. His focus on joyous, innocent,
carefree play has shaped one of the
most idyllic documents of childhood
in the history of photography.

It happened almost by accident.
Originally a sculptor, Laboile bought
a small camera to document his work,
but soon started taking photos of
his children. He posted regularly on
Flickr, where his images were received
rapturously by fellow photographers

and extensively reblogged. A few online magazines asked for interviews and from there the attention snowballed. 'Now I travel all around the world as a professional photographer, but it is all the result of the pictures I take just a few yards from my doorstep.'

Although his instinct for lighting and framing are masterful, Laboile claims to have little interest in the technical aspects of the medium. 'If there is emotion in the picture, that's good, even if it is a bit blurred or poorly framed. Accuracy is not the important thing to me. I want to capture the feeling of the moment.'

Laboile insists that the popularity of his photographs is a result of their timelessness. 'They strike a chord with many people because they remind them of their own childhoods. I can't count the number of people who have commented that a picture reminds them of themselves in the countryside with their grandparents, or brings back the smell of a summer vacation. I think that the use of black and white probably reinforces the feeling of universality.'

Whether Laboile's photographs honestly remind many viewers of their own childhoods is a moot point. What his arcadian portrait of childhood certainly offers is a welcome balm at a time when commercialization, violence and sexualization hamper what we see and hear about so many young lives.

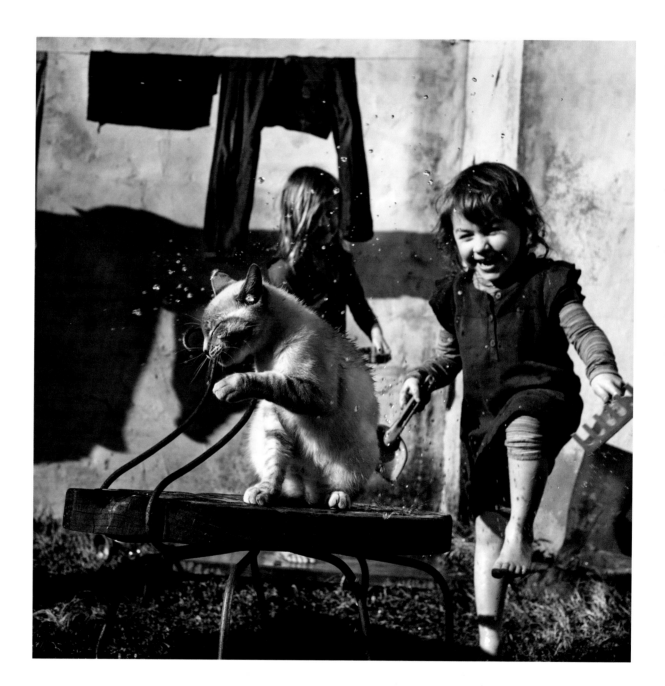

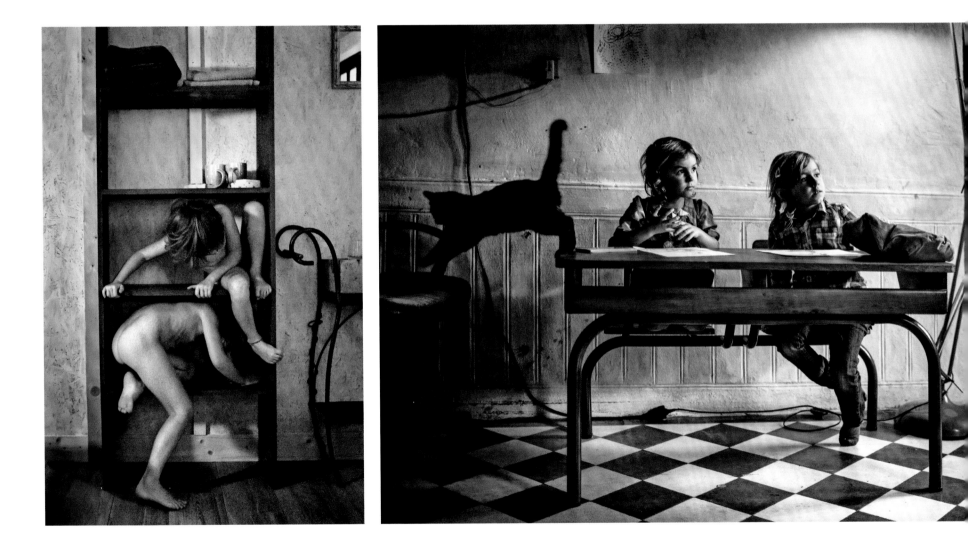

'I'm a father of six. My children are my subject ...

an endless subject.'

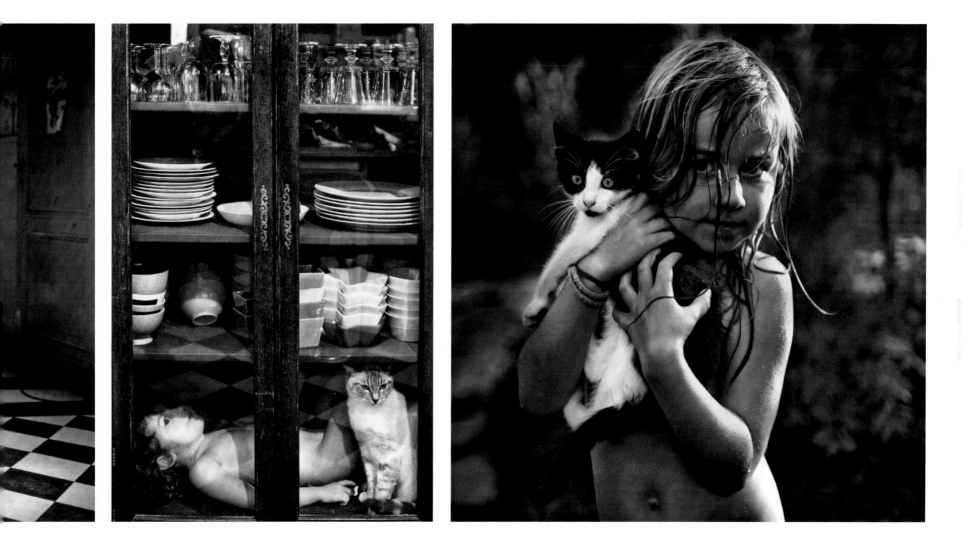

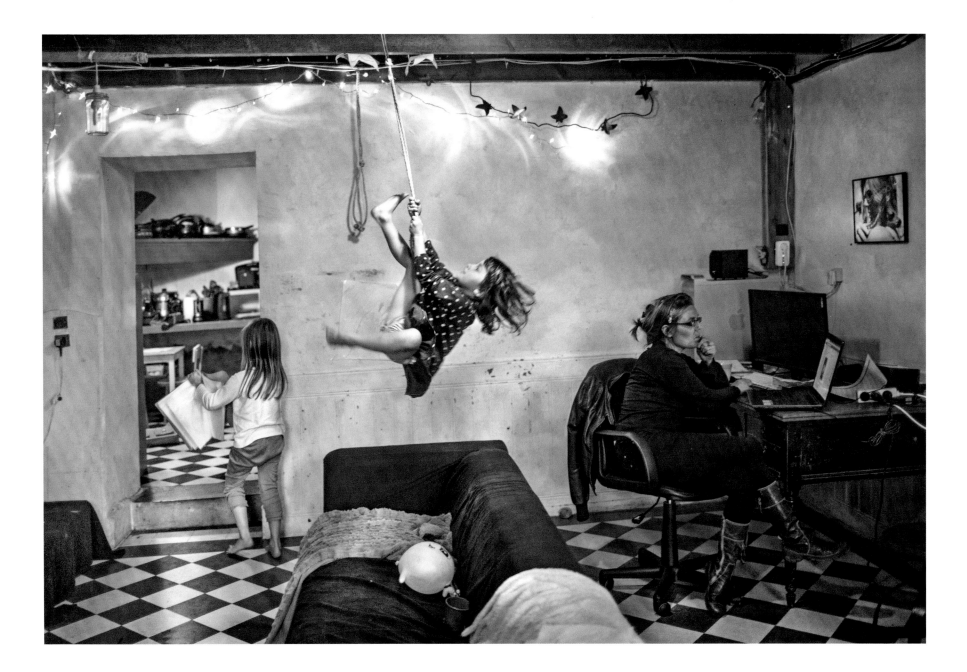

'My photography is like a daily diary. I don't have any influences,

and I try to stay away from photographic culture.'

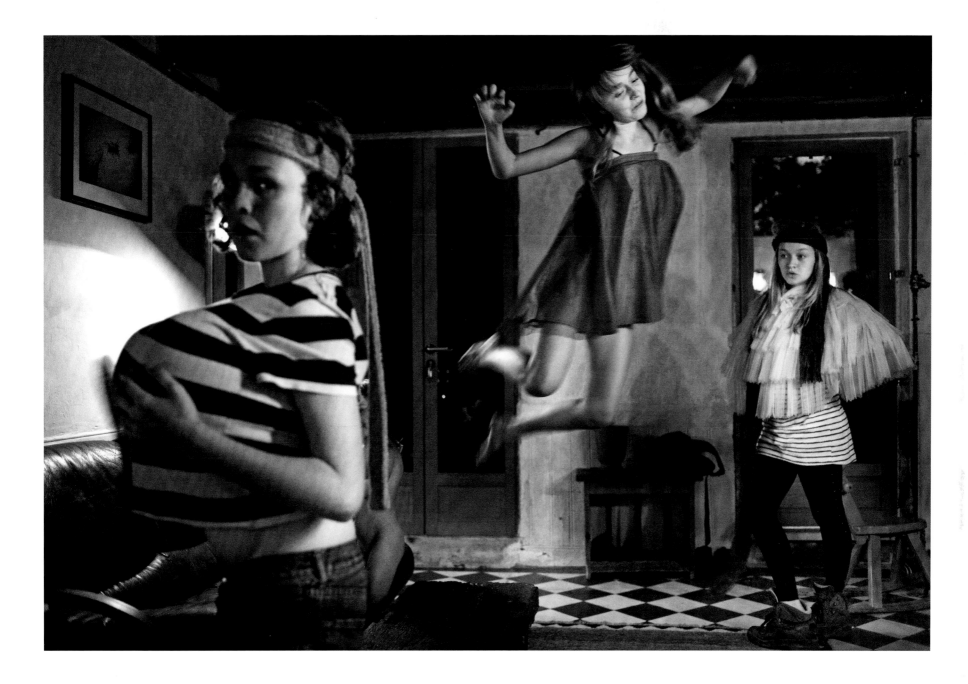

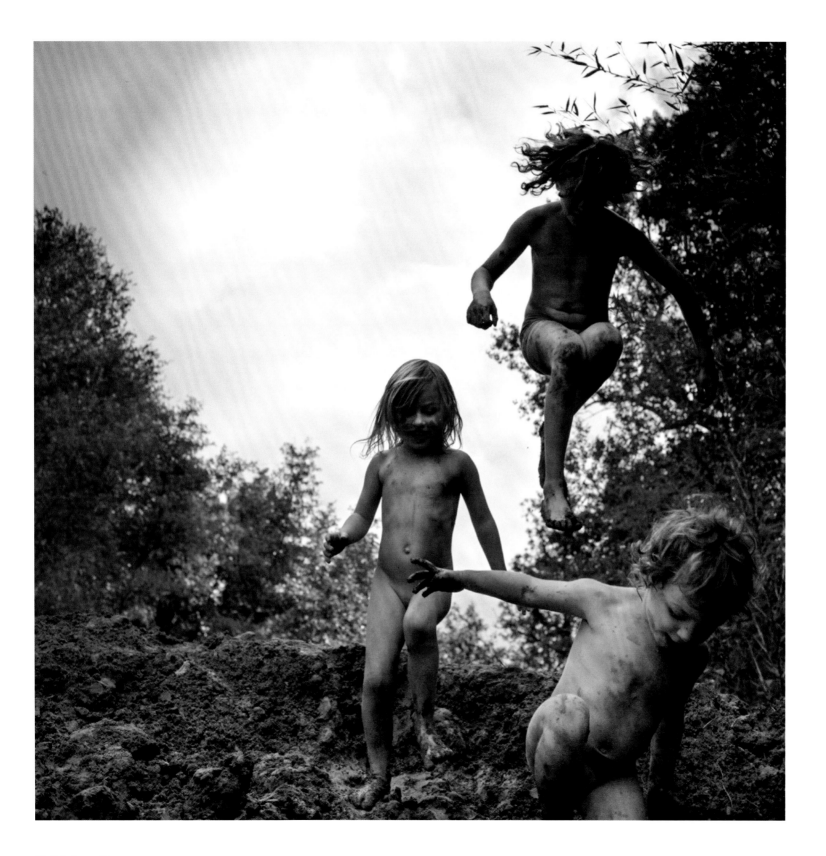

'Day to day I create a family album that constitutes a legacy I will pass on to my children. My work reflects our way of life, revolving around their childhood.'

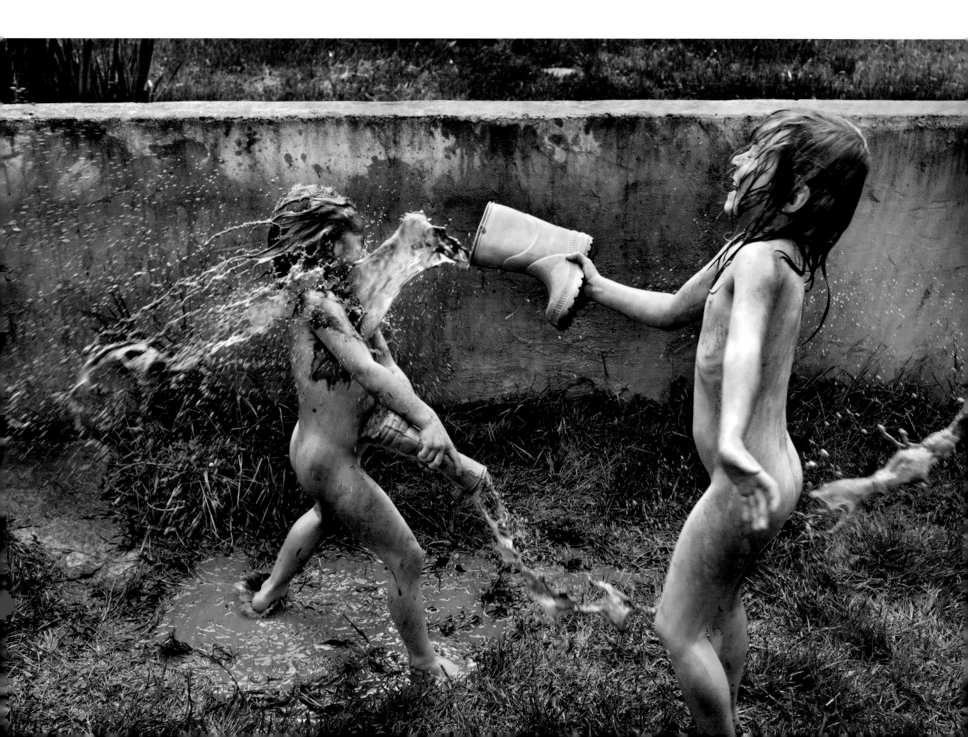

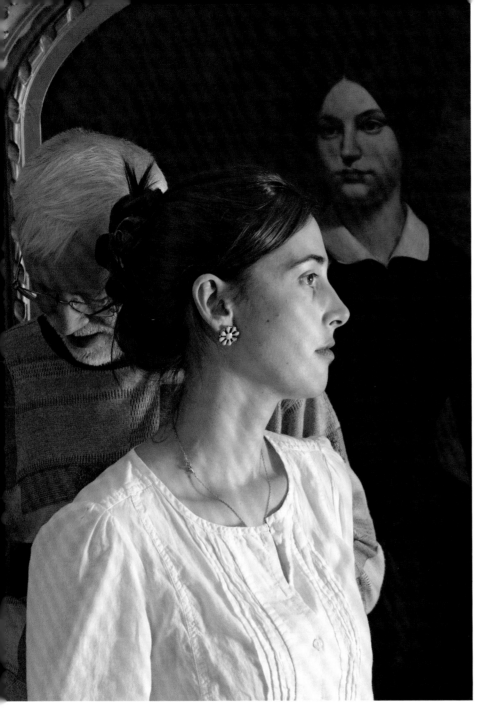

JESSICA TODD HARPER

born 1975, USA

*Painterly tableaux portraying
carefully orchestrated and highly
charged scenes of domestic life*

As one would suspect looking at Jessica Todd Harper's exquisitely lit photographs, classical art history has been a major influence. She remembers being taken to art galleries as a child and copying scenes from paintings by the likes of John Singer Sargent and Renoir. When she went to college to study art, she fell in love with the masters of Northern European Renaissance painting – Vermeer, Memling and de Hooch – all geniuses when it came to using natural light and representing it in paint.

In the two books of photographs she has published, *Interior Exposure* and *The Home Stage*, we see how Todd Harper applies art historical techniques to carefully composed photographs of her extended family, based near Philadelphia. These are not records of everyday family life; rather, they are artfully constructed scenes in which she directs family members to engage with each other in ways that are suggestive of small psychological dramas.

'I am inspired by everyday life,' she notes, 'but I work hard to create the image I want. For example, the image with the rocking horse reflects an actual afternoon spent at my grandparents' house, but that lighting was complicated and I was working with film. My preference for natural light means that the subjects often have to remain still … and that is especially hard for children! The version of the scene that you see was the only one where the characters are perfectly positioned, sharp and correctly exposed.

Achieving that means a lot of work: managing the subjects' moods so as to preserve the veracity, thinking quickly in order to capture the light, and moving furniture and objects around to get the right composition. But, all that said, my son really was on a rocking chair as my husband and grandfather looked on, even before the camera came out.'

At other times, Todd Harper starts from scratch. 'In "Abby Sees Hugh in the Front Hall", I knew I wanted an image in that spot in that house, so I made a date with the family who lives there. On the appointed day, our families had brunch, I positioned the furniture, and then I just let life happen. There was no way I could use available light with small children running around, so I positioned a strobe in front of the window and managed to get what feels like a private moment during what was otherwise a boisterous and animated visit.'

Ambiguous body language heightens the sense of family drama being played out for the camera, while heirlooms hint at ancestral forces. 'So many writers have made work based on their families. I knew that I wanted to make an autobiography some day. I just didn't know yet that it would be in photography.'

ABOVE Becky with Mary Anne and Dad, 2012
OPPOSITE Judith and her Children, 2006

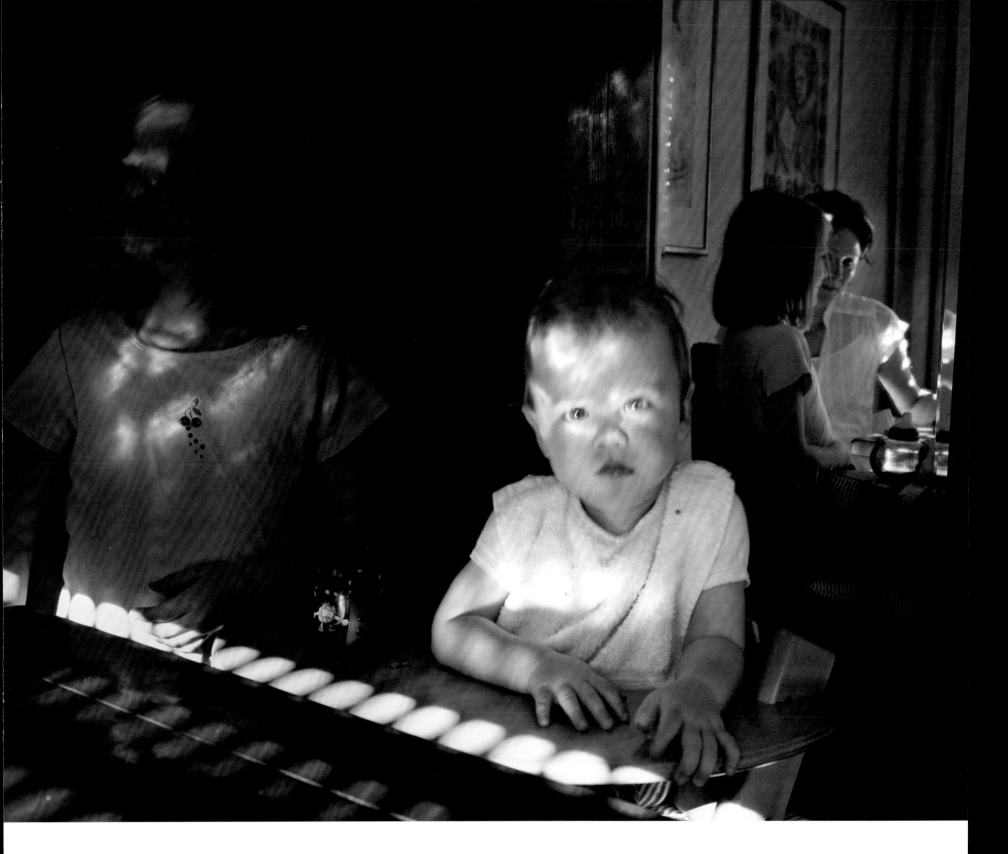

'I tell one version of my family story.

I'm sure my grandmother, for example,

would tell a different one.'

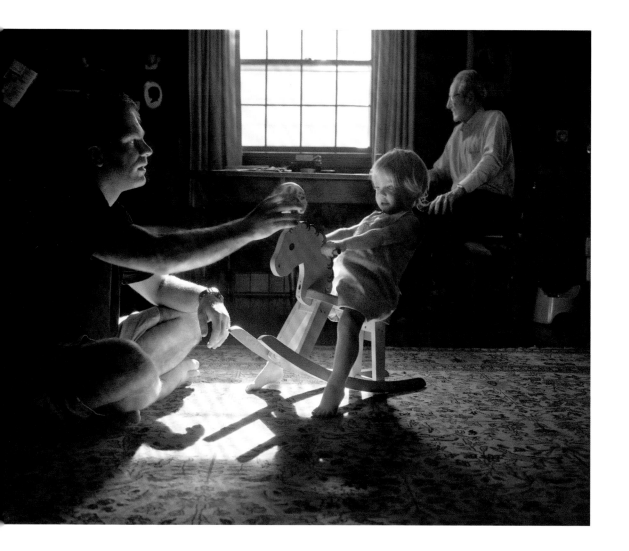

ABOVE Marshall with Christopher and Grandpa
(Rocking Horse), 2010 **RIGHT** Abby Sees Hugh
in the Front Hall, 2013

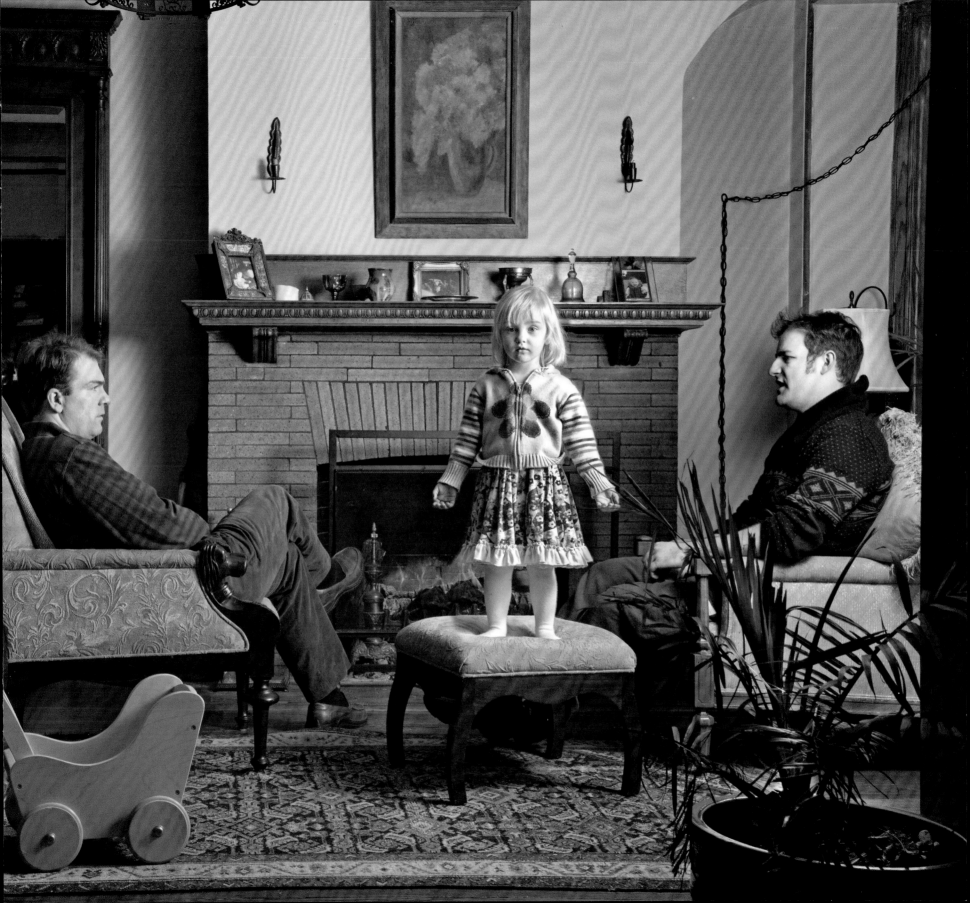

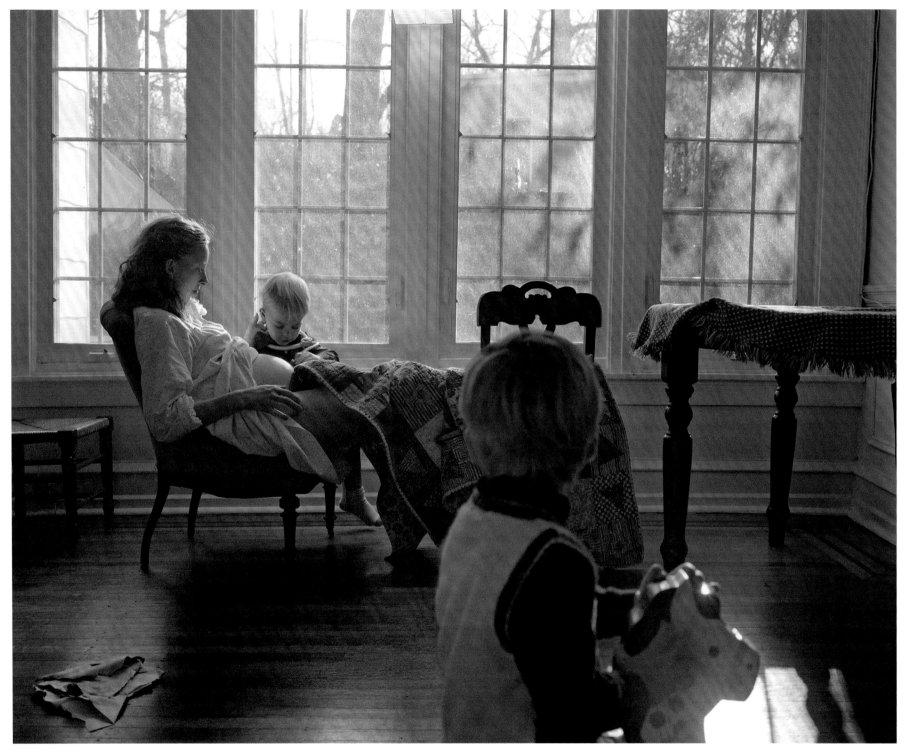

ABOVE Self-Portrait with Marshall and Nicholas
(Stethoscope), 2011 OPPOSITE Christopher with
Nicholas, 2008

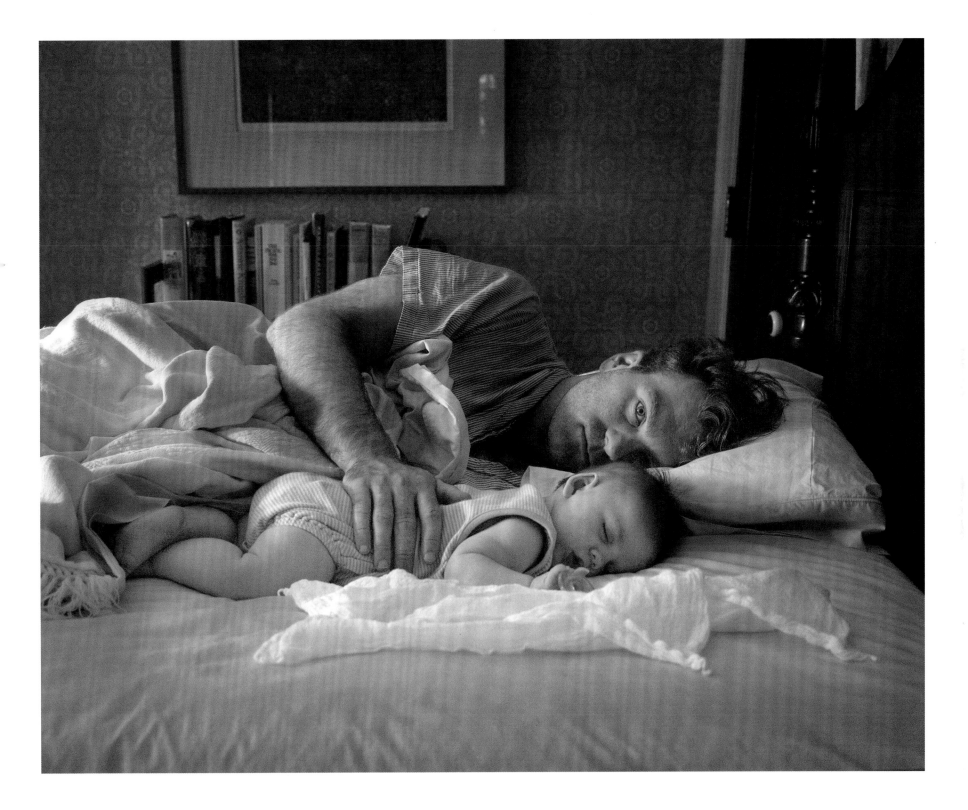

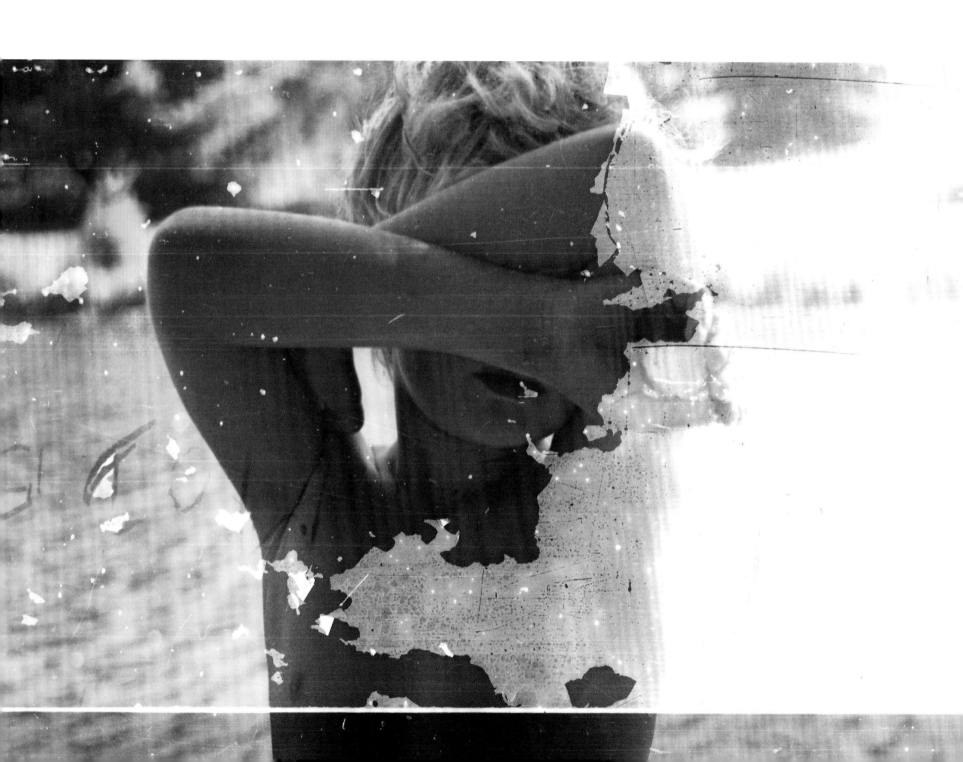

ROBIN CRACKNELL

born 1958, India; lives in England

'Still lifes' of a son: highly personal photographs by a single-parent father, recording unstaged moments in time

For a photographer who is a single parent and responsible for only one child, the spectrum of family photography is limited by necessity. 'There is never another point of view,' explains British photographer Robin Cracknell. 'I never appear in these pictures, smiling beside my son, because I am always behind the camera and Jake is always photographed alone. This presents a unique and very intense, undiluted sort of relationship, which would look very different if there were another parent or sibling around.'

As Cracknell notes, 'There is a sadness there; a vital component missing. There is no artifice to the pictures, no "staged happiness" that seems the norm in conventional family snaps. Maybe the "brokenness" was what I was trying to document? Or maybe I was convincing myself, through photographs, that what didn't feel like a family actually was one?'

These images were not produced collaboratively. 'Jake was always indifferent, disinterested in what I was doing, occasionally resistant. One of the first pictures that received any attention was of him with his arms blocking his face, refusing to be photographed. He wasn't interested in the process and has never asked to look at prints or published work, or come to any of my shows. By fourteen, he'd decided he didn't want to be photographed any more and I reluctantly accepted, so that's when it ended.'

Cracknell admits that he has experienced troubling concerns regarding his son's thoughts about the work. 'But I rationalise my conflicted feelings this way,' he says. 'In order to produce work of substance, I have to work selfishly and hope that one day Jake will look back on this period as having some truth and value. My experience of family albums is that they are largely lies, a sort of propaganda we present to ourselves and the world. Because Jake "allowed" me in so rarely, I think my portraits of him have a certain truth about them and feel less staged than other people's work, and I value that authenticity.

'Maybe this is why people notice a sort of melancholy, but I see it as just pictures of my child as he truly is – not performing, not coached, not mirroring the smile of the parent beside him. There is almost a glass wall there, with each of us – artist and subject – with different motivations, on either side. This is what has kept my interest for so long. Trying to get beyond the easy tricks of producing a cute picture of my son and finding, instead, the truth of an individual quite separate from me, which of course every child is.'

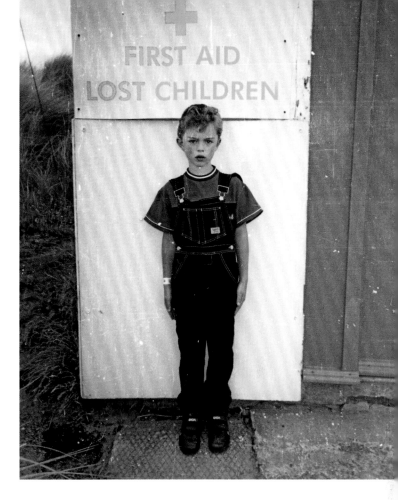

'There was a certain melancholy coming through, which is no accident, as I was, and remain, a single father trying to make sense of a very private relationship that is almost "non-family" - a consequence of a broken family.'

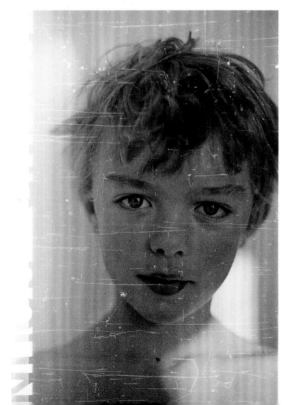

'I accept that these photographs were made for me more than for him but that is simply how "art" works and I hope, now that he is older, he understands.'

'*Echolilia* ended up being
the project, as clichéd as
it sounds, that literally
changed photography for me.
The results didn't look like
my photographs at all. Being
the greedy artist I am, always
looking for something new,
I immediately took credit for
these unusual-looking images.'

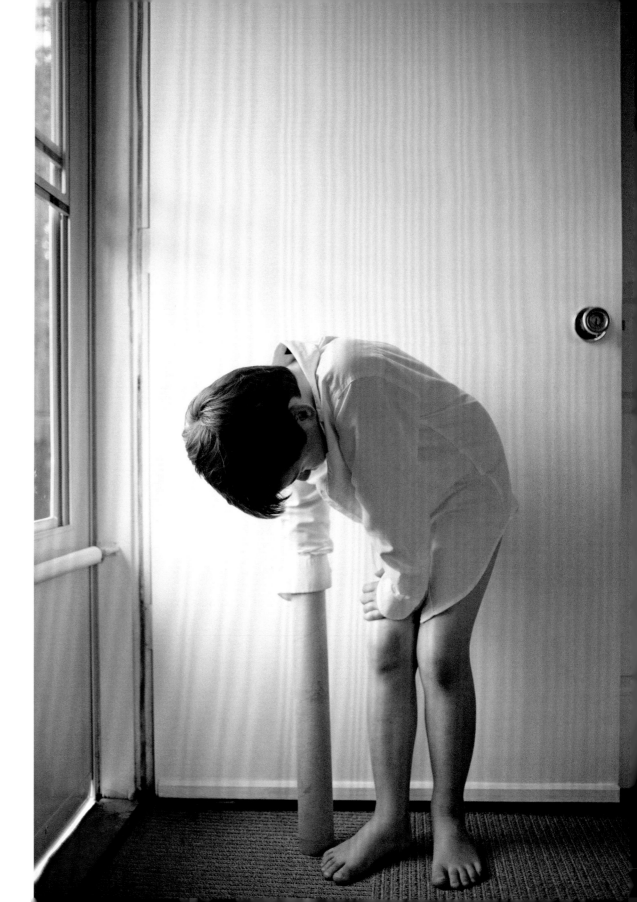

TIMOTHY ARCHIBALD

born 1967, USA

Echolilia: *A father's photographic collaboration with his autistic son*

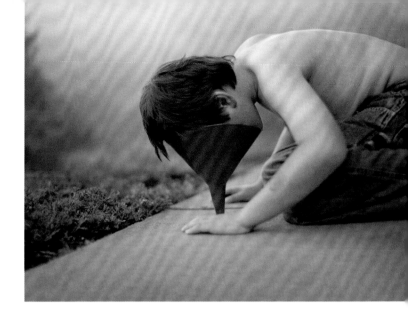

Autism is a medical condition that seems to have come to our attention only in recent times. As more children have been diagnosed as exhibiting the patterns associated with the condition, many parents have had to come to terms with caring for a child whose life is governed by unusual behaviour and difficulties with social interaction.

Timothy Archibald, a successful commercial photographer, noticed that his son, Elijah, seemed to be showing some of the symptoms of autism. As a way of interacting with his child, and in an attempt to get a sense of the complexities of his inner life, Archibald began to take pictures of him. A firm bond was created, which led to the publication of a book, *Echolilia*.

'When Eli was young – like, three or four – he was never really interested in toys. Toy cars, stuffed animals, games: none of those things caught his interest. But the mechanical world could fascinate him for hours. Electronic doors, doors on trains, gears, motors: anything that turned would monopolize him. Of course, at a young age anything a kid does is considered cute. As Eli matured a little, it was clear that he was on a different channel from his peers. He's not what we think of as traditionally autistic – he's a real communicator – but I think these days the spectrum encompasses a lot of things.'

The collaboration did not start out as a work project. 'It was me trying to pull some photographic quality time out of a domestic life that had snowballed into being all about the

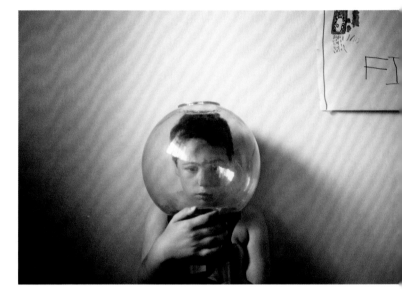

mystery of Eli. School was a problem, babysitters had problems, teachers had questions, and we were at a loss ourselves as to why he was so hard to raise. I knew he was different and I thought there was some hope that I'd point the camera at the problem, witness how he was different and capture it on film, and then take the photographs to a doctor for a pill or something that would solve it all.'

Echolilia is a beguiling mixture of drawings by Eli and photographs that he and his father worked on. The collaborative nature of the camera-play refutes any suggestion of exploitation. 'Eli wanted to be involved. He wanted to come up with ideas. He wanted to look through the camera and make suggestions. He realized he was the subject. He'd create the curious performance, and I'd find the pretty light to photograph him in. Soon we had a pattern, a map, a method to making the photographs, and we felt like we were on the same wavelength with a purpose. What purpose? Well, the purpose of figuring something out.'

Eli is now a teenager, and able to talk about his condition with honesty and candor. 'To him, autism is nothing but an asset... He seems to view the book as a piece of nostalgia, like any teenager would look at photographs of themselves when they were little.'

'The photographs that make up *Echolilia* really capture a time when I was trying to look at the evidence in my son and myself. I thought we both felt like we were digging and mining this situation together to try to figure it out, or figure something out. And in the end we didn't get any tangible answers ... but amidst it all we built a bridge.'

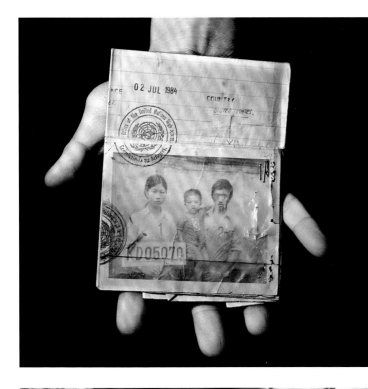

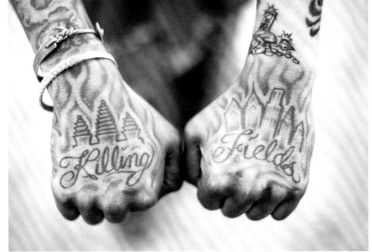

TOP Sonny Vaahn holds his family members' refugee identity card, Bronx, New York, 2011
ABOVE Shorty, 28, shows his 'Killing Fields' tattoo, Philadelphia, Pennsylvania, 2011
OPPOSITE LEFT Pete Pin's 79-year-old grandmother, Duong Meas, in Stockton, California, 2010 OPPOSITE RIGHT A family photograph taken in 1973, one of two objects saved by the Pin family when they were forcibly relocated to a Khmer Rouge work camp

PETE PIN
born 1982, Cambodia; lives in USA

Poignant exploration of memory, trauma and identity in the Cambodian-American diaspora community

Pete Pin was born in a refugee camp on the Cambodia–Thailand border at a time when the Killing Fields were headline news. Like many other families the Pins found their way to America, but quickly felt cast adrift from their roots and culture. In an attempt to reconnect with the Cambodian diaspora in the US, and especially to repair generational ties between elders who often don't speak much English and their children who have become more influenced by American culture, Pin has travelled throughout America using photography as a tool for reconciliation.

'I am interested in going beyond the image as the final product,' he says, 'and focusing on how the process of documentation and storytelling can itself create space, physically and emotionally, for family dialogue.'

One of the first images he made was a portrait of his grandmother, in 2010. 'Right before I took her photo, she spoke of my family's experience for the first time in her life. I learned that among the few possessions saved from before the war was a family portrait that had been buried during the revolution and later retrieved and brought to the US. I understood instinctively the significance of that portrait – not as a photograph, but as a tangible connection to the life my family had in Cambodia before the Killing Fields that forever changed them and their generation. As my grandmother spoke, I felt a connection to a past that had for so long been withheld from me.'

The civil war traumatized the entire population. Millions died and families were torn apart by Pol Pot's heinous policies, which aimed to replace family life with a life based on subservience to a totalitarian state. The sorrow that lies behind every family story of the time is what drives Pin forward with his project, 'Cambodian Diaspora'.

'Over the years, I have experimented with different strategies,' he notes, 'using my photographs in non-traditional installation spaces – the basement of a family home, a mental health clinic – to reach my community. I learned something very basic: the language of documentary photography is not universal, particularly for elders who have had no exposure to photography beyond the vernacular.'

Pin continues to be invited into homes to witness subjects sharing their stories, often for the first time. He also facilitates workshops, whereby 'Cambodian youth photograph family ephemera saved from before the war or produced during stays in refugee camps. These objects are often the only tangible bridge that connects the past with the present.'

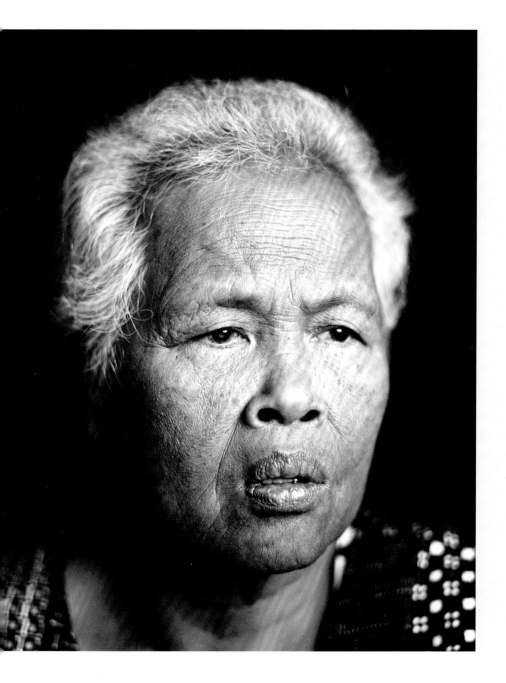

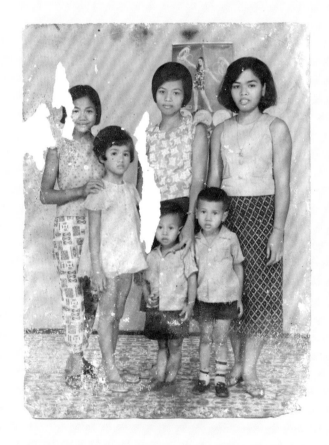

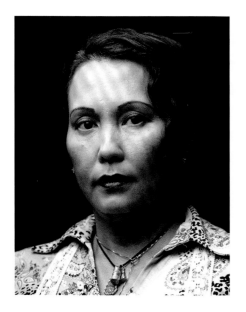
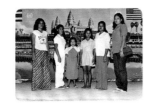
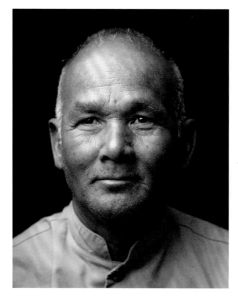

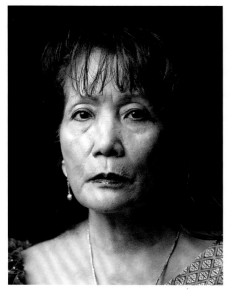

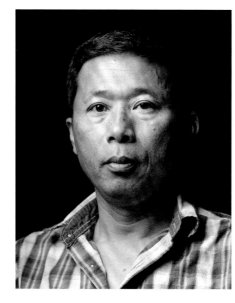

ABOVE Four members of the Cambodian diaspora and their treasured family photographs **OPPOSITE** Kaylee Tuy, 2, and Kevin Vann, 4, in the living room of their Lowell, Massachusetts home, 2011

'As a son of the Killing Fields, born in 1982 in the refugee camp to which my family had fled following the Cambodian genocide, I have struggled for most of my life to understand the legacy of my people.'

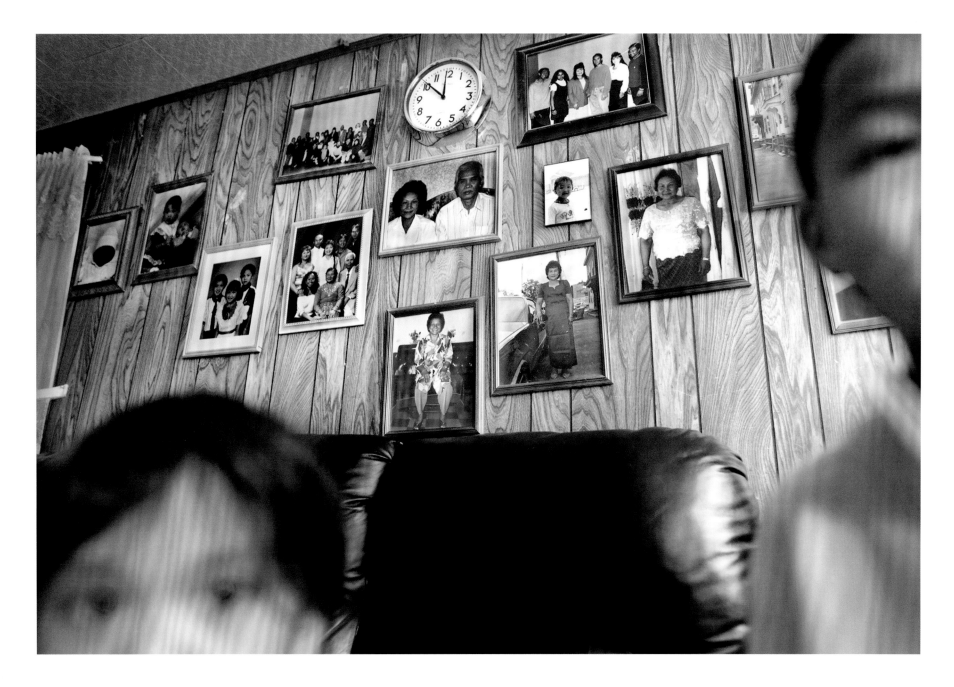

CECILIA REYNOSO

born 1980, Argentina

An affectionate look at intergenerational relationships within the photographer's extended family

In 2009, Argentinian photographer Cecilia Reynoso took a photo of her extended family gathered together for Christmas (see pp. 4–5). There are parents, grandparents and great-grandparents, uncles and aunts, cousins, in-laws, twins and a newborn – eighteen in total. 'We are very proud of having such a united family,' Reynoso states. 'My great-grandfather always said he considered himself a billionaire because of the family he had.'

Taking the photo inspired Reynoso, who makes her living as a stills film photographer, to turn her artistic lens closer to home. 'We are a big, loud, playful family. When we get together, we hug and kiss, laugh and joke a lot. We are naturally affectionate and very physical. I suppose we are fairly typical Italian and Spanish immigrants.'

'The one area of strain,' she notes, 'is the gap between keeping traditions and being flexible about them. It's one of the reasons the big family gatherings interest me so much. There are so many different attitudes and emotions at work: the little kids are bored, the young people's thoughts are elsewhere, the oldies are coasting, and so on.'

Being fully part of the family is more important to Reynoso than being a cool observer. 'I try to keep a balance between being in and out of the scenes, but if I feel I'm becoming disconnected, I put the camera away and just enjoy a good conversation. A sense of connection is crucial to my work. I get my best pictures when everyone feels relaxed and knows they can trust me.'

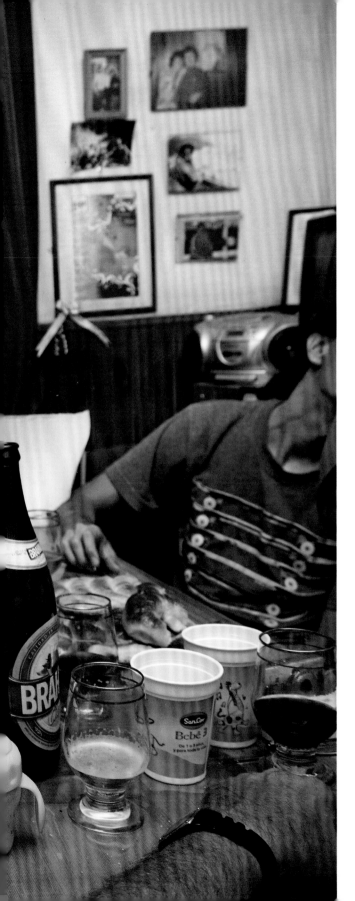

'Flores is our family name. I like to make images where

flowers are present, as a symbolism of the family.'

'In Argentina the family is sacred. Don't even think of skipping

a Sunday dinner, a birthday, or Christmas.'

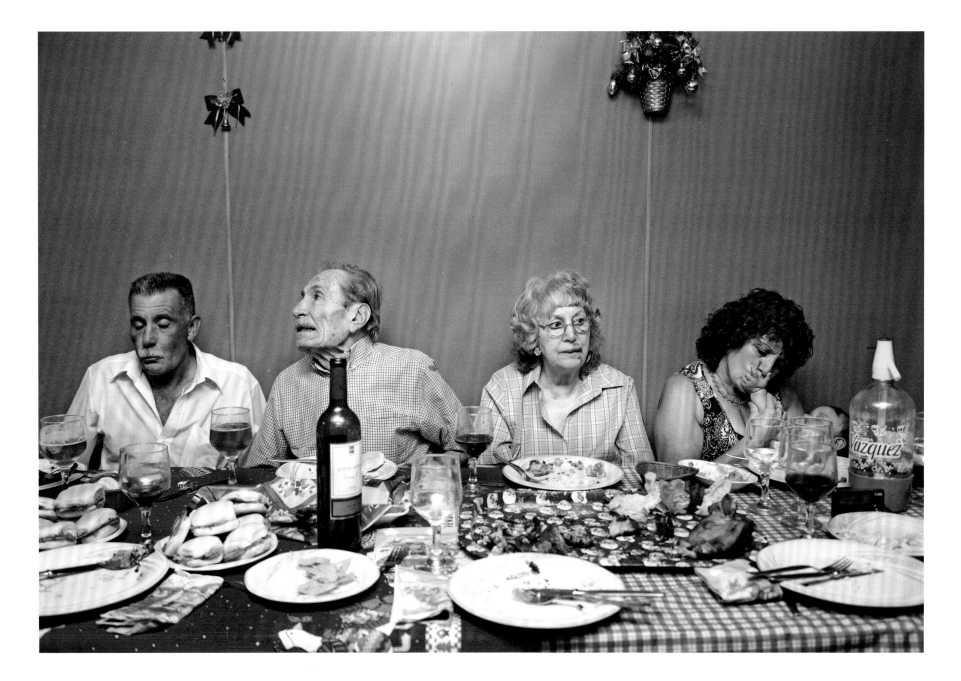

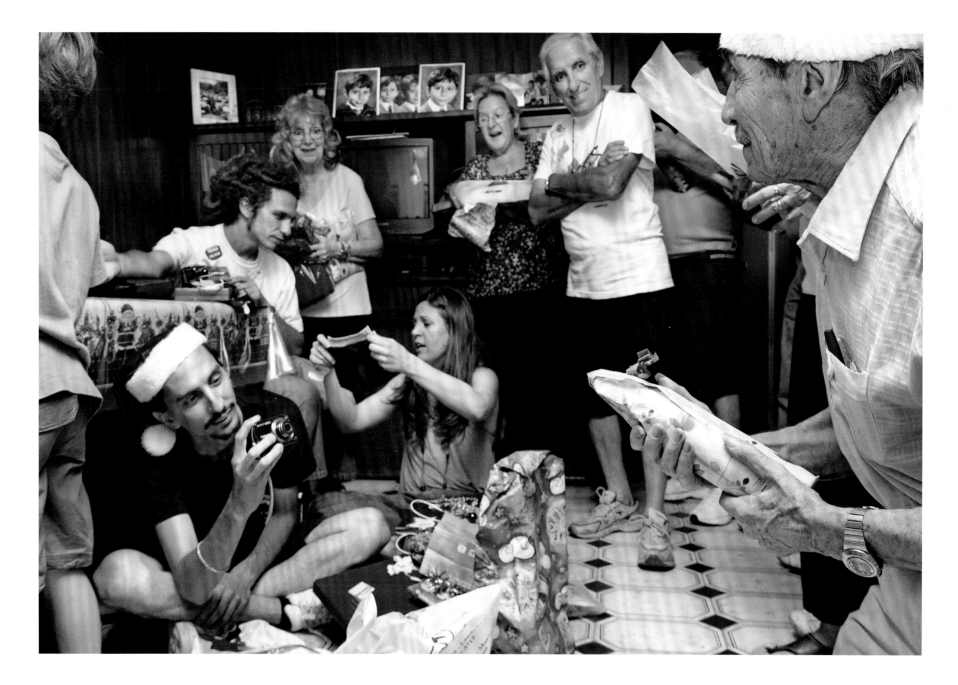

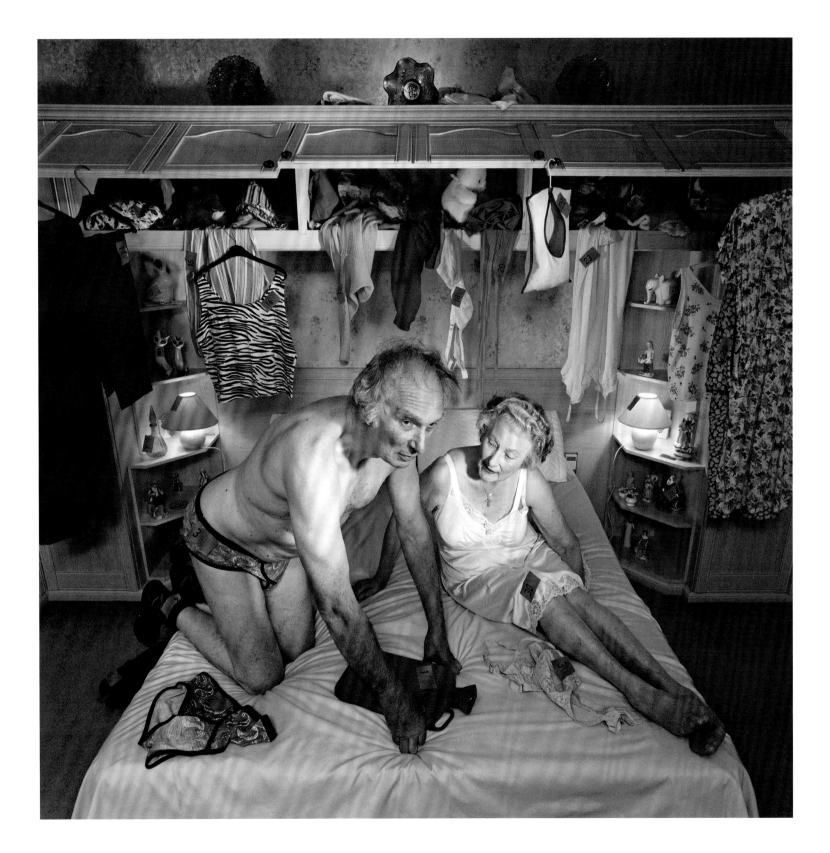

COLIN GRAY

born 1956, England; lives in Scotland

A 35-year project exploring the artist's relationship with his parents and their relationship with each other

'Where do I come from?' is something almost every child asks their parents at some point. For Colin Gray, it is the question that has defined his photographic career. Gray remembers photographing his parents on holiday and at family celebrations when he was just five or six years old, but it was not until he moved to London in his mid-twenties that he started consciously creating artwork both about and with them. It began as a way to channel his homesickness and developed into a lifelong curiosity about the two people who have shaped him most profoundly.

Gray made early works, such as 'Hull under Water' (1991) and 'The Lottery' (1995) during trips back home to visit his parents in the northern city of Hull. Blending childhood memories with suburban fantasies, he staged elaborate tableaux inside the old family home. 'We laughed a lot making these works. It was a very collaborative process,' Gray remembers.

After his mother Rene suffered a severe stroke in 2000, and his father Ron, increasingly frail himself, became her main carer, the emotional trajectory of Gray's work took a plunge. 'I used photography as a way to try and understand what was happening. It was such a dark time. My father and I didn't talk a lot about what was going on, but the photography felt therapeutic for us both. Perhaps it's an odd thing to say, but my own depression at that time probably helped me to understand the

difficulty of the experience my parents were going through.'

Gray has been struck by how many people have talked to him about love and loss in their own families after seeing his photographs of his ageing parents. He admits that some have been shocked by how candidly he has shown the realities of dying and death.

'Some people feel I've been too intrusive,' he says. 'The photograph of my mother in her coffin and the portrait of my father curled up with grief in his duvet have both divided opinion. They were not easy works for me to make, and they have not been easy for me to show. Of course there have been times I've wondered if I've done the right thing. But I don't think I'd have shown my parents looking so vulnerable if I had not also shown them looking so vibrant in earlier years. My mother was such a radiant person, so playful and so intelligent. I hope she would both forgive me for showing her as I have done and approve of this work.'

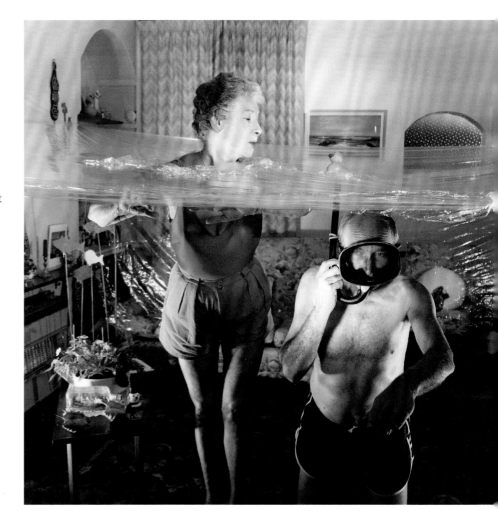

OPPOSITE The Lottery, from *The Parents* series, 1995 **ABOVE** Hull under Water, from *The Parents* series, 1991

'Seeing my parents' faces drift out of focus is like looking at my own reflection. I see the history in my own future.'

ABOVE AND OPPOSITE Photographs from 'In Sickness and in Health', which forms the final stages of *The Parents* series

'I have let people in to share my family's quiet agony by documenting

things I wish were not happening and, although painful, the process

has also been cathartic.'

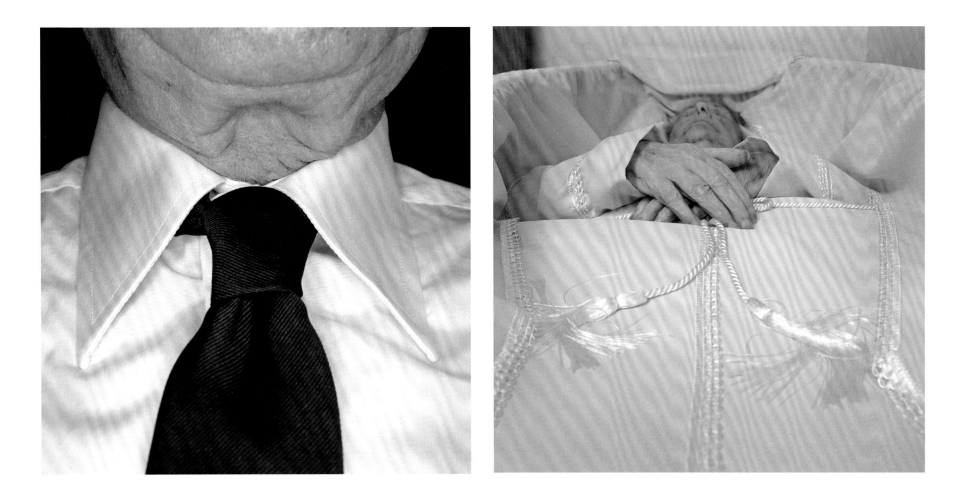

ABOVE AND OPPOSITE Photographs from
'In Sickness and in Health'

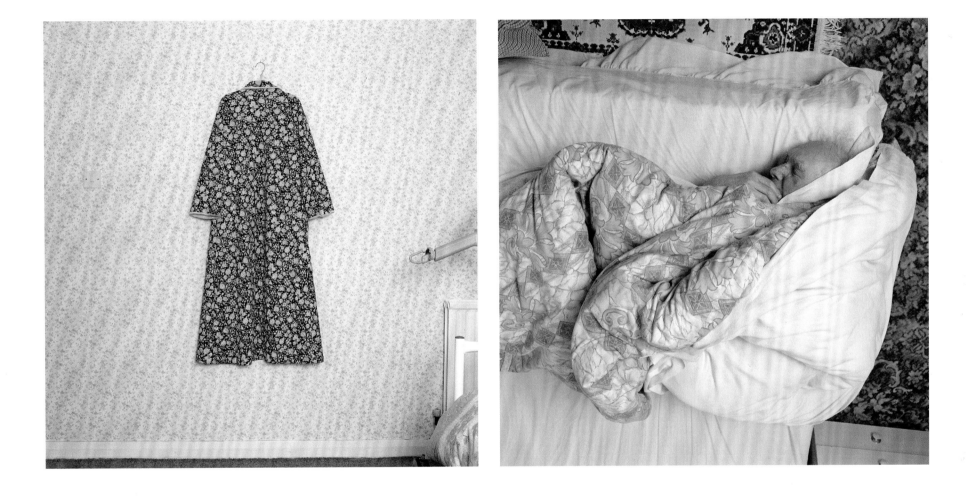

'This is very personal work, this is *my* family,

and we have faced challenges that are very specific

to our experience.'

DANIEL W. COBURN

born 1976, USA

The aftermath of growing up in a troubled evangelical family and grappling with a loss of faith in the institutions of family and religion

'My family history is haunted by suicide, severe domestic violence and substance abuse,' reports photographer Daniel W. Coburn. 'I was frustrated by the lack of images in my family archive to document this series of tragedies, so I set out to create a more potent and accurate supplement to the album assembled by my parents. The people and landscapes that appear in these photographs are metaphors for a family that exists at the intersection of domestic duress and spirituality.'

It was Coburn's relationship with his mother that instigated these disquieting pictures. 'I made a portrait of my mother while I was a graduate student. I have always seen her as the matriarch of the family. She has a presence that is simultaneously menacing and fragile, and this photograph got close to capturing her essence. That's when I began to take a close look at my family album in an effort to examine the family narrative.'

Coburn's project has involved research into early advertising and the culture that has solidified the visual construct/archetype of the quintessential American family. 'Most albums present a sanitized, idealized representation of domestic life. They are filled with clichés and are almost interchangeable. This project was designed to puncture that illusion. It is, in many ways, an anti-family album.'

With the rise of digital media, the album as hallowed object and receptacle for family togetherness may not be around much longer. However,

the notion of an agreed family history recorded in photographs continues to exert a pull on our consciousness, and Coburn is aware that there are issues of power and agency between those who take the photographs and those who are posed and photographed, which makes for a contested narrative of domestic life.

His own family are active collaborators in the making of the photographs, and he credits them as co-authors. 'They are my family members but they are also actors; participants in a dramatic work, or tableau. I describe myself as a visual novelist; someone who uses the people in their lives to inspire a complex set of characters.' Coburn also uses found photographs, which he alters for narrative effect.

He acknowledges that the work has forced his family to confront their history, and has thus become cathartic for all involved. His hope is that the personal aspect broadens the appeal of the work. 'I believe that accessibility is facilitated by specificity. I try to be as specific as possible. I hope that most people can identify with these characters that I present. I hope they see a bit of themselves, or someone they love, in each of these photographs.'

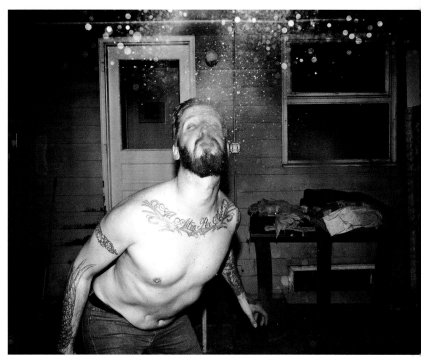

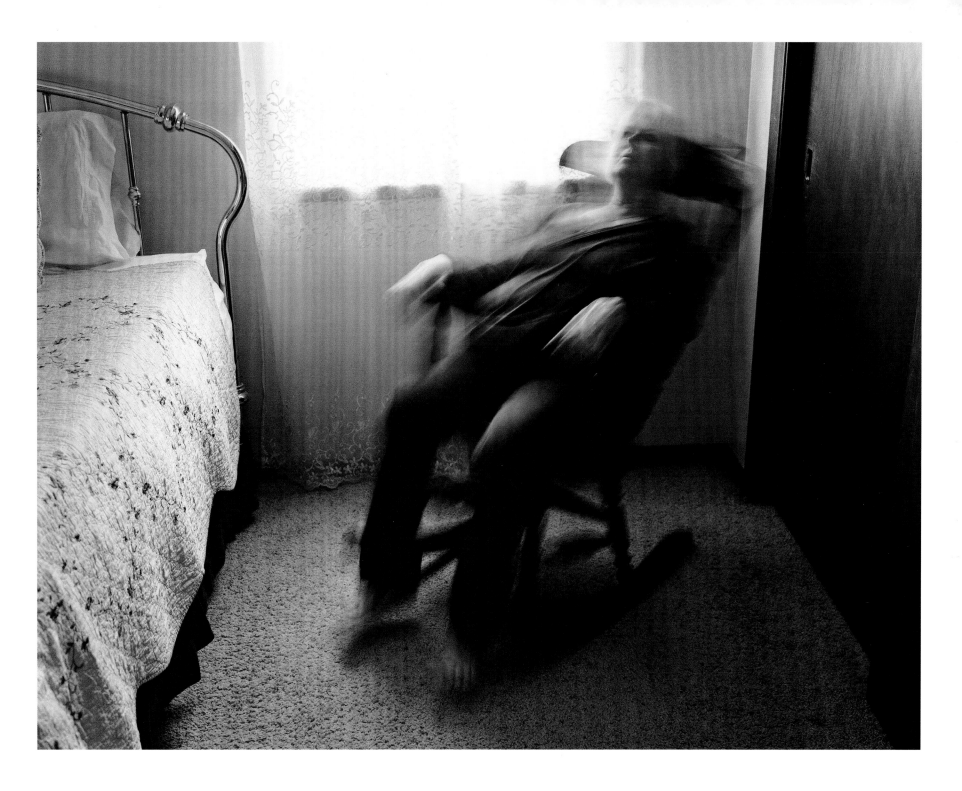

'I photograph my family, or people and places that represent my family. At this point, all of my work is made in response to the idealized family photo album. My own family history is haunted by instances of suicide, domestic violence and alcoholism.'

CAROLLE BENITAH

born 1965, Morocco; lives in France

Photo Souvenirs: *a subjective interpretation of childhood memories and a refashioning of image and identity*

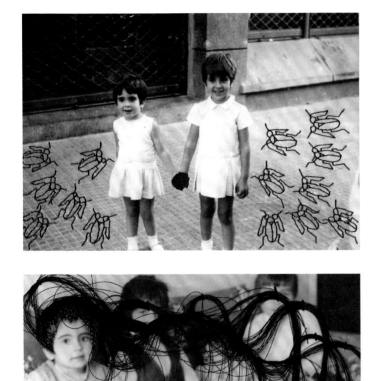

TOP *Les cafards* (The Cockroaches)
ABOVE *Sur le canapé* (On the Sofa),
OPPOSITE *Chez le photographe* (At the Photographer's Studio)

Many of us have had the uncanny experience of feeling disconnected from the photographs of ourselves we find in old family albums. Leafing through an album of her Moroccan childhood in 2009, Carolle Benitah was struck by this sense of alienation. 'Those moments fixed on paper represented me, revealing my family, my identity, the fears that shaped me and everything that defines me today. And yet I remembered almost nothing about the occasions on which they were taken.'

Benitah became preoccupied by the unreliability of memory and its effect on adult identity. Having started her career as a fashion designer, she began to cut, unpick, collage and reconnect the photographic archive of her life with a tailor's attention to detail. In what she describes as 'excavations', she unearthed photographs from albums and shoeboxes, scanned and reprinted them onto new paper, and set about embroidering and embellishing them with red, black and gold thread, glass beads and wire.

'The precise and slow process is a metaphor for the process of remaking myself and for the passage of time. I think of it like an exorcism. The red thread is a connecting thread, leading me through the maze of my past; it's the colour of violent emotions, of blood, and of sexuality; I used it in all the childhood images. Adolescence is represented by black for the anguish associated with this period of my life. Gold, the colour of affective ties, of fidelity and of disincarnation, is used for the adulthood album.'

Anguish and fantasy mix to dramatic effect in these meticulous fabrications. We see cockroaches embroidered with angels' wings, mouths sewn shut, faces disfigured, figures cut out of the photograph altogether. In one image Benitah traps her whole family inside a cage of gold thread; in another she appears about to be engulfed by a needlepoint wave. As black and white snapshots give way to colour film from the 1970s onwards, we see Benitah getting married and tending her newborn. In an image titled 'Madonna', she embroiders a halo around herself as she holds onto her young son.

Benitah has described her work as an exorcism. 'I am exploring the memories of my childhood to help me understand who I am today. The past of any human being is never permanent, but constantly being reconstructed in the present.'

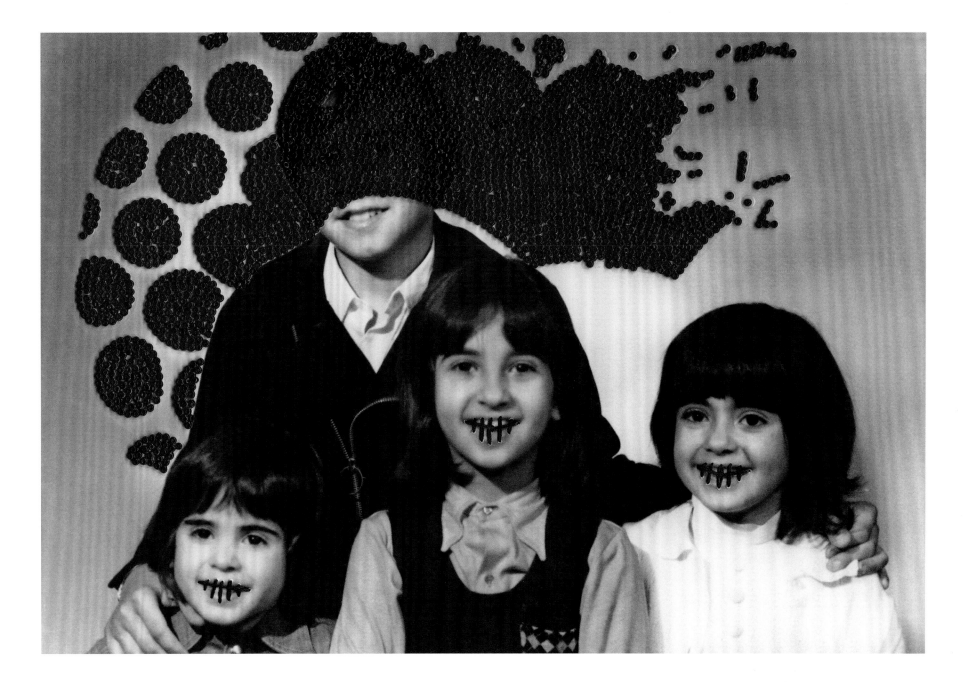

'The photos reawakened an anguish of something both familiar and totally unknown,

the kind of disquieting strangeness that Freud spoke about.'

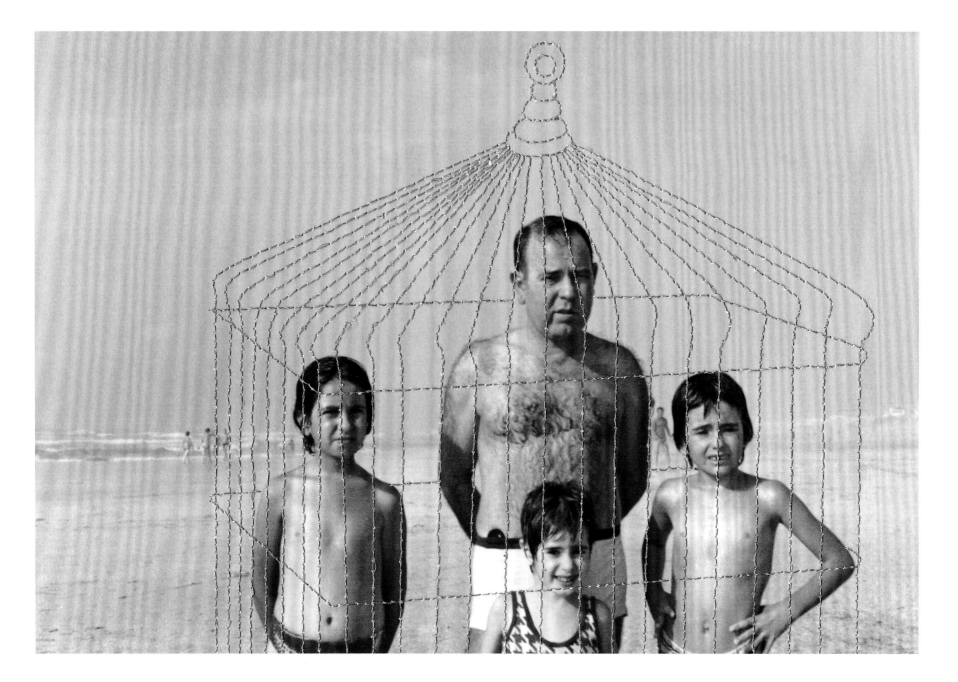

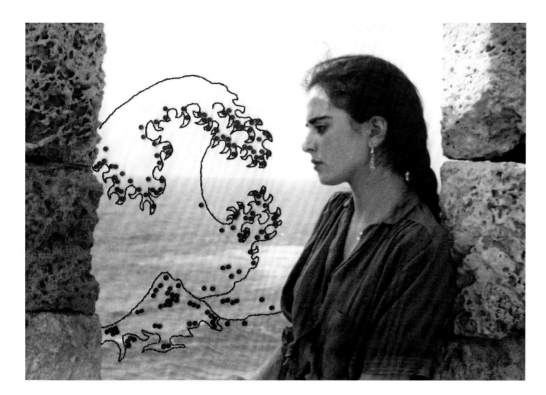

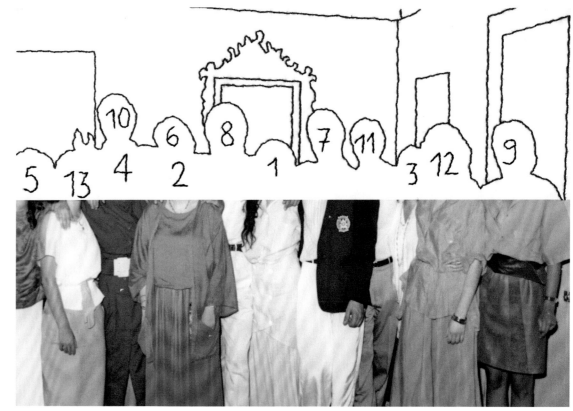

OPPOSITE *La cage dorée* (The Golden Cage)
ABOVE *La vague* (The Wave) RIGHT *Photo de groupe* (Group Photo)

'With each stitch I make a hole with a needle. Each hole

is a putting to death of my demons. It's like an exorcism.

I make holes in paper until I am not hurting any more.'

ELINA BROTHERUS

born 1972, Finland; lives in Finland and France

Annonciation: *a series of raw self-portraits conveying the desolation of infertility*

Elina Brotherus's work has always explored her own identity. Since her early twenties she has made a series of self-portraits documenting the ups and downs of her emotional life. She made *Wedding Portraits* (1997) when she got married, *Divorce Portrait* (1998) when she got divorced, and *I Hate Sex* (1998) when that was the way she felt. 'When life is "shaky",' she says, 'I get the urge to take photographs. I work the pain into a beautiful object that I can look at, detached from myself, and that consoles me a little.'

Annonciation, a series of photographs made between 2009 and 2013, is Brotherus's most unflinching work to date. It documents what she calls the 'hopeless, inconsolable reality' of not becoming a mother. The photographs were made over five years and trace a repeated cycle of hope and sorrow as she goes through failed IVF treatments.

The work references traditional Annunciation paintings, in which the angel Gabriel appears to the Virgin Mary to tell her she will give birth to the Son of God. But, as Brotherus explains of her work: 'This is a series of false annunciations. It is about waiting for an angel who never shows up. First we don't know if he's there because he could just be hiding behind the doorway. Gradually it becomes clear that he's not coming.'

Although Brotherus has shared raw emotion in much of her previous work, *Annonciation* involves a new level of personal exposure. The decision to show the work in public in 2013 was in part an act of defiance against the false hope that the media builds up around fertility treatment.

'Documentaries, interviews, articles and TV programmes on infertility all have a happy ending. In reality, happy endings occur in only 25% of the cycles. So this repetitive pattern – of executing precise scientific experiments on the body, waiting, being disappointed, and repeating the whole thing over and over again, to the point of being sick of it, to the point of almost no longer caring – is something I share with a surprisingly large number of women. The success stories are rare, but they are the ones we hear of.... I am showing this series of photographs to give visibility to those whose IVF treatments lead nowhere. The hopeless story with an unhappy end is the story of the majority.'

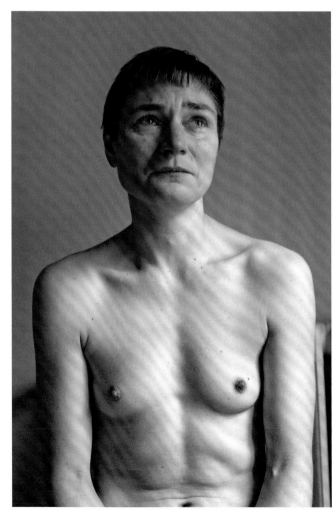

ABOVE LEFT Annonciation 8, Avallon, 12.04.2011
BELOW LEFT Annonciation 12, 2012
OPPOSITE Annonciation 6, Helsinki 10.02.2011

'People these days are not ashamed of talking about sex,

psychological problems, alcohol and drugs, but for some reason

involuntary childlessness is still very much a taboo topic.'

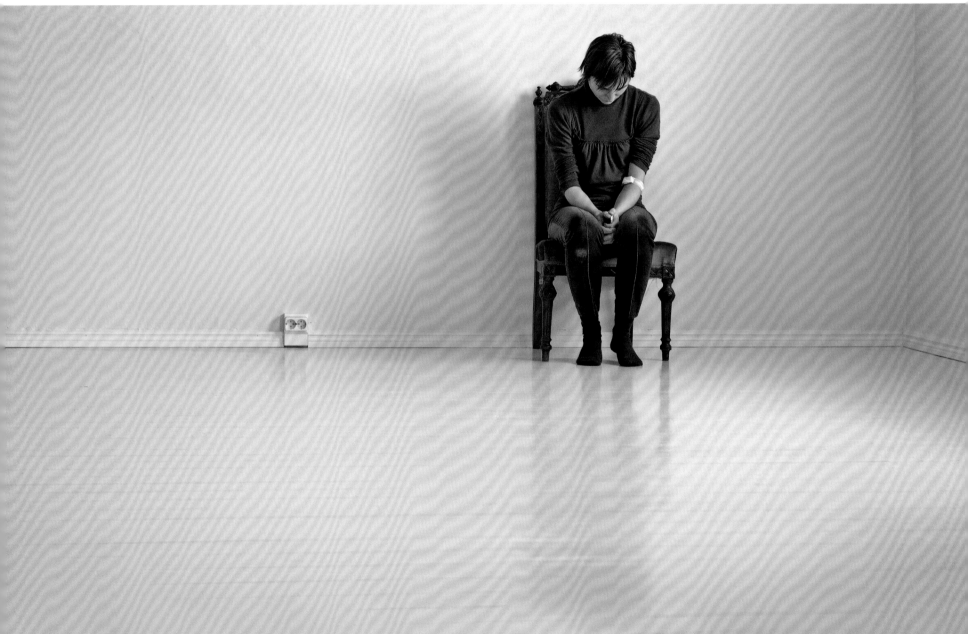

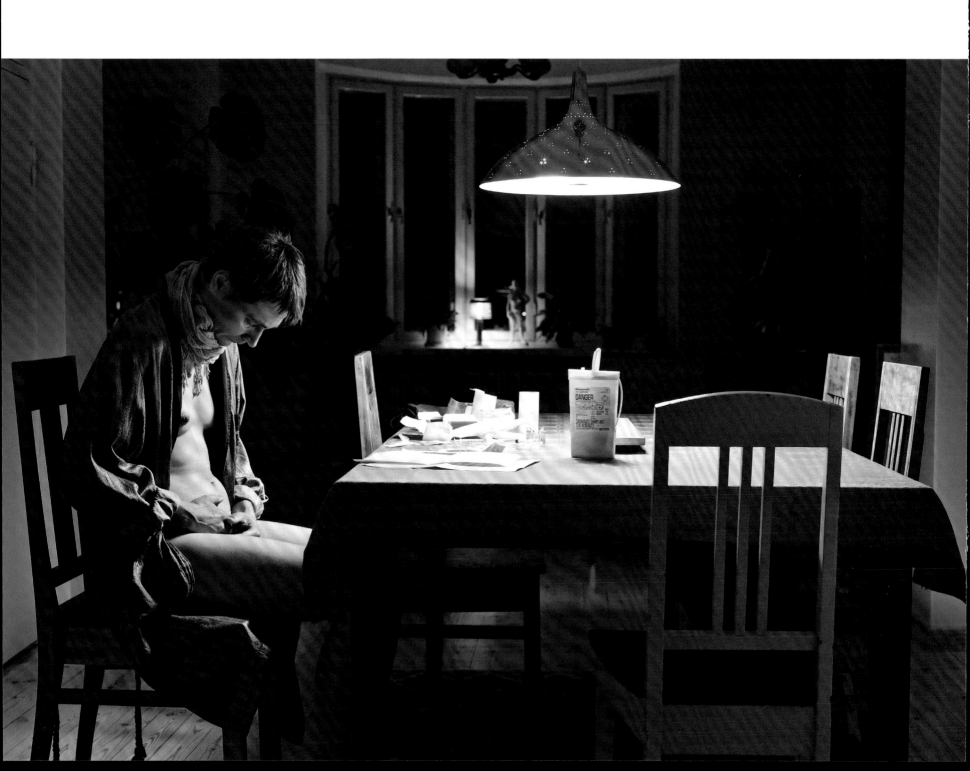

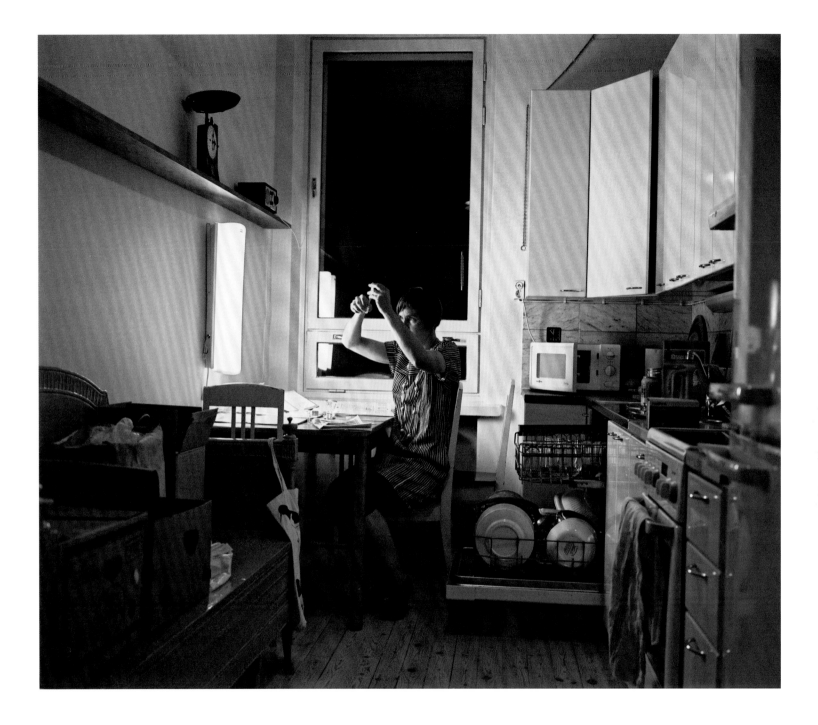

OPPOSITE Annonciation 10, 2011
ABOVE Annonciation 19, 2012

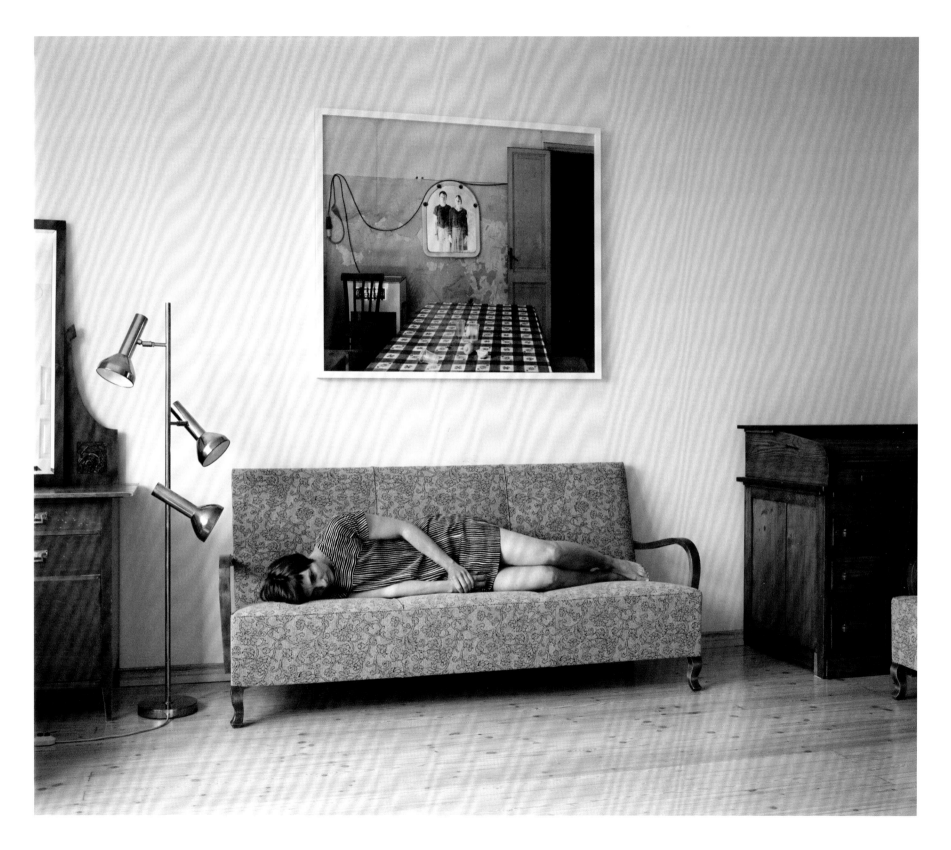

'When the treatment is unsuccessful, it is not exaggerated to say it feels like mourning someone who died. The loss is very concrete. Not only does one lose a child, one also loses a whole future life as a family.'

OPPOSITE Annonciation 18, 2012
ABOVE Annonciation 21, New York
11.07.2012, Part 4

'Nick has cerebral palsy. Taking pictures has been a way

for me to deal with the reality of having a twin brother

who struggles through life in ways that I do not.'

CHRISTOPHER CAPOZZIELLO

born 1980, USA

A photojournalist's reportage documenting his twin brother living with disability

Christopher Capozziello and his twin brother Nick were born in May 1980, in Milford, Connecticut. Chris was born five minutes earlier than Nick and both boys initially seemed healthy, but one was not. Over the next year, their pediatrician noticed that Nick was reaching physical milestones later than his brother, and at two years of age Nick was diagnosed with cerebral palsy.

More than thirty years later, Chris's photoreportage, *The Distance Between Us*, offers an uncompromising account of how these brothers' lives have been affected by the diagnosis. It is frank and full of empathy.

'I would like you to meet my brother,' writes Chris. 'I have been drawn to photographing him for as long as I have been making pictures. The time I spend with him, looking through my camera, has forced me to ask questions about suffering, and faith, and why anyone is born with disease.'

An accomplished photojournalist who regularly confronts highly emotive subject matter, Chris has chosen to feature written diary entries alongside his photographs, as well as some photographs taken by Nick. The result is an intimate photo-essay that could only come out of the intimate bond that exists between the two brothers.

'Sharing this story was not something I set out to do,' Chris has noted, 'but, over the years, one picture has led to another and a story has emerged.' As he has acknowledged, 'When there is suffering we often want to know why. We want answers.

I want answers. I want explanations as to why some suffer and others do not. I want to know why some get better while others get worse. Is it fate, or is this chance, or is it just bad luck?'

Occasionally Nick's voice appears as a counterpoint to Chris's sense of guilt and loss of faith: 'I sometimes wonder why God put me on this earth the way I am. It feels like He doesn't answer me, but I never get angry at God because if I didn't have cerebral palsy I would be a different person.'

Although Nick is disadvantaged by his condition, he is a spirited and adventurous personality, keen on socializing and engaging with people to the best of his ability. Chris's images show Nick's painful spasms and medical interventions, but we also see Nick out on the street, singing in a karaoke bar and travelling with his brother. The warmth between the pair, as we see them navigating the open roads of the Midwest en route to Las Vegas, is both joyous and inspiring.

'After all these years, there is still a part of me that is shocked and scared ... finding him on the floor, his body contorted, looking like a twisted and mangled car after an accident.'

'Nick is having Deep Brain Stimulation Surgery next month.

The doctors say it probably won't stop all of his cramps,

but it could significantly decrease their effects.'

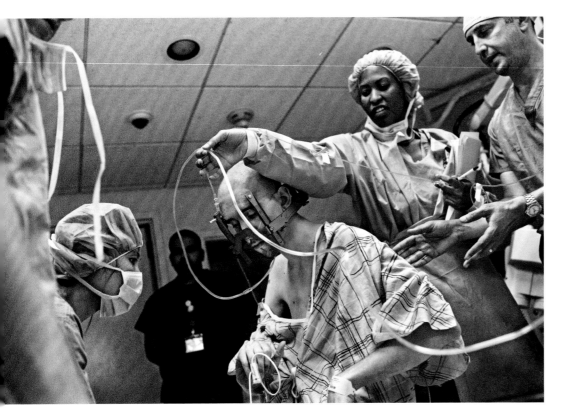
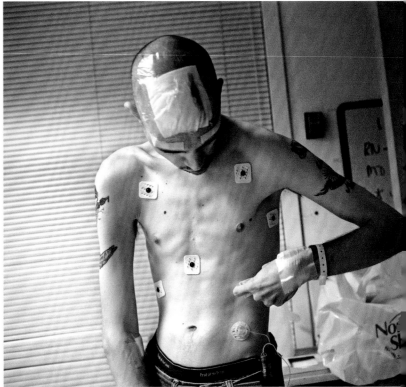

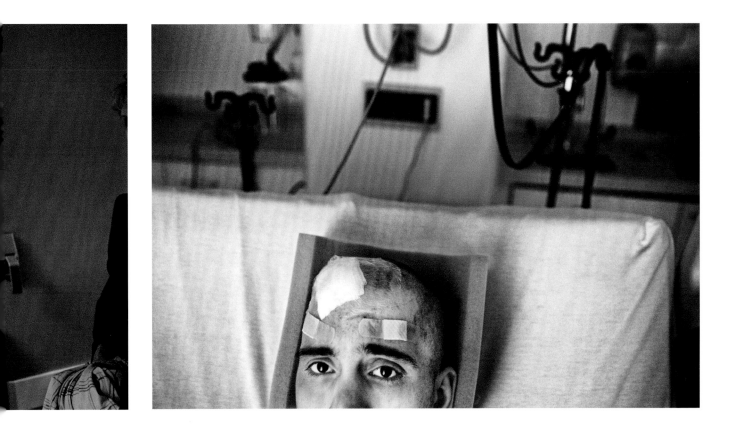

'"We understand you're a photojournalist," the hospital executive

said in an email, "but you're also Nick's family - his twin, no less.

The hospital's policy is no family members in the operating room

during surgery."'

'After all these years, instead of asking why, I am starting, for the very first time, to ask what's next?'

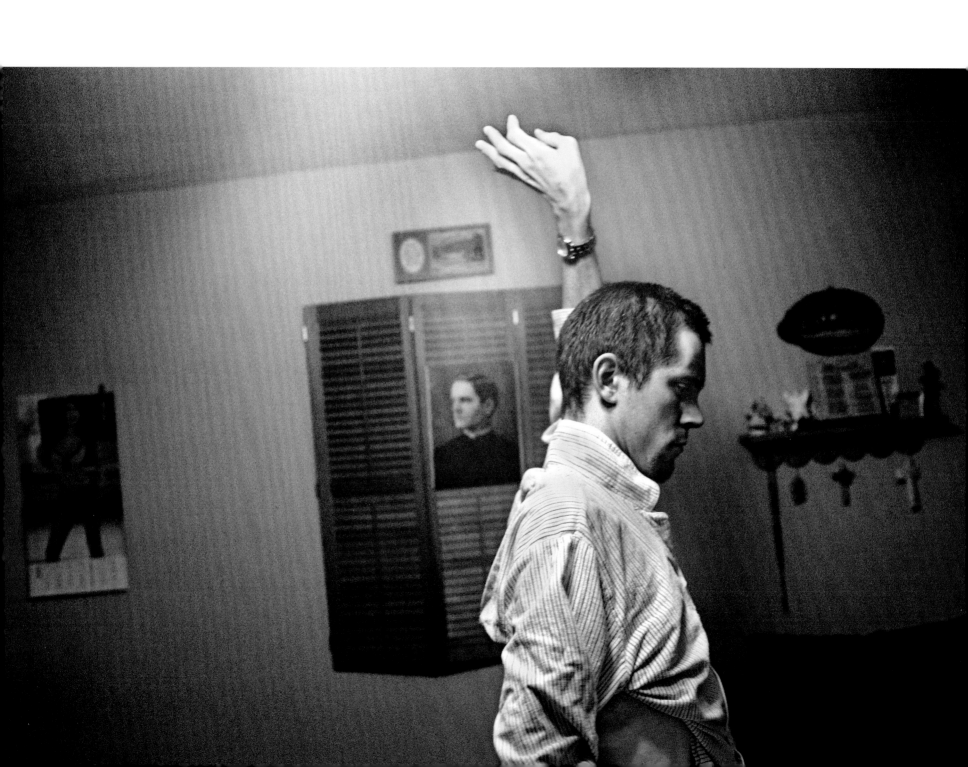

MATT EICH

born 1986, USA

A young photographer's response to the life-changing arrival of children and the new centrifugal force of family and home

Matt Eich, a youthful documentary photographer from Virginia, found early acclaim for his poetic but gritty photographs, brought together in a collection of projects known as 'The Invisible Yoke', focusing on the American condition in Mississippi, Ohio and Virgina. Marrying his long-term girlfriend Melissa and having two children, however, gave him great pause for thought, as he wondered how his documentary work could co-exist with his desire to play as much of a role as possible in his growing family.

Eich found himself fully immersed in photographing his family at all times and in all places. He and his camera followed Melissa's pregnancies, and he photographed both of his children's births. Avoiding any sense of intrusion, his images instead convey an impression of a highly creative person revelling in the intimacy of everyday family pastimes.

'I am the oldest of four children,' he reports, 'and we grew up in pretty rural parts of Virginia, being homeschooled for a lot of our early education. My first daughter was born when I was quite young, 21, and my wife was 20. The photographs do not claim that we are unique, but rather catalogue some of the common emotions and experiences wrapped up in family life. I am hoping to achieve something more universal with my representations of family.'

Eich is resigned to the fact that, in focusing on something as intimate as family life, he is unlikely to be able to see his work clearly until time offers emotional distance. 'Even then,' he says, 'it will be coloured by nostalgia. In the act of making the work, that critical distance collapses into something that is more immediate and personal. As with all of my other work, I don't initially understand what I'm doing. I'm drawn by questions, and I'll chip away at something for a while before I get a clearer idea. It's a chance to unpack some of my own issues as I try to understand familial bonds and the parts of life that test them. I don't think of it as a project as such. It began when I first picked up the camera and will end when I put it down.'

His family – parents, siblings, wife and daughters – are used to him capturing every aspect of their lives. 'I've photographed compulsively since I was a child,' he admits. 'It doesn't mean that they won't get upset at me or ask me to put the camera down from time to time. A lot of the photographs are the result of me begging them to be patient with me for just one more frame. But the family work allows me to fully delve into making photographs of my immediate surroundings in a new way and to work with people I love to create a record of this fleeting time in my life.'

'When my wife and I started

dating I joked with her at one

point, "You know if you get

pregnant, I'm going to

photograph the whole thing."'

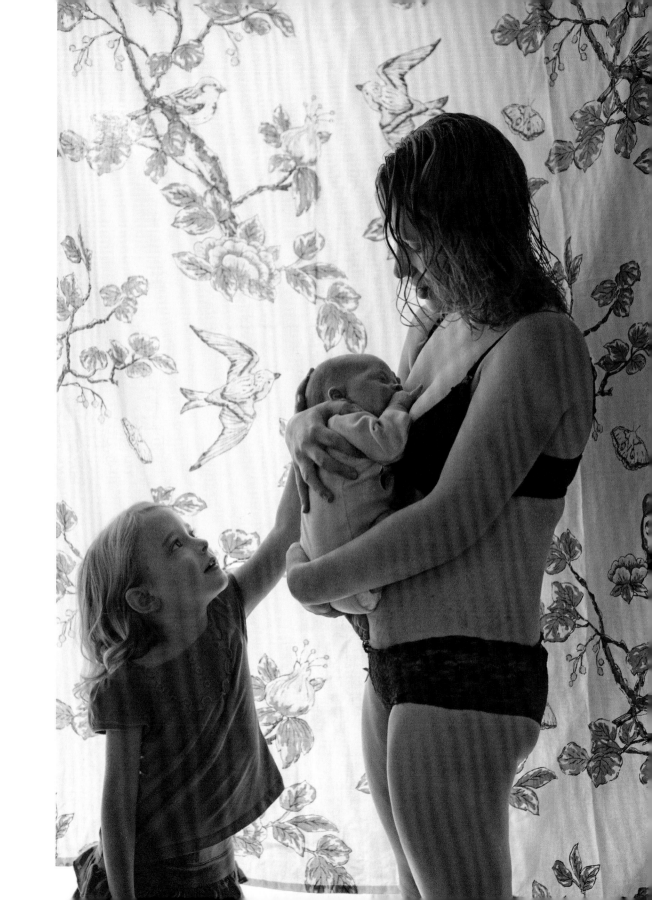

'There are no goals or aspirations for this work; just that it will resonate

with my children in twenty years and give them a better sense of who I am,

and the depth of love I feel for them.'

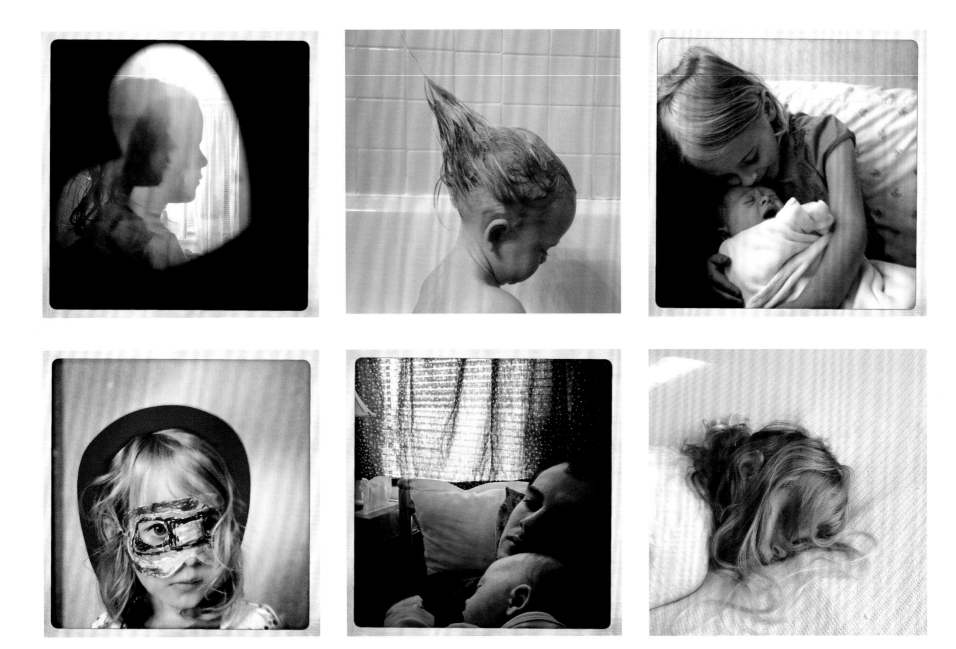

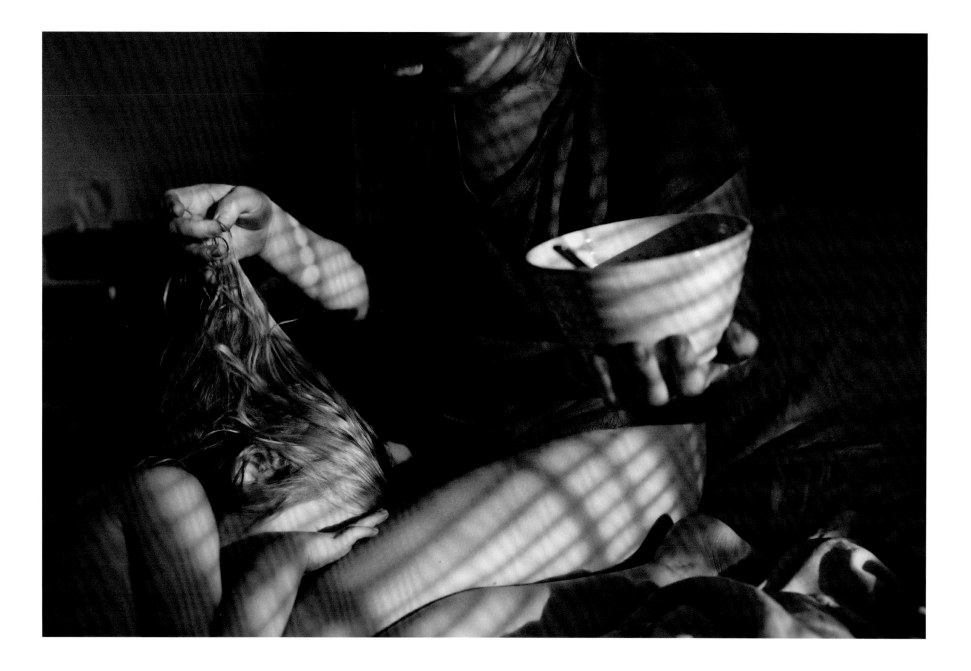

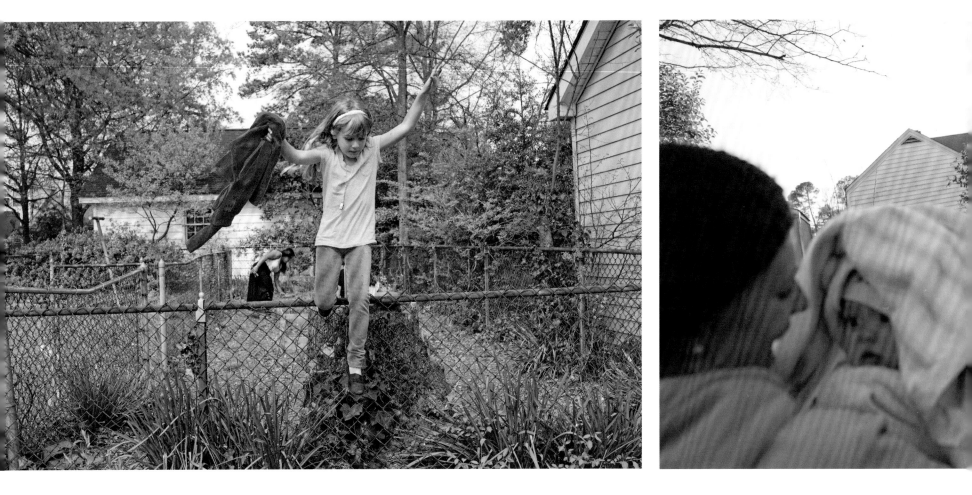

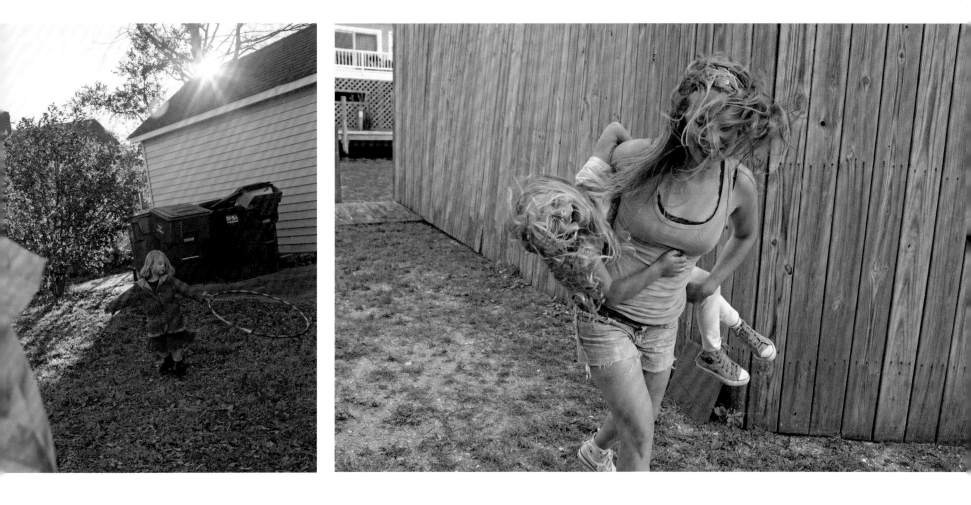

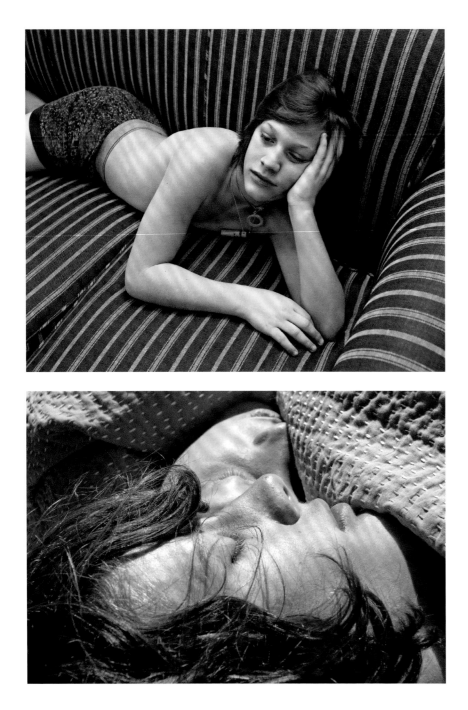

MARTINE FOUGERON

born 1954, France; lives in USA

A sensual visual diary of the photographer's adolescent sons

Teenage boys often get a bad press. Renowned for mood swings, non-cooperativeness and extreme self-consciousness, they are regularly labelled as egotistical and destructive. Martine Fougeron's sensitive and empathic documentation of her two sons moving from boyhood to manhood stands apart from the trend. 'Most photographers portray adolescents as outsiders with a despairing outlook on their world and the world around them. This was not the perception I had of my sons' lives. I was fascinated by the way they were searching for their own identities, and I wanted to show their emotional, creative, sexual and intellectual awakening.'

Fougeron came to photography late, after a successful career as a creative director in the perfume industry. It was not until her late forties that she formally studied photography. By that time (2005), her sons Nicolas and Adrien were just becoming teenagers, and her house was regularly full of their friends, and so they became her subject. Series I of *Teen Tribe* was her graduation project at New York's International Center of Photography. Ten years later, the full body of work was published.

Adrien, the younger of the two brothers, immediately enjoyed the opportunity to collaborate with his mother, and has gone on to become an artist-photographer himself. Nicolas, a year older, was a much more reluctant subject. 'He was 14, and in full adolescent revolt. His power over me was to refuse to be photographed.

That resistance became an essential part of the early portraits. Capturing it became a way to alleviate the rather sorrowful reality.'

Observing the boys as they observed and experimented with their own bodies, formed and struggled with new friendships and romances, Fougeron had to tread a fine line between curiosity and respectful distance. 'Of course I didn't want them to feel stalked by my camera. I would often photograph them at night, when I could be a bit more invisible. I'd stay perhaps twenty minutes at a party, and then make myself scarce. They needed to know I wasn't going to hang out with them all night!'

Fougeron includes Dutch genre painting and French cinema among her influences, and her attention to colour, light and geometry give her photographs a deep sensuality. There are times when it almost seems possible to smell the heady combination of sweat, pheromones and cigarettes as these teenagers sleep, shave, eat, read, chat or party.

While her boys reached a peak of physical health, strength and mental capacity, Fougeron was clearly aware of what a hazardous time they were experiencing emotionally. As she notes, 'The oscillation between swagger and vulnerability, the mood swings and the long lie-ins: these are linked to very real and dramatic changes in the brain during adolescence. I tried to focus on these adolescents' heightened state of mind.'

'Photographing my sons really strengthened our bond. It helped me to understand far more than I would otherwise have about the incredible emotional, creative and sexual changes adolescents go through.'

'The work explores adolescence as a liminal state, between

childhood and adulthood, between the feminine and the masculine,

and between innocence and a burgeoning self-identity. I was

fascinated by the search that they had for their own person.'

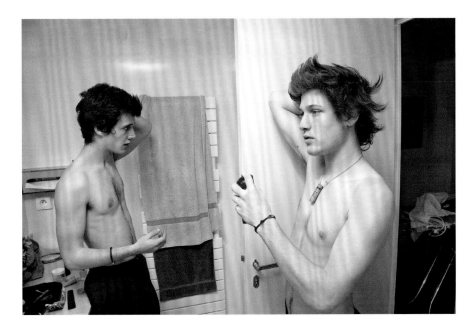
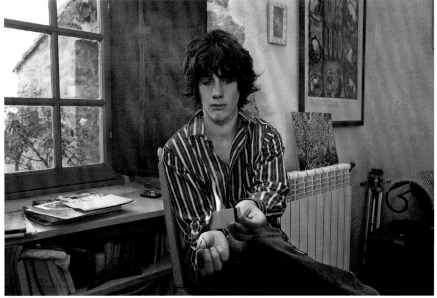

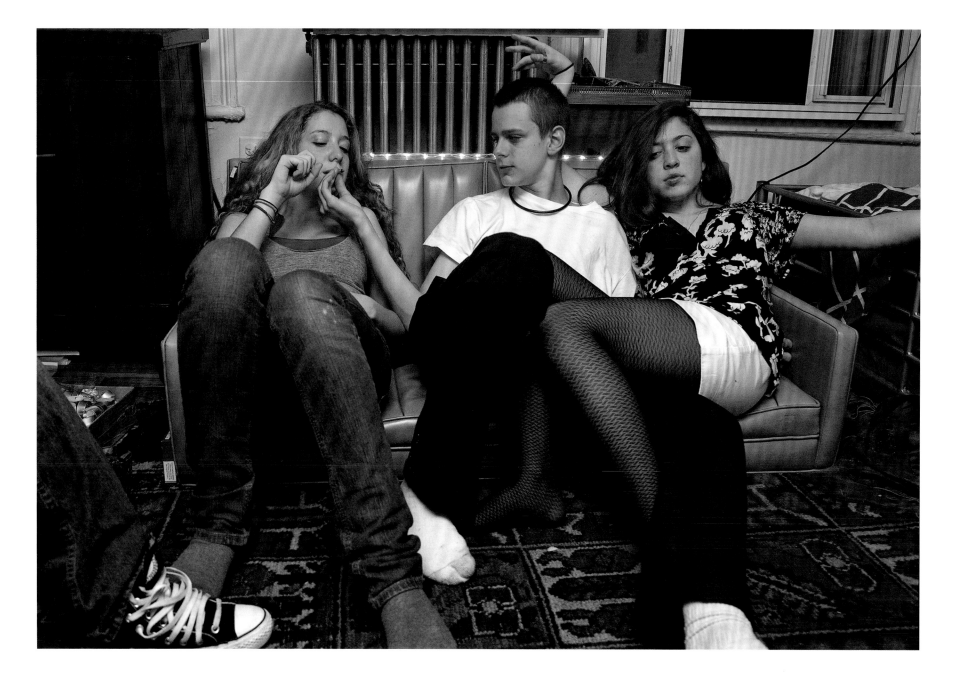

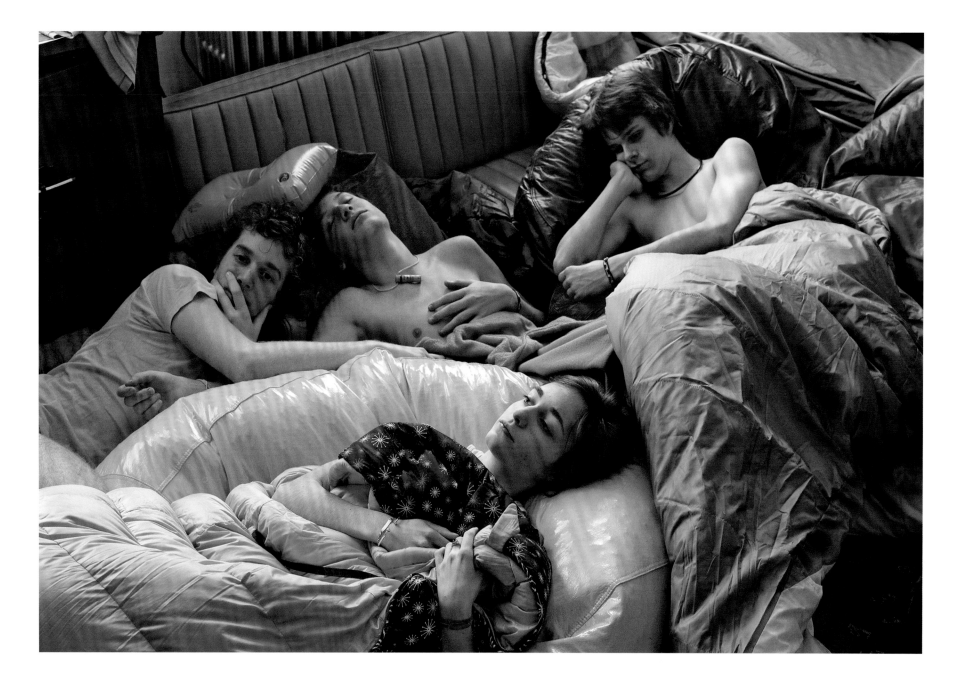

MOTOYUKI DAIFU

born 1985, Japan

Project Family: *a flash-lit riot of
colour, clutter and disarray in
a crowded apartment in Japan*

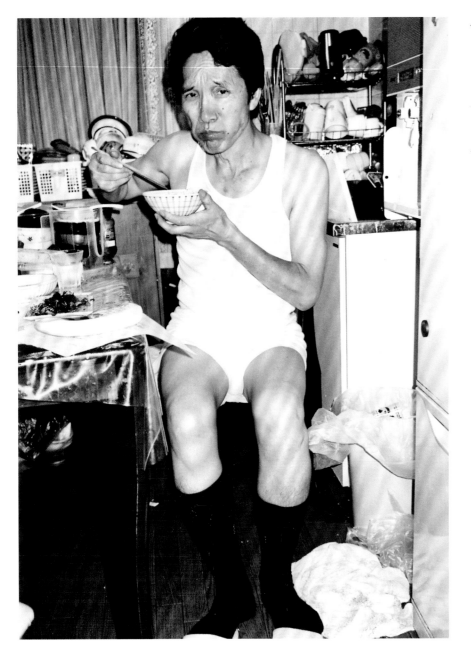

A small and rather cramped apartment
in Yokohama, Japan, is home to
photographer Motoyuki Daifu and
seven other family members: his
parents, two younger sisters, two
younger brothers, and a cat.

The series of pictures he has made
in and around his home is simply titled
Project Family and is a riotous flash-
filled account of the family going
about their daily routine of chores,
meals and relaxation.

Daifu's work sits in a tradition
of snapshot diary-type photography,
which has become popular in Japan
in the last decade. The minutiae of
people's domestic lives are of inherent
interest to Japanese photography
audiences, and Daifu's up-close-and-
personal shots are of higher impact
than the work of other photographers
in this genre.

'I had thought there was nothing
special in my home until I started
photography. But after that I've
noticed that I have to take photos
of everything. The feeling happened
quite naturally.'

Daifu's project was shortlisted
for the prestigious Prix Pictet, which is
awarded for photography that promotes
or relates to issues of sustainable living.
His supporting statement to the jury
was sparse and to the point: 'My
mother sleeps every day. My dad does
chores. My brothers fight. There are
trash bags all over the place. Half-
eaten dinners, cat poop, mountains of
clothes: this is my loveable daily life,
and a loveable Japan.'

Quite how much Daifu's family
are enamoured with his camera
intruding on so many personal and
intimate moments is unclear. When
asked if everyone in his family enjoys
the experience of being photographed,
Daifu only has this to say: 'No one in
my family has any feelings about what
I am doing with my camera; they are
totally disinterested.'

The cliché that pictures speak
louder than words seems to apply
here. When Daifu is asked whether
his photographs all portray happy
moments or whether they also contain
sadness, he replies, 'There is no answer
to that. I hope that the viewer will feel
as they like about these pictures.'

'My mother sleeps every day. My dad does chores. My brothers fight. There are trash bags all over the place. Half-eaten dinners, cat poop, mountains of clothes: this is my loveable daily life, and a loveable Japan.'

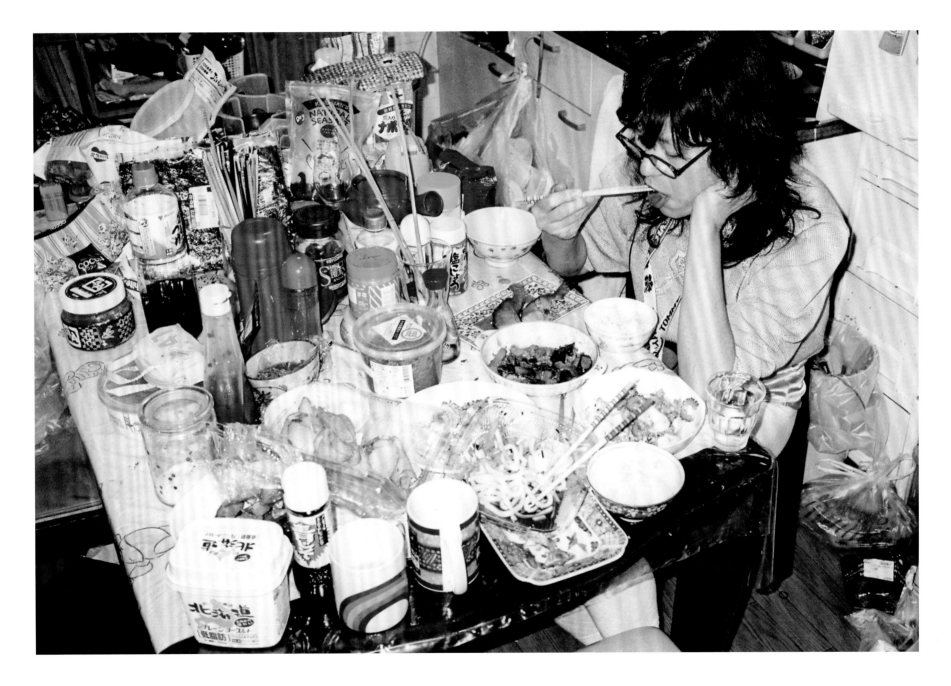

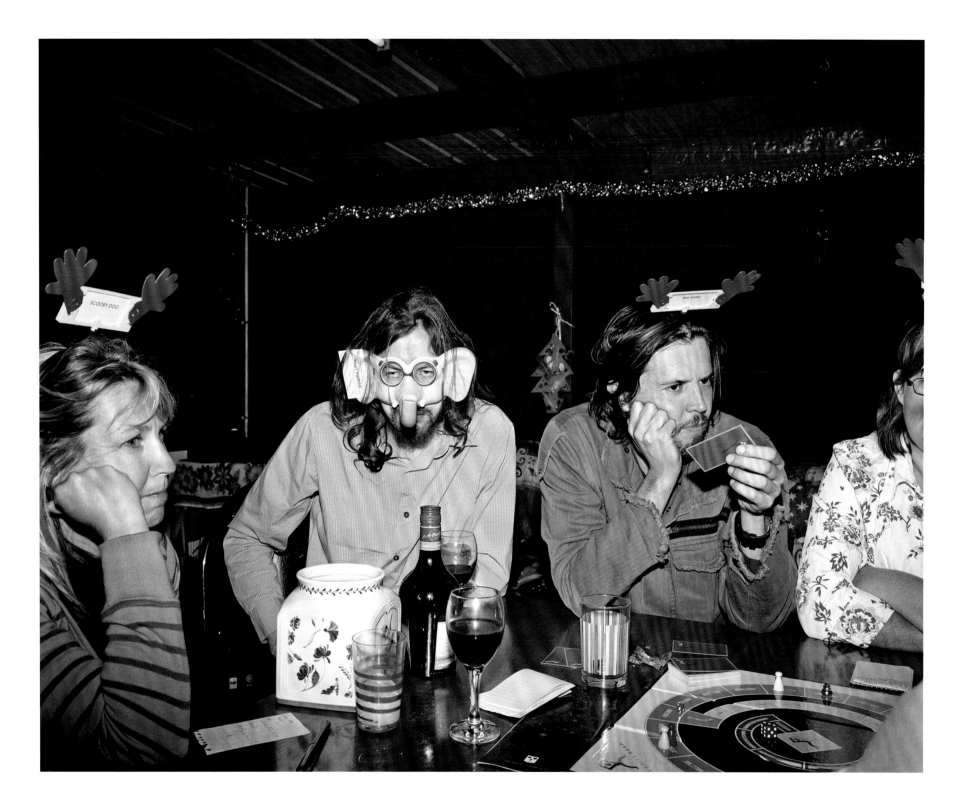

'My dad recently said to me that family is more important than anything. I have to agree.'

TRENT PARKE

born 1971, Australia

A warts-and-all portrayal of suburban
Australian festivities with the in-laws

The Christmas Tree Bucket is a hilarious photo-book by Australian photographer and Magnum member, Trent Parke. This dark and absurdist tale about family celebrations proves that a canny photographer can take a set of family photos and turn them into something much more potent than a mere record of domestic life.

'I photograph everything, and I always photograph what I am closest to,' Parke reports. 'Time moves fast, especially when your children are young. It seems to be the period when life is at its fullest and there is little time for reflection. Being thrust into parenthood as we are, no matter how prepared we think we might be, is overwhelming and scary, but at the same time exciting and strange. One moment I was walking the streets of Sydney every day, looking for the pieces of the puzzle, the next day I was holding a baby boy. As a consequence, with the absolute need to continue to photograph and the fact that everything was now strange, the family project started.'

Parke's books are known for taking everyday moments and imbuing them with suggestive dark undercurrents and psychological fears. *The Christmas Tree Bucket* contains many pictures of the Parke household that will raise more than a few laughs, but the overarching narrative and the title originated from a less than pleasant episode that took place one Christmas Eve.

'It was while I was vomiting into my in-laws' Christmas tree bucket, every hour on the hour for fifteen hours

straight, that I came up with the idea. As with all my books, *The Christmas Tree Bucket* is a narrative: a story book in pictures. They may have been singular at the time I pressed the button, but that's where it ends for me. It's always about the relationship of that moment with others that builds the story.'

At that time Parke and his wife Narelle would read to their children at night. 'Most fairy tales are actually very dark. I wanted to make my family album like a modern-day Brothers Grimm fairy tale for kids ... but a black comedy for adults.... After I get the storyline, it's amazing how the pieces of the puzzle fall into place. Maybe it's being in a state of continual awareness while immersed in a project, but I've always found that the answers are all around us. It's just a matter of asking the right question, and once that happens it's like turning a key.'

Not all the images were in fact taken at Christmas time, but the family and friends captured with Parke's medium-format camera and flash seem to be willing participants in this tale of festive excess. 'Nothing was pre-conceived. I've taken the most extreme moments that have happened over many years to build this Christmas tale. There are stories behind most of the pictures, but they don't have any impact on the narrative that takes place in the book. Once again, things in my world are never as they seem to be.'

'Events and mundane daily occurrences that seemed completely unimportant at the time

can suddenly become crucial pieces of the puzzle years down the track.'

'I always used to look at my grandma's hair. She had beautiful

black hair. I saw it turn grey, and eventually almost white.

The idea of life fading is the key to these photographs.'

SARKER PROTICK

born 1986, Bangladesh

What Remains: *an ethereal portrait of the photographer's grandparents at the end of their lives*

Sarker Protick's grandfather John was a Baptist priest. He and his wife Prova spent their working lives posted all over Bangladesh, and Sarker grew up knowing them as strong, hard-working and loving people. *What Remains* is a portrait of the final years of their life, when old age and poor health had slowed them down.

'We were very close. They loved and cared for me a great deal,' Sarker recalls. 'I would always visit them at Christmas wherever they were living, and they often came to stay with me and my parents in Dhaka. When I started university, our lives drifted apart. I focused less on the family and more on the outside world, and illness kept them more and more confined to their home. I visited them often, but, as the pace of our lives became very different, I sometimes struggled to know what to talk to them about. I started taking photographs as a way to spend time with them. They loved it. It really restored some excitement to their lives. And it helped me to slow down. Sometimes the experience of photography gives you more than just photographs.'

One afternoon, while sitting on his grandparents' sofa, Sarker took a photograph of a shaft of light shining through a gap between the white door and the white walls of their apartment. This became an aesthetic touchstone for the whole of *What Remains*. All the images are exposed for long enough to bathe them in an ethereal white light, while the compositions are pared down to their essentials. 'This spare, otherworldly aesthetic seems exactly the right visual language for a story about the transition from one life to another,' Sarker explains.

The photograph of John and Prova embracing one another in bed is a particularly poignant one for the photographer. At the time he took it, the couple's declining health meant they slept in separate beds and were rarely able to get physically close. Sarker moved their beds together to set the picture up. It turned out to be the last photograph taken of them together, and John now keeps a copy on the walls of his apartment.

Sarker didn't photograph Prova in the final weeks before her death in 2012. Her health had declined rapidly and he did not want to strip her of her dignity. Nor did he photograph John for a whole year after Prova died. 'I visited him almost every day during that time, but the important thing was just to be with him. One day I remember we were looking at the picture of Prova's hair together, and he told me that whenever he looks at it he thinks she is about to turn around.'

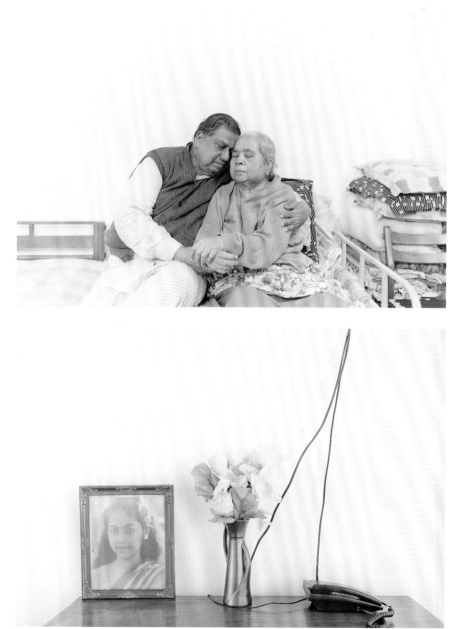

'When I photograph people I love, I want to do it

with delicacy, sensitivity and respect.'

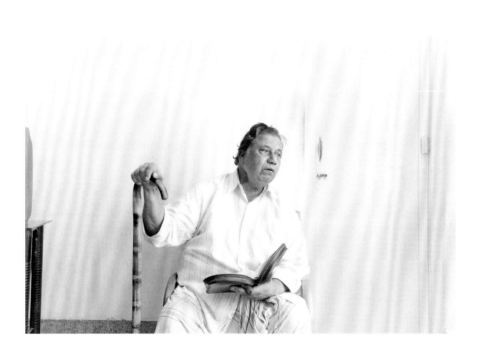

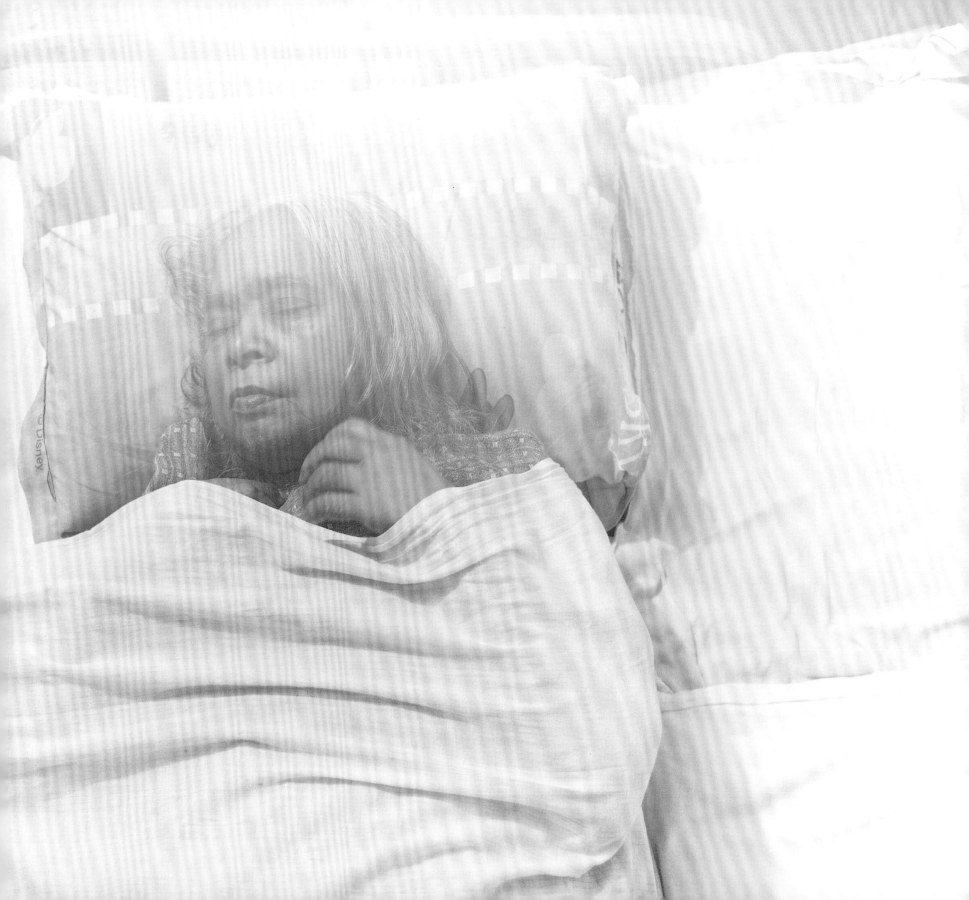

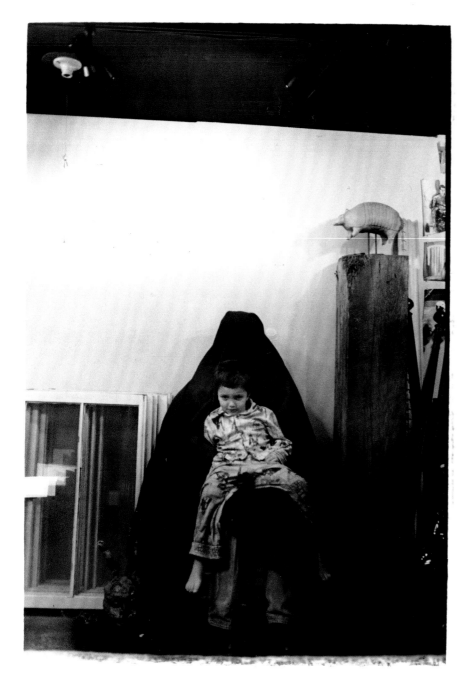

TIM RODA

born 1977, USA

Elaborately staged, highly symbolic and darkly enigmatic series of family tableaux

New Yorker Tim Roda has produced what may be some of the most complex and indecipherable family photographs ever taken. The scenes he creates from scratch are bewitching low-tech confabulations that are suggestive of the complex notions of ancestry that all of us carry around in our personal back-stories. With series titles including *The Watermill*, *The Butcher's Block* and *Games of Antiquities*, these collections of photographs – which include his wife and four sons in role-playing mode – are dark and mythical.

'My work is all about metaphor,' Roda stresses. 'The rough edges, irregular margins, erratic fixer stains and haphazard tonal range are suggestive of the working-class way of life my grandfather experienced when he came to America as an Italian immigrant. This set of values was passed down to my father, and then to me, in all of its eccentricities.'

Originally a ceramic artist, Roda hand-builds his elaborate sets, which his wife then captures by pressing the camera shutter. Props, masks and wild costumes abound, and mirrors are often used to introduce characters. Although photography is the end medium, Roda embraces many artistic disciplines en route to his one-of-a-kind dreamscapes.

'I started using photography because it's the medium I can use to best depict my vision of life, art and time. Although the final product is a photograph, the work casually travels within arenas of installation, photography, film and performance.

A camera is used to record one moment in time that balances between childhood memories and constructed commentaries, yet is a documentation of "real" events for my wife, Allison, and children. Over time, we have developed an unspoken language intuiting my vision of art.'

Each scene that is created is first envisioned in Roda's mind, and then played out by his family. 'Although we are the immediate subjects, the work is filled with metaphorical reverberations of my family history and my memories of childhood. The props or devices I include in the installation – photocopies, wood, tape and unfired clay – are important to my work because they are all materials that are impermanent and contrast historical works.'

While Roda's children, especially oldest son Ethan, get to enact roles that exhibit great menace and even acts of violence on the artist himself, all the scenes are of an open-ended nature that allows the viewer to interpret them in different ways. Roda's visions may be replete with a sense of dread and hints of inter-generational vengeance, but they are undeniably suggestive of the kind of fantasy scenarios that many of us have lurking in the recesses of our imagination.

ABOVE Hidden Father 12, from *Hidden Father* series, 2015 **OPPOSITE ABOVE** The Centaur, from *Italy* series, 2009 **OPPOSITE BELOW** Untitled #163, from *Mallorca* series, 2008

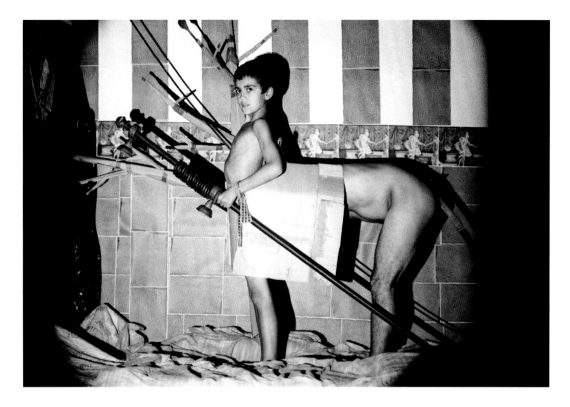

'The photographs capture moments of ambiguity that can be understood on several layers, both personal and universal.'

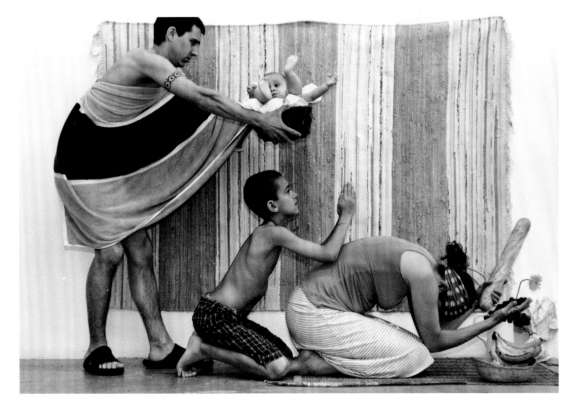

'I strive to produce a sensation that makes people both familiar and uneasy about how incongruent our lives can be.'

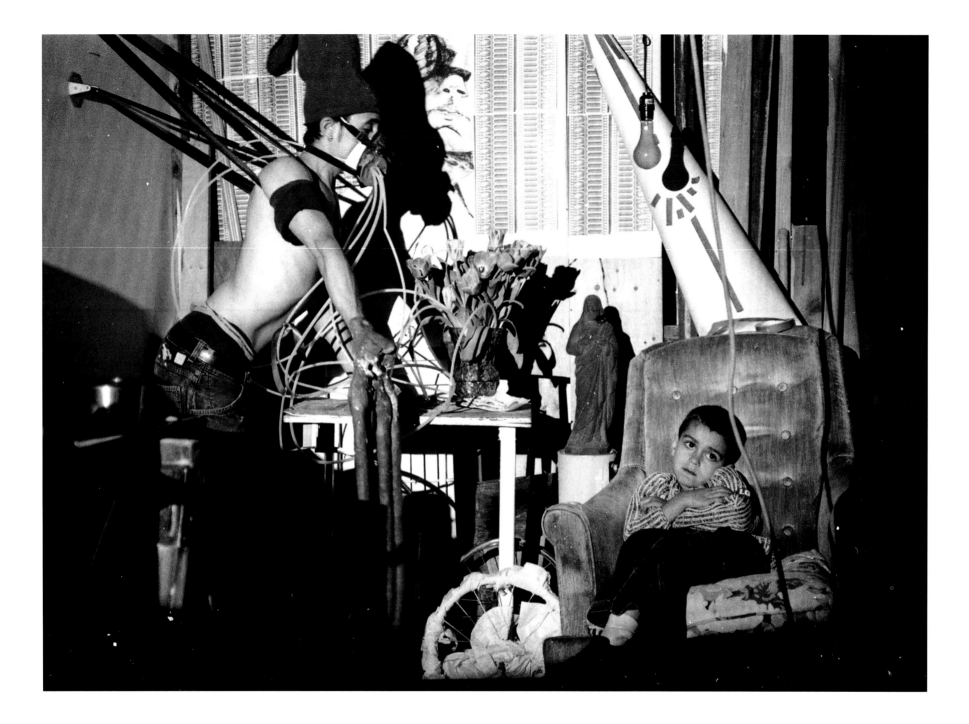

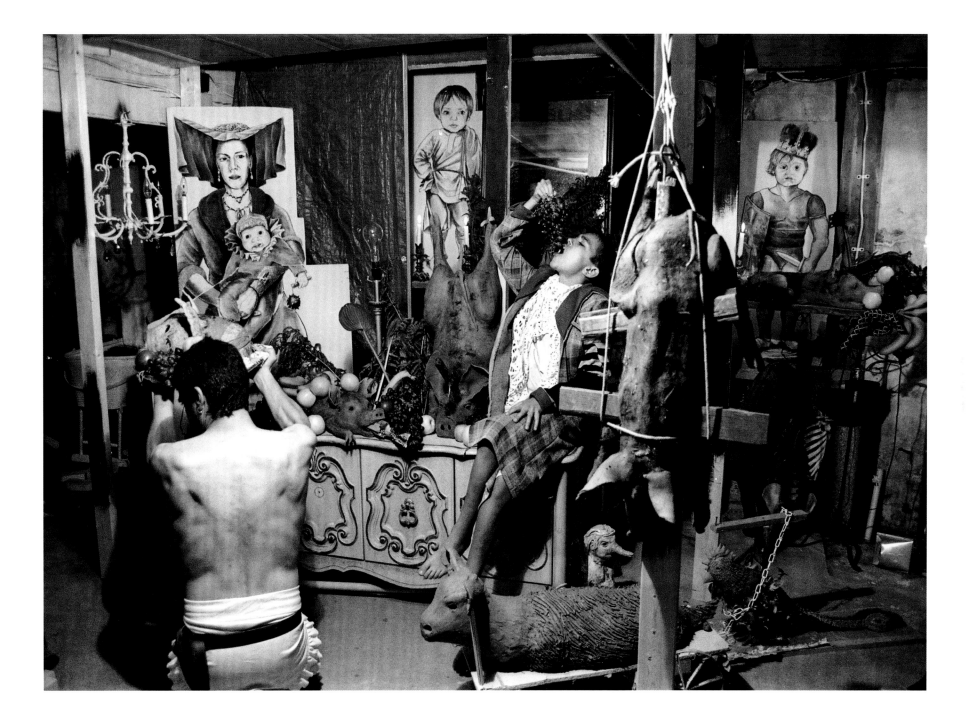

OPPOSITE Untitled #180, from *Italy* series, 2009
ABOVE The Butcher's Block, from *The Butcher's Block* series, 2011

'Although the overall quality of the print

comes across as visceral, the "content" of

the image has always been most important.'

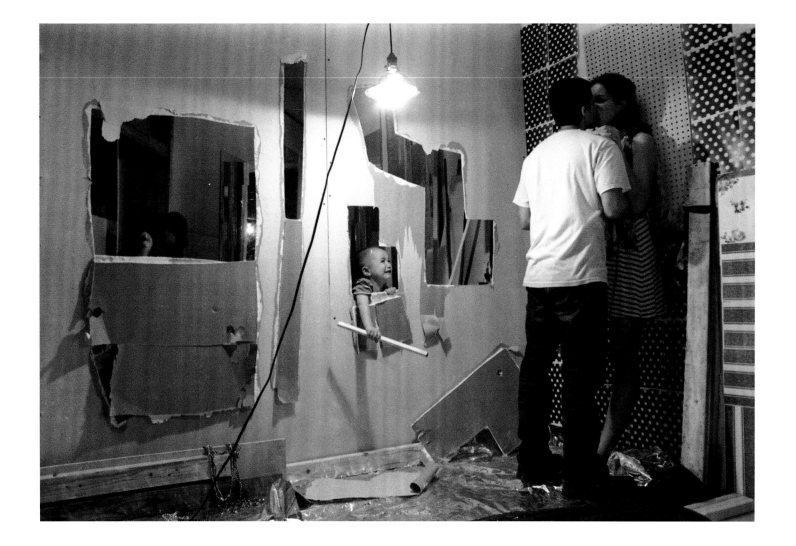

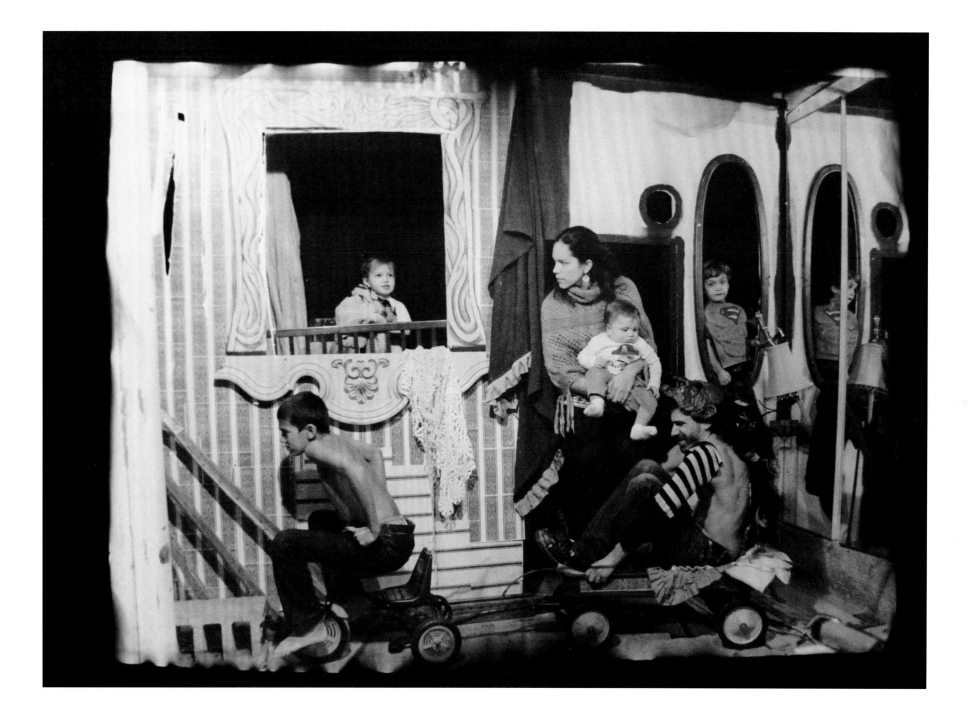

OPPOSITE Untitled #204, from
Family Construction series, 2012
ABOVE Family Portrait, from
Hidden Father series, 2013

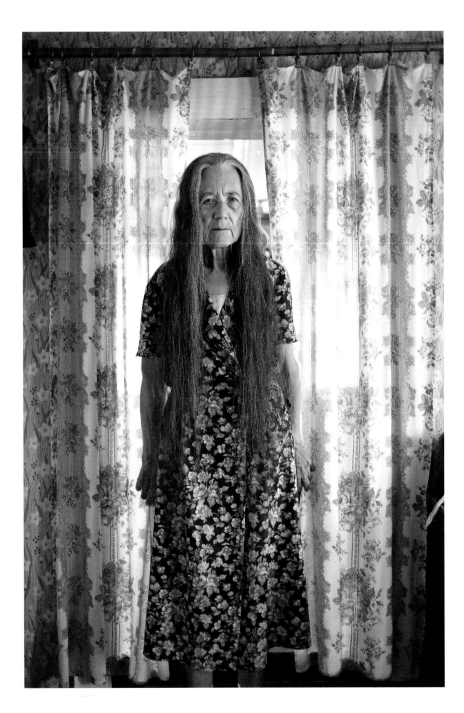

NADIA SABLIN

born 1980, Russia; lives in USA

An extended portrait of the photographer's elderly aunts becomes a meditation on ageing, family and a sense of belonging

Nadia Sablin emigrated from Russia to the US when she was twelve. 'I was on the cusp of adolescence and it was a huge culture shock,' she recollects. She did not return to Russia again until she was twenty-eight, and since then most of her work has been about re-engaging with her homeland. 'I'm drawn back by a mix of memories, fairy tales and family connections. People in the villages where I photograph always ask where I'm from, and they are reassured when they find out I have family roots here.'

Sablin has stayed with her two unmarried aunts, Alevtina and Ludmila, every summer for seven years. The sisters live in a simple wooden house built by their father in Alekhovshchina, a rural village in northwest Russia. Sablin spent many of her early childhood summers there.

'The house was built before widespread access to electricity, so it was designed to have maximum access to daylight. The sun dictates where the day starts and how it progresses. It makes for a very natural way to live: lighting the stove and cooking the day's meals as the first rays of sunlight illuminate the kitchen, going out to weed after the dew evaporates, and reading by the window as the sun lingers in the west.'

The sisters live a frugal existence, surviving on their meagre state pensions. They chop wood for heat, collect water from a well, grow their own fruit and vegetables, and make their own clothes and curtains. A few of Sablin's photographs show them resting or relaxing – a particularly touching one shows them absorbed in a crossword together – but overall this is a portrait of a physically demanding way of life, especially for two frail women in their seventies.

'I could just sit and watch them go through their daily rituals the way one would watch a ballet or a snowfall,' says Sablin. 'However, this is very different from how they experience the same moments. Ludmila grumbles about having to perform chores, while Alevtina sets the agenda with stoic determination.'

The experience of photographing Alevtina and Ludmila has deepened Sablin's respect and affection for them. 'As a child I had little understanding or empathy for my aunts,' she notes. 'They seemed cold and aloof, very different from my immediate family. Having never had children, they weren't sure how to communicate with me. Since starting this project, I have come to understand them better and to love them. Hearing stories about their lives and watching the choreography of their daily movements has made me feel like a part of something ancient; a recorder of traditions and dreams.'

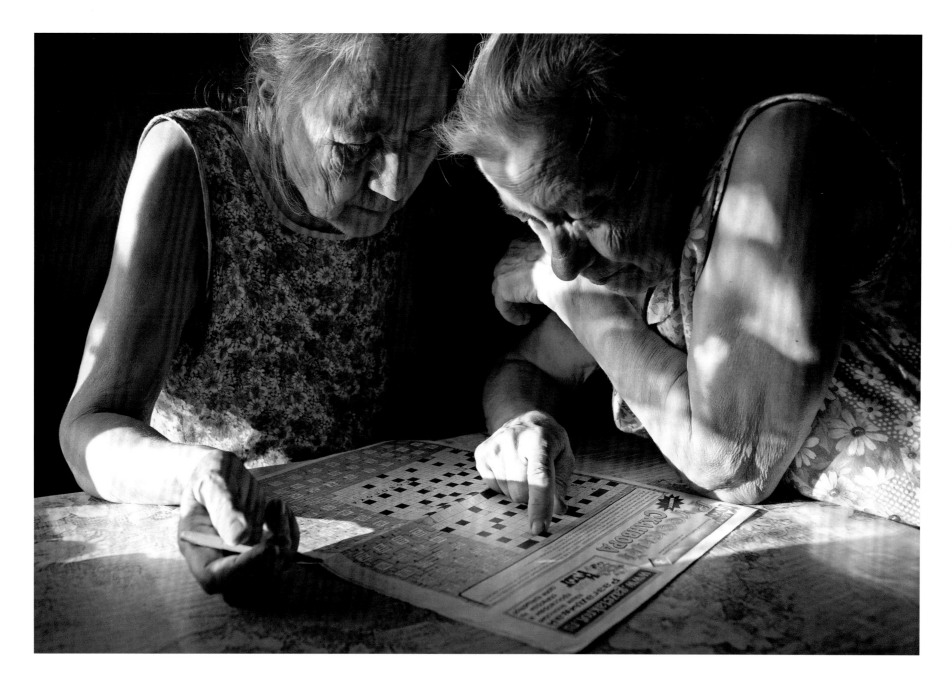

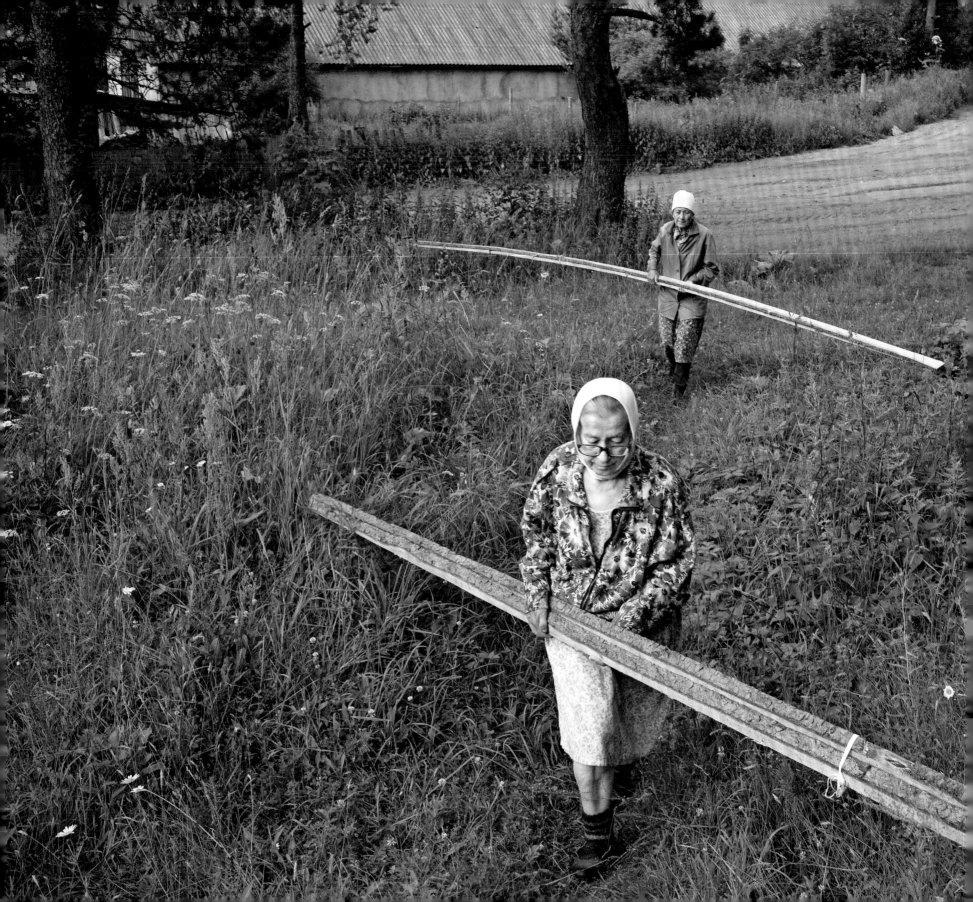

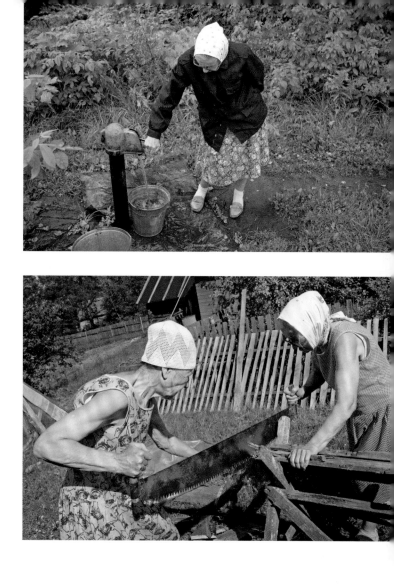

'My aunties' lives are breathtakingly beautiful, but much of what they do is physically exhausting. I'm not allowed to help in any of the activities. "We have our job and you have yours," Auntie Alia once told me. "Your job is to take pictures, so don't get distracted."'

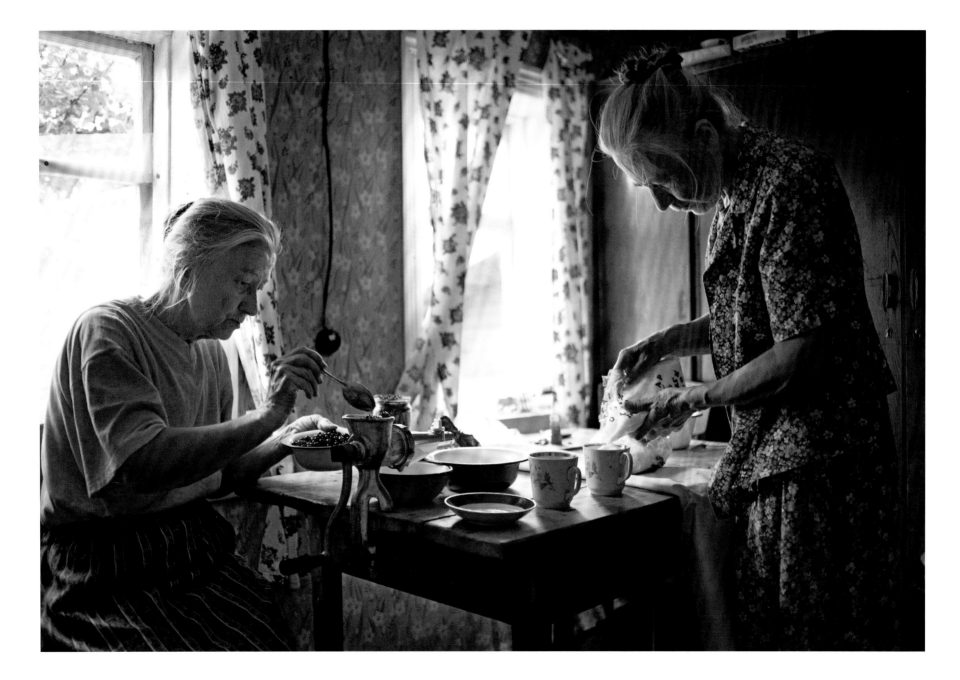

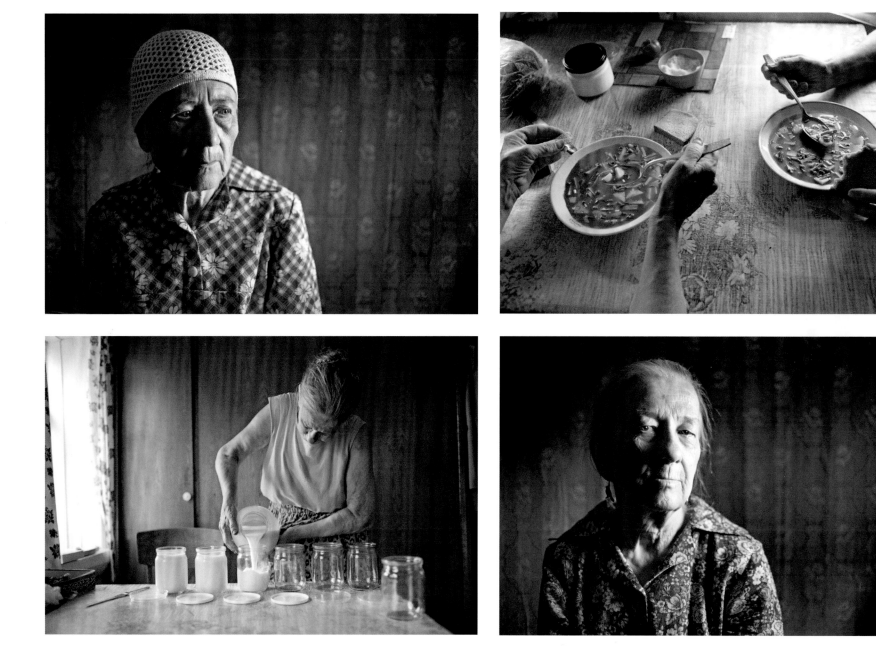

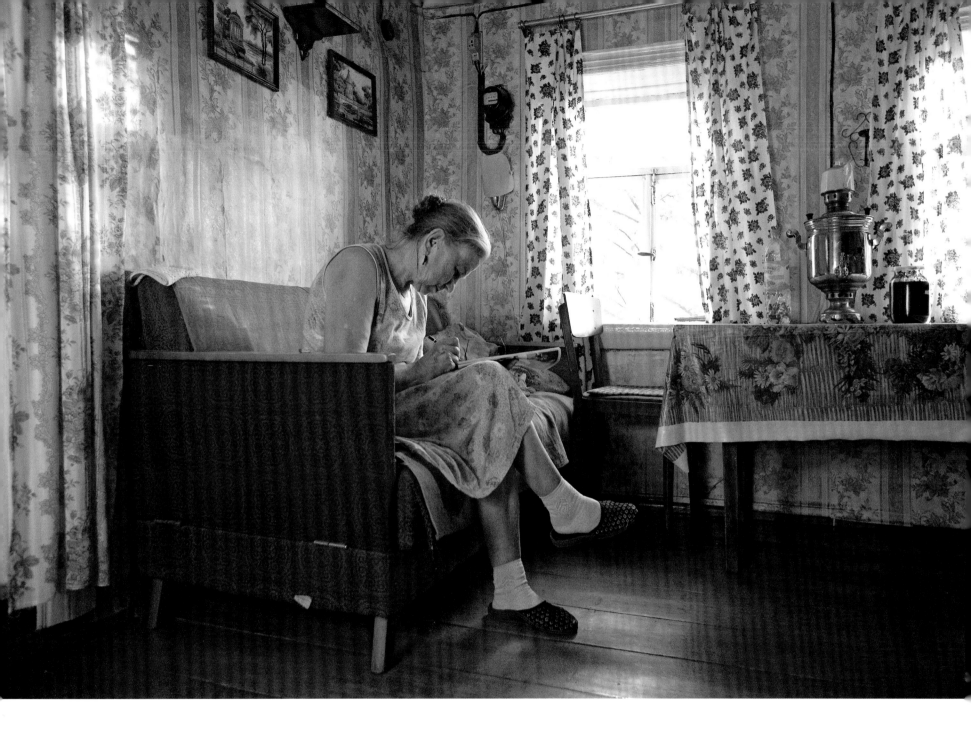

'Sharing these images has become a way to build a sense of empathy and connection. People responding to them often share memories of their grandmother in South Africa, or an elderly neighbour in Australia, or growing up in a village in the Dominican Republic.'

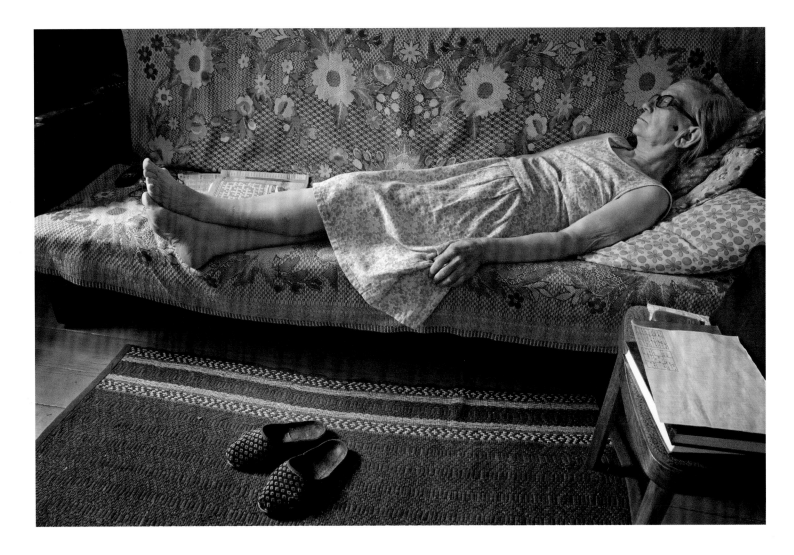

PHILLIP TOLEDANO

born 1968, England; lives in USA

*A brutally candid yet tender look
at two ends of the spectrum: birth
and death*

A few years ago, photographer Phillip Toledano would never have imagined that photographs of his family would become his best-known work. However, after his mother's death in 2006, it fell to him, as an only child, to care for his ageing father. Fearful of forgetting the life they shared together during those twilight years, he started a photoblog, 'Days With My Father'. 'I made the photographs for myself and didn't think anyone else would have any interest in them. But when the blog went up, a magical thing happened. I started getting thousands of emails. People told me how moved they were by the blog, how it had encouraged them to get in touch with their own parents, and helped them see the importance of saying goodbye. It was extraordinary how much it seemed to touch people.'

Four months after his father died, Toledano's daughter Loulou was born. 'I was never particularly interested in having kids,' Toledano admits. 'I think it's fair to say that I was neither ready, nor vastly enthused, when she was born.' Over a year and a half – in a series entitled *The Reluctant Father* – he documented his emotional journey from confusion to joy with disarming honesty. What begins as a collection of detached photos of a screaming, scrunched and alien-like newborn becomes a tender portrait of a toddler blowing bubbles, smiling and playing in the bath. Love wins a battle over ego; affection and even sentimentality creep in; and Toledano accepts his fate as a proud father.

In 2013, he embarked on a much more harrowing project: to tell the story of his sister, Claudia. She died when he was six, and his only surviving memories are of kicking her bedroom door, screaming 'I wish you were dead', and two policemen coming to the house to tell the family there had been an accident. Claudia was never spoken of again. After his parents died, Toledano found a cardboard box containing photographs, letters, toys and a death certificate – evidence of Claudia's life and death, neatly packed away. 'When I Was Six' is the story of the unpacking of this box, over many months, photographing and emotionally processing the contents. 'She had remained a constant, unknown presence in my life. Now I had the chance to get to know her and, in a sense, myself.'

Reflecting on the impact of family on his work, Toledano comments: 'I am the artist I am now because my parents are gone. When your parents die, they leave a shadow within you, and that shadow is everything they've given you. They also leave you with unopened boxes, both metaphorical and, in my case, literal. It's up to you to choose whether to open them or not.'

'It's sad, but I realize as I get older that all clichés are true. I do something I said I'd NEVER do: Baby photos. It's really quite embarrassing. When I meet other parents, I lunge for the iPhone. I can't WAIT to bore people. *"Look, I know you don't like baby pictures, but Loulou is different!'"* I'm that sad statistic. The proud father.'

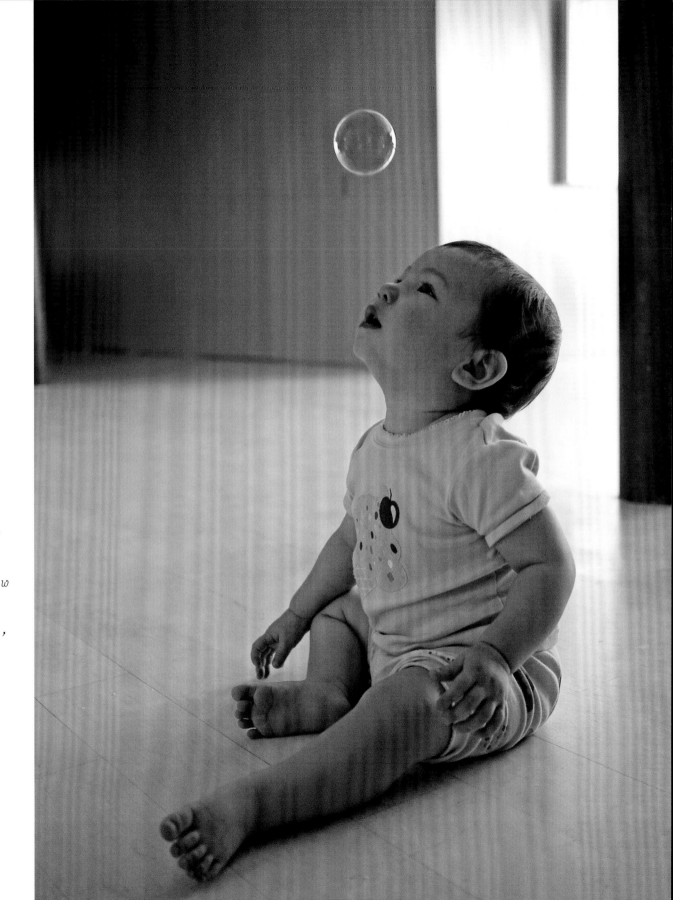

'I can't imagine the strength it must take.

To pack up your child's life.

Nine years. Into one box.'

'There I am. 12th July, 1974. 'Ready for Sportsday.'

Two weeks after Claudia's death.

I seem so happy.

What did my parents tell me?

What could they have told me? Did I even know?'

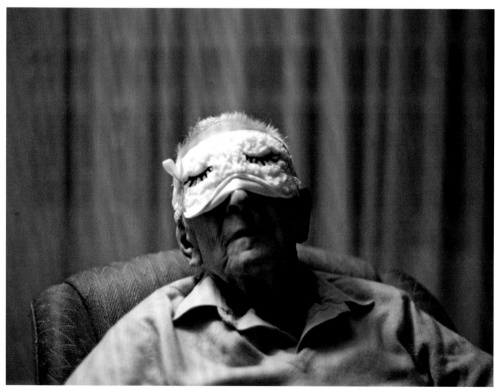

'My mum died on September 4th, 2006.
Suddenly, I found myself taking
care of my 97-year-old father
who was suffering from dementia.
I decided that my job as his son was
to make whatever time he had left as
happy as possible. We all have to say
goodbye to our parents at some point.
I discovered that it can be a really
beautiful experience.'

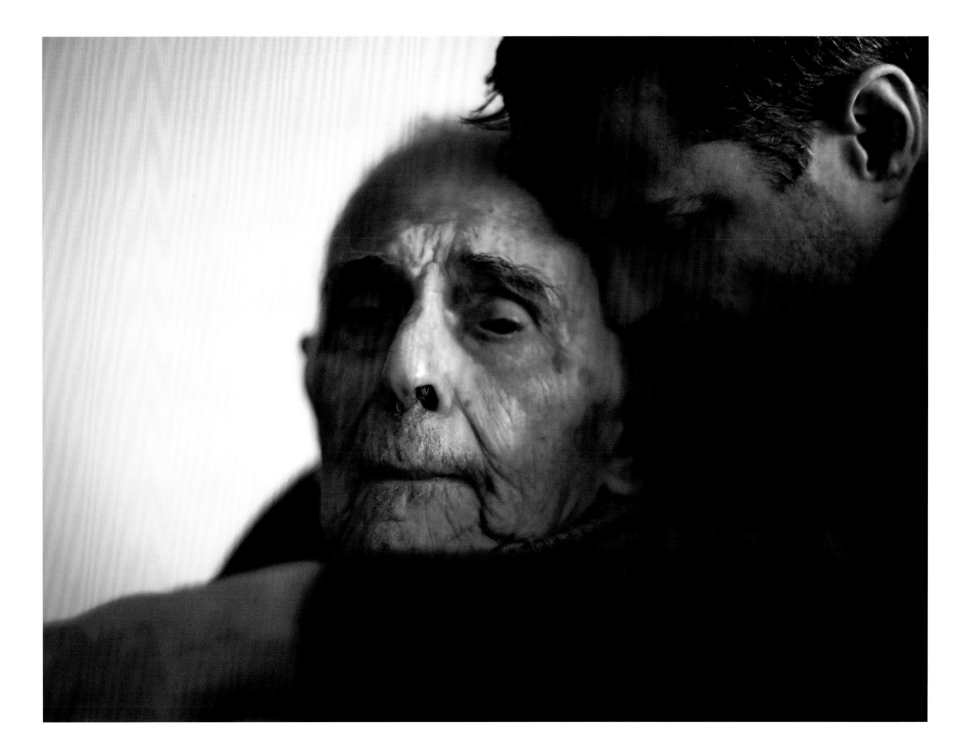

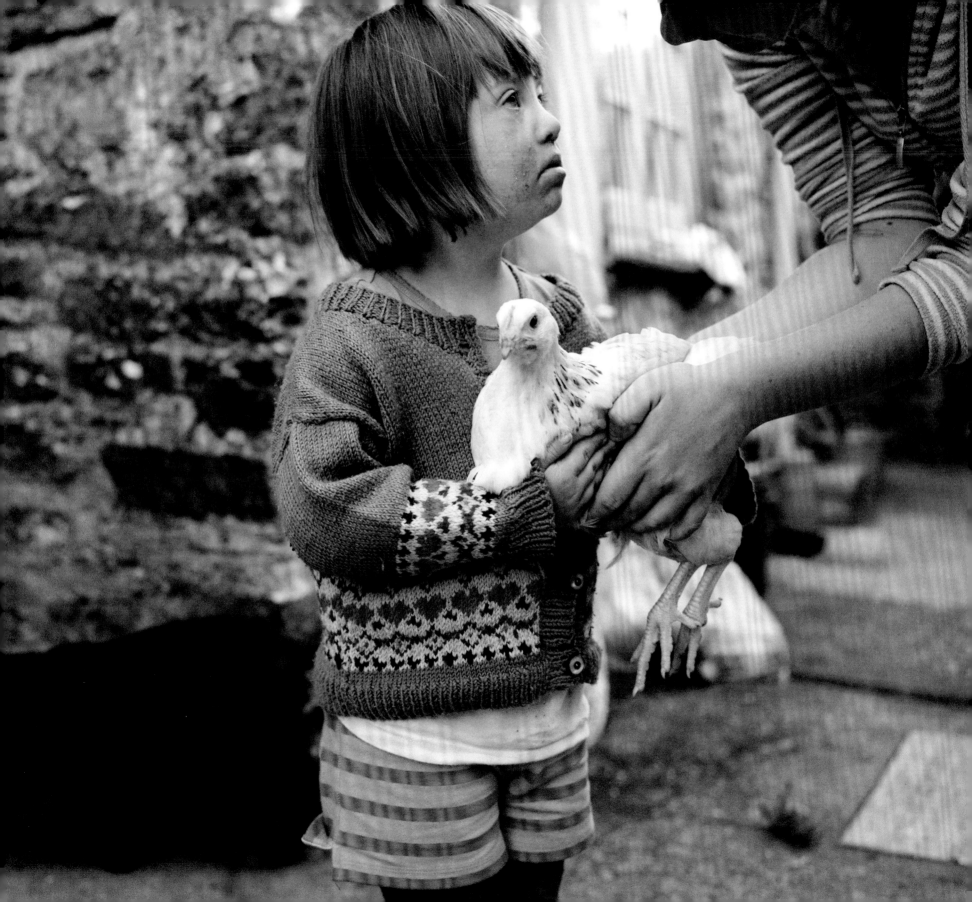

SIAN DAVEY

born 1964, England

A heartfelt and life-affirming series of photographs taken by the mother of a child born with Down's Syndrome

Looking for Alice is the title of a series made by Sian Davey, who lives in the South West of England. Her daughter Alice, born with Down's Syndrome, is the central focus of this intensely personal work, and it is immediately apparent that her presence in the Davey family is a source of great joy. However, Davey, a trained psychotherapist, at first struggled to come to terms with Alice's condition. Her use of the camera might be seen as her way of navigating the uncertainties that the new arrival brought about.

'I was deeply shocked when Alice was born as an "imperfect" baby,' she admits. 'It was not what I had expected. Our first experiences in hospital did little to diffuse this. Examining Alice the paediatrician pulled back her legs, pushed her thumbs deep into her groin, and promptly announced that we should take Alice home and treat her like any other baby. But she didn't feel like any other baby.'

Davey became fraught with anxiety, to the extent that it affected every aspect of her relationship with her daughter, and even penetrated her dreams. 'On reflection I saw that Alice was feeling my rejection of her and that caused me further pain. I saw that the responsibility lay with me; I had to dig deep into my own prejudices and shine a light on them. The result was that as my fear dissolved I fell in love with my daughter. We all did.'

Davey states that her work is to photograph and stay attuned to life moment by moment. 'When you are working at such depth with another person, an extraordinary intimacy develops. This became an entirely inter-subjective process between my daughter and myself. It was clear to me and only enriched the process.'

Since many of the images were taken indoors, with very little light available, Davey had to work quickly, with the added challenge that Alice – still only a young child – was resistant to being organized in any way. 'However, once I began the project, I worked continuously without my thinking mind getting in the way. I found I was able to access both some of the more conscious ideas and also some of the more unconscious ones that arose. When images presented themselves, I discovered they were rich in signifiers of the ideas that I had been thinking about.'

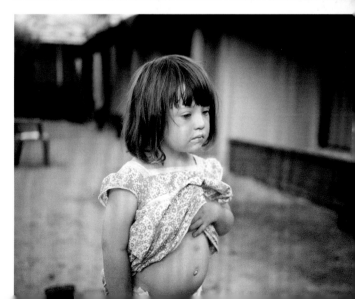

The series' publication in book form was made possible by a crowd-funded initiative – apt testament to the universal themes of togetherness and acceptance. 'My family,' Davey concludes, 'is a microcosm for the dynamics occurring in many other families. We are no different. As a psychotherapist I have listened to many stories, and it is interesting that what has been revealed to me, after fifteen years of practice, is not how different we are to one another but, rather, how alike we are as people. It is what we share that is significant. The stories vary, but we all experience similar emotions.'

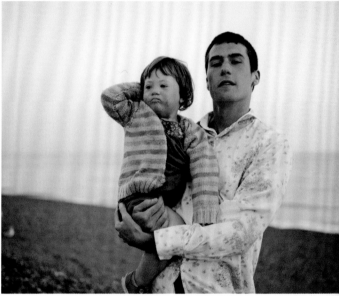

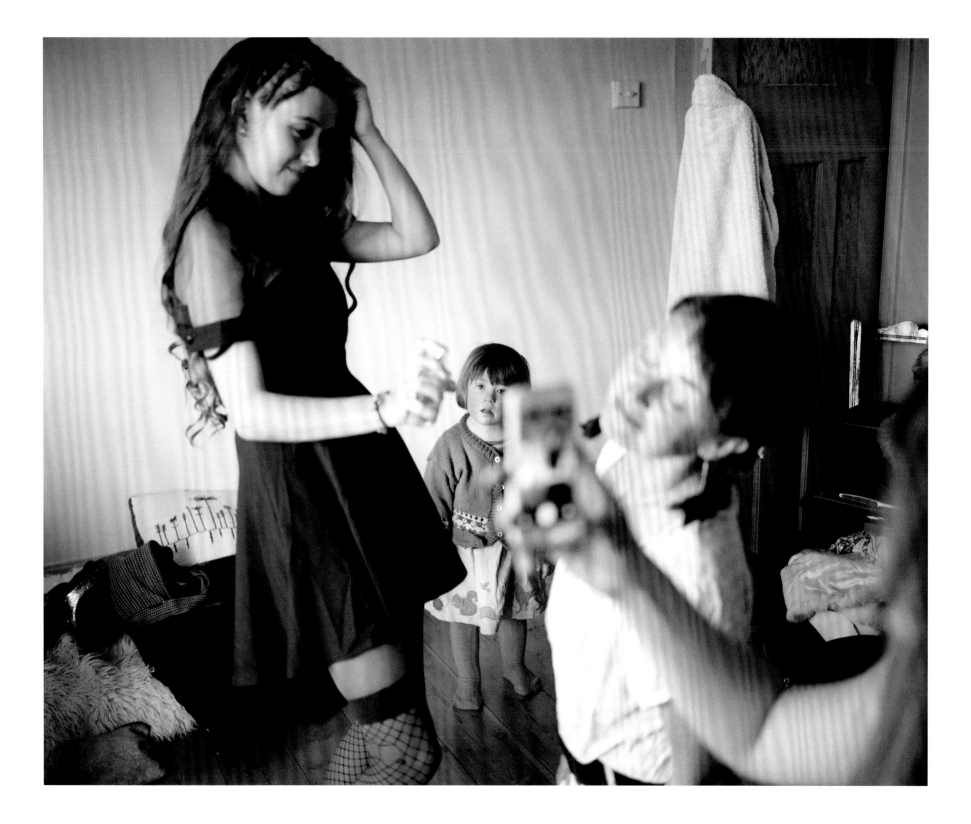

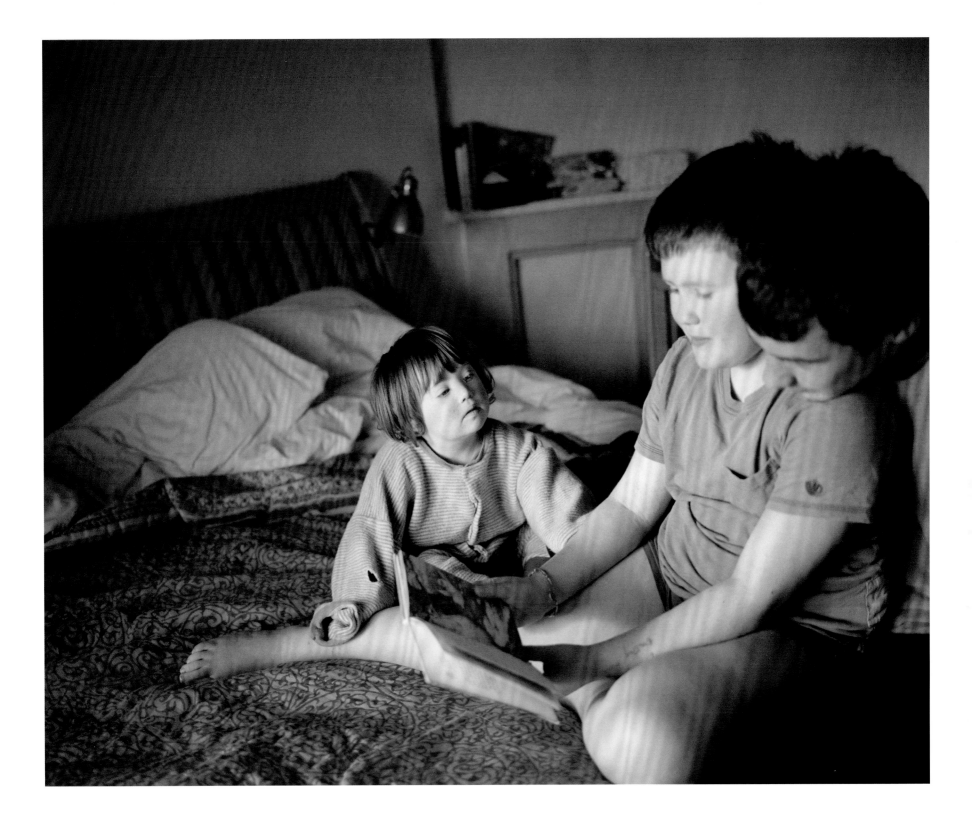

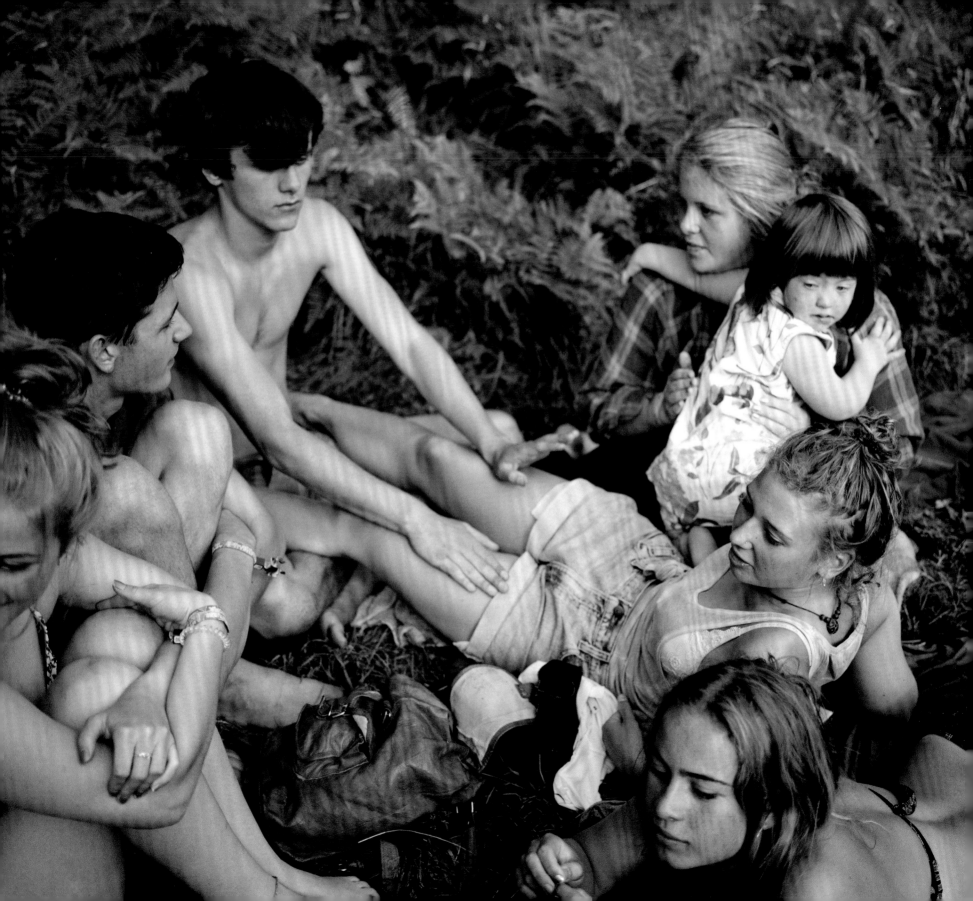

'This series is an illustration of family life - all the tensions, joys,

ups and downs that go with the territory of being in a family.'

Thanks for sharing! Stephen McLaren

LEFT Photographs by Matt Eich. 'My [Instagram] feed will reflect where my mind is. I'll go from Mississippi where I am interested in using Instagram as a bridge between two polarized parts of a community to my home where I am finding little pieces from daily life that are full of beauty and meaning.'

When not brutalized by war, eradicated by famine or scattered through exile, families are the most resilient and flexible networks of humanity we have. As an institution they have adapted repeatedly as societies and economies have become more complex and less anchored in tradition.

So it was only to be expected that our online social media platforms – still amazingly only fifteen years old – would be inundated with family photographs thanks to their global, always-on reach and the low cost of participation. These may be relatively new technologies, but the ease with which they have inserted themselves into the fabric of everyday life makes it hard to remember a time when sharing photos meant passing round glossy paper prints fresh from the lab. This essay looks at how photographers, both professional and amateur, are using social media to distribute and promote the photographs they are taking and asks if the photo-sharing revolution has led to a paradigm shift in family photography.

The 1982 sci-fi film *Bladerunner*, featuring Harrison Ford as a hard-boiled detective taking out 'replicants' or cyborgs who believe they are actually human, is often regarded as a reliable, if depressing, take on what lies ahead in our techno-future. In the three decades since it was released, director Ridley Scott's vision – based on Philip K. Dick's novel, *Do Androids Dream of Electric Sheep?* – seems to predict much of our own near-future: self-driving cars, tourist trips to off-Earth colonies, and evil corporations bent on world domination. While the film is from the familiar 'seek and destroy evil robots before something really bad happens to humanity' genre, it also has as an intriguing plot device a meditation on how our family photographs encode for us much of what it means to be alive and human. Whether on printed paper or on an LCD screen, these origin stories tell us much about where we have come from and give comfort when feelings of mortality threaten to overwhelm us. In a scripted scene between replicant-hunter Deckard and Rachael, a personal assistant at the Tyrell Corporation being assessed for human or replicant status, a family photograph plays a key role.

RACHAEL: You think I'm a replicant, don't you?
Deckard takes off his wet raincoat and throws it on a chair.
RACHAEL: Look.
She goes to him holding a picture in her hand. Deckard looks at it. It's an old snapshot, a little girl with a mother.
RACHAEL: It's me with my mother.
DECKARD: Those aren't your memories. They're implants. That's what Tyrell's niece remembers.

The replicants in *Bladerunner* obsess over their collections of personal photographs, paper totems attesting to a seemingly reliable narrative of their life to date. Each dearly wants to believe that they grew up in a loving human family, when in fact they were created only a few years previously by Tyrell Corporation boffins who implanted them with fake memories derived from random photographs. Deckard, the hero of the film, is a rootless divorcee who is often lost in an alcoholic haze, but when he longingly strokes a collection of his own family photographs propped up on a piano in his apartment, we get a telling insight into the all-too-human need to know that we once belonged. Both the piano and the photographs, some of which are vintage black and white, appear like relics in his life, but after his confrontation with Rachael about her family snapshot we begin to wonder if Deckard is also a replicant and whether his memories might have been similarly implanted.

Bladerunner got much right in its imagineering of how the 21st century might appear, but there is an obvious omission: the existence of a global audio-visual messaging facilitator, aka the internet. Coincidentally in 1982, the same year the film was released, the science-fiction author William Gibson invented the term 'cyberspace', which he poetically detailed as: 'A consensual hallucination.... A graphic representation of data abstracted from the banks of every computer in the human system. Unthinkable complexity. Lines of light ranged in the nonspace of the mind, clusters and constellations of data. Like city lights, receding.'

It would take until the middle of the next decade for the world wide web to come into view and to incorporate some of Gibson's prose into a technological platform that we all now regard as just as necessary to everyday life as electricity. Initially the web was a text-and-graphics only affair but marching right alongside the rise of HTML and modems was the rise in digital imaging technology, which enabled first imaging scanners and then digital cameras themselves. I vividly remember my first experience of launching a family photo into cyberspace, when in the late 1990s I scanned an old crinkly picture of my grandfather standing next to his beloved taxi and emailed it to my parents who were shocked that this picture still existed, never mind that it could be 'transmitted'. I paraphrase, but the sentiment expressed in the return email was definitely: thanks for sharing!

Since those early days of squawking modems and image scanners the digitalization of photography has accelerated, and now of course we have a superabundance of photographs pinging their

way around the world every second. Some are attached to emails to be printed out by loving grandparents on their home computer printer; others on Snapchat are designed to vanish after viewing; the rest spew out of our online feeds and absorb us for a second before retreating over the horizon of our viewing window, never to be looked at again.

In Dave Eggers's dsytopian novel *The Circle*, published in 2013, a young Californian woman, Mae, is working at a new internet company which implores and cajoles every human on the Circle network to become fully transparent to each other. One day a new corporate missive from the secretive board of directors flashes up on Mae's monitor at work: 'SECRETS ARE LIES, SHARING IS CARING, PRIVACY IS THEFT...'. The company invented by Eggers, The Circle, is a cross between Google and Facebook, and the story looks at how internet users are being conditioned by technology to make the very fabric of their lives accessible to everyone else on the network. One of the ways in which Mae believes she can be closer to her family is if they all have video cameras attached to them and running constantly so they can see what each other is up to every day. Initially this seems to be a good idea until Mae's parents have some impromptu love-making broadcast over the Circle to the world. From the collapsing of Mae's relationship with a boyfriend to her disintegrating links with her shamed parents we know that Eggers is highly sceptical about the aspirations many people have towards sharing their most intimate experiences online, and indeed the rest of the book turns into a fable about how secrets and privacy are necessary for a fully human life.

Some of these troubling issues are bubbling throughout all branches of the media as I write. A fashion and beauty blogger on Instagram, Essena O'Neill, has announced to her half a million followers that her stream of risqué selfies were fake, commercial and narcissistic, and she has retired to what she calls 'real life'. In the very lucrative land of 'mommy blogs', American Heather Armstrong, who started her financially lucrative blog, Dooce, fourteen years ago, has taken down her cheery photos of herself and children because she belatedly realized that her family photos were essentially advertising for products that she was being paid to endorse.

So what's new? Pre-digital everyone employed the camera to create an idealized image of themselves, whether it was in the bonhomie exuding from vacation snaps, the dignified triumph accompanying school graduation portraits, or the forced jolliness of Christmas holiday moments. A major difference with the online sharing model is that we are now susceptible to all the ranking mechanisms of the internet, thus our photos become proxies for craving validation from 'friends, followers, or fans'. The number of likes, downloads and retweets has created a whole system of hierarcky that puts pressure on everyone who has ever uploaded a photograph to think less about the personal value residing in the image and more about a nagging desire for affirmation. 'Status updates' are well named for this reason, and we consequently risk making our photographs prone to be reclassified as tokens of communication rather than as repositories of complex memories.

The one contributor to this book who is utilizing social media as an investigation of how photo sharing can enhance his practice, rather than being a marketing exercise, is Matt Eich. 'I always have several projects going on at the same time, so as I move from one thing to the next, my feed will reflect where my mind is. I'll go from Mississippi where I am interested in using Instagram as a bridge between two polarized parts of a community to my home where I am finding little pieces from daily life that are full of beauty and meaning. The key is to not post a stream of "cute kid pics" because I'm not interested in that or the super polished "look how awesome my life is" version of Instagram. I'm interested in the friction that

BELOW 'Refugees land on Lesbos, Greece' by Patrick Witty

occurs between the personal and the professional, the tension that happens when everything blurs together in a stream of consciousness format. There is a lot of untapped potential within the platform and I'm excited to see how its use continues to evolve.'

The great family-centric story of the present day, and probably for many years to come, is that of human migration. In past eras many migrant groups lost touch with kin in the old country due to slow-moving postal services and expensive phone calls. Now look at the Middle Eastern refugees sailing for Europe: the majority have smartphones and are using the in-built camera to document their trek. Freelance photojournalist Patrick Witty recently went to Greece to witness the surge in migrants coming ashore and noticed that the taking of a portrait by smartphone was often the first ritual to be performed when boat hit sand. As soon as the migrants reach safety, photographs of exhausted but smiling families are being posted on Facebook so that those back home know that their loved ones have made it. Suddenly this is a tale of achievement over adversity and, yes, even proof that the funds it took to make the journey were ultimately well spent. These images of families just delighted to remain alive will doubtless fulfil the function of holding together family networks across continents.

The here-and-now concerns of humanity's forced wanderings are a salutary reminder that photography's new global and instantaneous reach is a powerful force for human connection and kindred resilience, and that the sharing of digital photography can be as adept at resolving where we have travelled from as at establishing where we might be going. In the last few years, curious millennials have been taking a fresh look at their parents' and grandparents' family albums – often slightly battered and dusty from years of inattention – and finding pictures which, in their analogue un-filtered nature, are suggestive of more innocent times and which they can adapt for their own ends.

Typically, after a resonant picture has been chosen from the album, a time-travel feature is then employed, as the old photograph is brought to the place where it was originally taken and is then re-photographed in front of the same scene or in front of a digital photograph of the current-day scene. Often we see the old photo being held by the photographer's hand, and this act of holding is what imbues many of these composite images with a sense of longing and nostalgia for more innocent and explicable times. That gap between the old and the new, the analogue and the digital, black and white and colour, is where the magical effect of these confections lies. Once the new composite picture has been made, text is added explaining how this new image came to be and why it resonates. All that remains is to share it with a wider audience.

Several websites have thrived in this zeitgeisty space which could be branded as 'nowstalgia', but it is notable that the finished photograph only really makes sense when shared online with an audience. One such platform for these time-travel photographs is 'Dear Photograph', a website founded in 2011 by Canadian Taylor Jones. Talking to the *Guardian*, he said, 'It is a little crazy, but seeing all these photographs, and reading the stories, has given me a perspective on life. My parents are still around and I have grown a lot closer to them.'

Jones used a photograph from his own family album to kick things off on the website, but then opened it up to the wisdom-of-crowds and a rush of similarly mashed-up composites poured onto the site. It had gone viral. Clearly there was an appetite for this new technique of taking vintage family photographs and bringing them right into the present day and a sense that it was a way

RIGHT Photograph by Chloe Orchard, posted as part of the 'Dear Photograph' project

of connecting a family through the generations. As photography student Chloe Orchard noted in her contribution to the site: 'Dear Photograph, This church holds many special memories for me and my family history past, looking through my grandmas album and finding photos dating back to 1950's. These photos I have exhibited for my project at college using the Dear Photograph technique, I reunited these 1950 photo's with the place today–where my nan and grandad got married in Bolton St. James Church. It was a rainy day, but I got the best photographs I got a grade A* for such an amazing idea thanks to Dear Photograph for the inspiration. I now have reconnected with my family history. –Chloe' [*sic*].

Many of the 'Dear Photograph' contributions are witty and wistful, but some professional photographers are now using the technique for more complex ends. Louis Quail has made a series of photographs of UK families who lost loved ones in the Afghan war, contrasting photographs of the families taken in happier times with photographs of matched contemporary scenes that have a very obvious absence in the frame. Clearly the meme of juxtaposing and contrasting vintage analogue photographs with those taken in contemporary times and then sharing them online is a device that photographers will return to again and again.

American photographer Rachel Hulin knows what it is like to have an online family photography series go viral on the internet. Back in 2011, as a then-blogger and photo editor, she was seeing lots of online pictures of 'floaters', subjects who were caught by the camera in mid-air, an effect created mainly with the assistance of photo-editing software such as Photoshop to complete the visual illusion. Bored at home with her baby son Henry, she decided to see if she could replicate the technique and make Henry fly, and thus was created the 'Flying Henry' series of photographs, which went on to have a huge online audience and eventually became a book.

Hulin's new family-centric photography project debuted recently on Instagram and is a fictional narrative called 'Hey Harry Hey Matilda'. The story follows Harry and Matilda Goodman, who are thirty-something twins from New England. Matilda is an artist and Harry is a writer, and through mysterious photographs and excerpts from email correspondence we explore their affection for each other and their desire for independent lives. Hulin intends to tell the story on Instagram in daily posts over nine months, which covers the timeline of her tale. As befits the disjointed and spontaneous nature of most Instagram streams, 'Hey Harry Hey Matilda' is meandering and difficult to parse on casual viewing, but this

ABOVE Photographs by Rachel Hulin from her 'Hey Harry Hey Matilda' and 'Flying Henry' projects

combining of photography and fiction on social media is perhaps a harbinger of a new interactive genre which photographers and writers will explore as photo sharing becomes ubiquitous.

At a time when most people's social media feeds seem clogged up with images of the 'this is me, now, doing this' variety, it is a relief that photographers are beginning to use these platforms for more emotionally rich and complex narratives. Given that it is through family relationships and domestic life that photography is introduced to babies and small children, it is not surprising that much of that richness derives from the photographs that young parents are taking of their children.

Jared Iorio is a Los Angeles-based photographer whose two-year-old son, Nye, has had his image shared on many social networks, including Flickr, Tumblr and Twitter, almost every day of his life. Indeed his home birth in 2013 was both followed on Twitter with the hashtag #ruthshomebirth and shown on Instagram. Subsequently Iorio and his wife have gone their separate ways, but in order to stay close to his son the photographer has created a Tumblr site called 'A Boy and His Dad', which details the developing relationship between the single father and the son he can only see at certain times of day. Iorio, a talented photographer who conveys a deep love for his son with a sense of bemusement that this small person is in his sole care for long periods, has clearly thought long and hard about what it means to share so many unguarded photographs of his child.

'I began photographing Nye – like I do all the important things, people and ideas in my life – from the moment I met him. A picture of Nye was used in publications around the world, after his somewhat dramatic and beautiful home birth in our two-bedroom Venice, California apartment went viral as his mom and I sought to celebrate and demystify the birth process by tweeting and Instagramming

(is that a word now?) it in real time. He was about a minute old at that point and internet-famous within the day. I grapple with ideas regarding privacy and consent daily as I photograph him and wonder if I'm making a mistake by publicizing his life to the extent I have. The internet doesn't forget – and neither do books. I just hope that every twinge of embarrassment he may feel later when he looks back at these photos is tempered, and dare I say even trumped, by seeing just how much he was loved and adored by his mom and me.'

Throughout modern times the father of the household has typically taken on the role of designated photographer; indeed family albums from past decades have generally been the creation of men who would rather wield a camera than pose for it. Thankfully, as families have become less patriarchal and technology has brought cameras into the hands of many more family members, both young and old, so the digital nature of photography has allowed for more inclusive and authentic records of family life.

Some mothers, like Swiss-born Rahel Krabichler, are finding that the photographs they take of their children are the impetus for them beginning a new career, especially when they are able to receive ongoing critical feedback from followers online. 'After I had a child, I quit my job as a graphic designer and started to work as a professional photographer. The most powerful images are the

LEFT AND ABOVE Photographs by Jared Iorio, taken for his 'A Boy and His Dad' Tumblr site

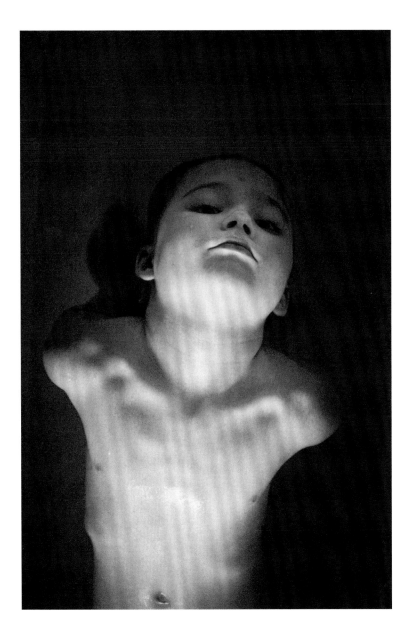

ones I take of my small family, because they are here, every day. As a single mom, this is mainly my son, but there is also my father and my stepmom, and they are very open and honest in front of my eye. There is a lot of experience, trust and braveness in this small family. So I started mirroring what's burning inside me by watching them. Looking for the things I feel are true for me. Looking for identity, intimacy, the right questions.' Krabichler's photographs on Flickr and Facebook are artful but honest accounts of home life with a playful and curious son who appears to be totally relaxed about his mother recording play time as well as bath time.

A new child will make new extra demands of any professional photographer, whether they be a mother or a father. Time given over to projects, travel and long days on location is suddenly shunted while the demands of a baby require attention. Some photographers, however, are able to take on their new responsibilities and find a way to bring a camera along to record the new reality of their day-to-day life. London-based photographer Mimi Mollica found a way to make a project on Instagram from time spent with his daughter, Nora.

'"Nora There" started during my walks around London while pushing Nora and her pram. At first I photographed her from a distance against gloomy backdrops of London's streets, alleys and former council estates, then I started including human figures, mostly unaware of being included in the frame. Then I started looking for situations that were to the opposite spectrum of childlike contexts. I was looking to capture the contrast between the innocence of my one-year-old and the world of strangers she would have to be dealing with in the future. I wanted to capture the introduction of Nora to the world she'll be interacting with, while showing a cross-section of today's Londoners, rich and poor, young and old. The idea of using Instagram to showcase the project was given to me by my buddies who suggested it was the perfect platform because I shot the entire project exclusively using a smartphone camera. The posts became regular and the audience quickly grew in numbers, although I finished the project shortly after my daughter turned two years old because as soon as Nora became more conscious of her surroundings I noticed in her the early signs of what could have possibly turned eventually into an unpleasant discomfort.'

The photo-sharing service Instagram is now the second largest social network in the United States, behind Facebook, with more than 400 million monthly active users. Those other photo-sharing networks Snapchat, Tumblr, Pinterest and Flickr are not far behind. Online photo sharing has made family photography much more

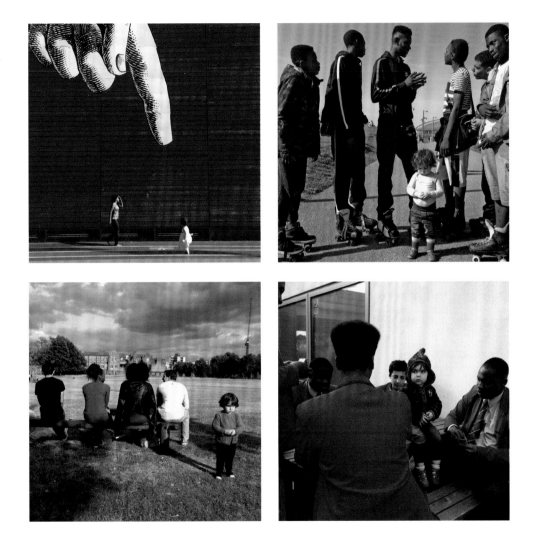

playful and democratic for all family members, but also more disposable. Will a digital equivalent arise of the soft-padded, cellophane slip sheets of the traditional family album? For all its fustiness the album, brought out for friends and strangers alike, has been a way of demonstrating the coherence of families in a world of major societal upheaval. Perhaps in the near future an ethereal multi-platform, cloud-based photo-feed will follow us all around like a suffocating blanket of family-ness. Conversely, could the algorhythms, over-sharing, mega-posting and endless status updates ultimately leave us disaffected from all those family 'moments'? Might it be the case that our children or grandchildren will want to get off that cloud and re-immerse themselves in real life?

It is also worth considering that, while social media networks in our hypermediated existence are always on, that doesn't guarantee their permanence, as Friends Reunited and Myspace can attest. So all those pictures you have of your children, siblings and parents lingering in the cloud: what will happen to them when the hosting company goes out of business? I'm sure you read those end-user licence agreements and terms of service, so do you know what provision they make for those irreplaceable family photos?

But we are not there yet. Many households still find pride of place on mantelpieces for framed pictures of beloved family members and don't feel the need to launch them into cyberspace for the validation of a thumbs-up. The future may be hunching over finger-smudged screens and endlessly swiping through photographs that have not been edited or selected with particular care, but we will definitely see family births sooner, learn of new camera techniques from our grandchildren, and thrill to ultra-high-definition wedding ceremonies photographed live on the cloud. Got to be a good thing....

LEFT Photographs by Mimi Mollica, from the 'Nora There' project

May I come in?

Photographers documenting other people's families

A photographer knocks on an unfamiliar door.
A friendly, curious or hesitant greeting is shared.
Children show up, parents negotiate, elders pass
through. If enough trust develops, a photographic
project is born. The photographers in this section
are captivated by the mystery of how other people's
families come together, adapt, struggle, thrive, and
sometimes fall apart.

'Any family is intriguing,

if you look closely.'

Penelope Lively, Family Album

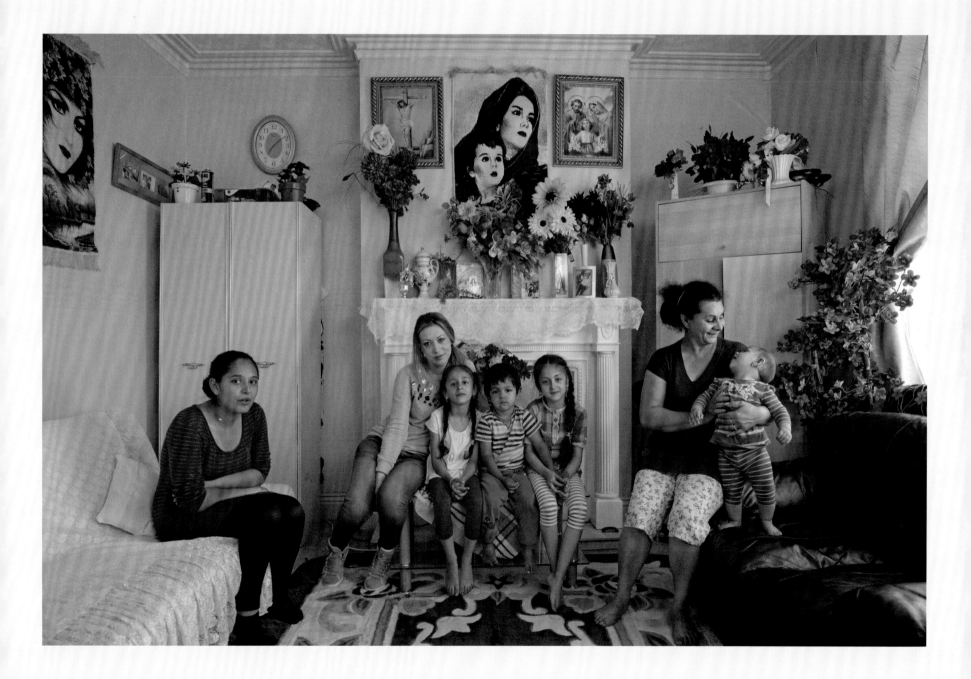

PATRICK WILLOCQ

born 1969, France; lives in Democratic
Republic of Congo and Hong Kong

*Artfully constructed photographs
of first-time Congolese mothers,
documenting indigenous customs
and exploring personal narratives*

In these carefully composed *mise-en-scènes*, produced in collaboration with the Ekonda pygmy tribe of the Democratic Republic of Congo, photographer Patrick Willocq captures a fascinating and lyrical aspect of indigenous life. While in seclusion from the rest of their tribe, first-time Ekonda mothers – known as *Walés* – create 'songs' of their lives. When their seclusion ends (it can last for several years), the occasion is marked with highly competitive rituals of singing and dancing. Willocq translates these ceremonies into photography.

'First with the help of a ethnomusicologist we record, translate and understand the songs of the *Walé* mothers. Then we make visual drawings of the songs. Once satisfied that the drawing corresponds to the meaning of the song, I move to production.'

With the help of a team, Willocq constructs a vast backdrop and stage. 'An artist friend helps me build the most complex props, such as a plane carved in wood. The whole enterprise becomes a community art project, from kids who know where to find a flower in the forest to old papas who know how to make traditional ropes.'

The Ekonda are proud that Willocq has shown such interest in their culture, but relations were not easy at first. 'Distrust was high. It was not the first time that foreigners had ventured there, looking for natural resources, so they initally thought I was, too.' Once Willocq had persuaded them of his intentions, and had helped some *Walés* financially

and with material goods if their families requested it, he was able to access the inner circle of women, whom he was also allowed to photograph in their huts.

Of the performative project, he reports: 'The *Walé*, author of her song, comes for the shoot, facing a very happy public of 50–150 (a photo session is similar to a circus coming to town). Lighting is natural light. I shoot at 17:00 during the dry season, at a specific time when the sun hides behind high-level clouds and the whole sky turns into a giant soft box. During this 45-minute window, the colour, texture and materials all come out: 30 minutes earlier the sun is too strong, 30 minutes later it's total darkness.'

Willocq himself spent several years in the Congo as a child, hence his close affinity with the country. His transformation of a complex rite of passage into photographs, which are not part of Ekonda society, is an intriguing cultural transaction. But 'they all proudly take them and look at themselves with awe. The crowd all want to see them. Some pictures are damaged in the process of exchanging hands, but it doesn't matter. What is important is the burst of joy and pride they all feel when they see the images.'

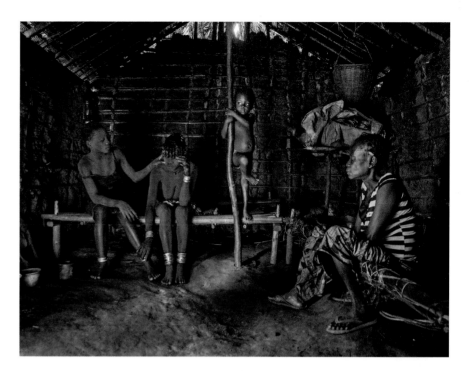

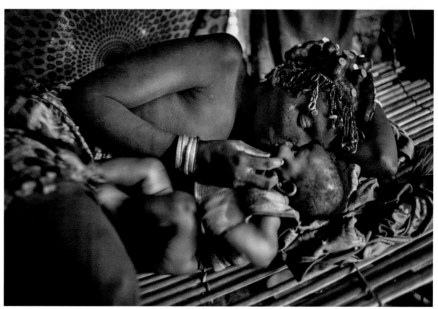

'I lived a very happy childhood in the Congo and fell in love with the country

and people. That is most probably why my pictures are what they are.'

'Each set-up worked as a visual representation of one of the subjects that

the *Walé* would sing about on the day of her release from seclusion.'

DENIS DAILLEUX

born 1958, France; lives in Egypt

Egypt, Mother and Son: *World Press Photo award-winning portraits of bodybuilders and their mothers*

Denis Dailleux's tender and provocative portraits of Egyptian bodybuilders and their mothers resonate with conflicting emotions. Some of the men confidently show off their sculpted torsos, while others seem shy to bare their flesh. Some of the mothers swell with pride next to their grown sons, while others look away from the camera submissively. There is great love, but also great vulnerability, often within the same image.

Dailleux, who has lived in Egypt for over ten years, describes making the work: 'Some of the men I know very well, others I just met in the street. Egyptians are generous; they easily open up their doors and let strangers into their homes. I started every shoot in the same way, with the mother and son sitting behind. I never asked for displays of affection, and sometimes there was an atmosphere of great restraint. But on other occasions the son would kiss his mother, or lay his head to rest on her of his own accord. Of course I was glad when they had their own ideas for how to pose together.'

Dailleux was raised a Catholic, and, with their strong echoes of the Pietà, his photographs also raise issues about sin, forgiveness and absolution. He has spoken of the series being a 'kind of coming out', but says his homosexuality should not determine how other people read the photographs. 'They are photographs about the intensity and complexity of the love between mothers and sons.'

LEFT Hussein and his mother, 2012
BELOW Aïd and his mother, 2013
OPPOSITE Ramy and his mother, 2012

'Aïd right away said,

"I have some ideas."

He lay down on the bed

and rested his head

on his mother's lap,

then he gently took

her hand and placed

it on his body.'

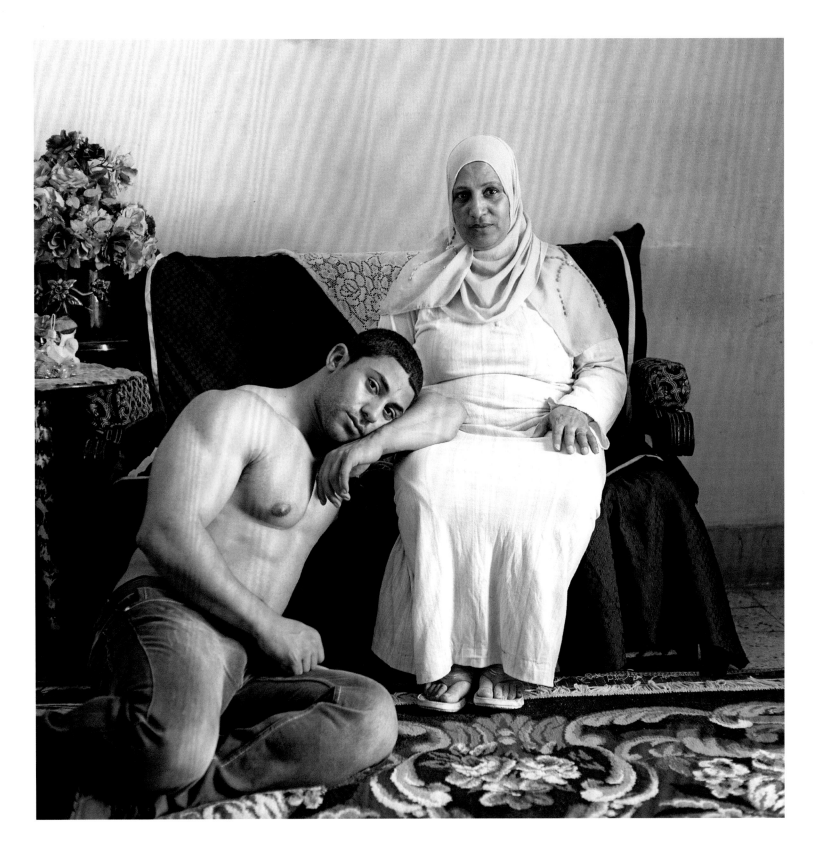

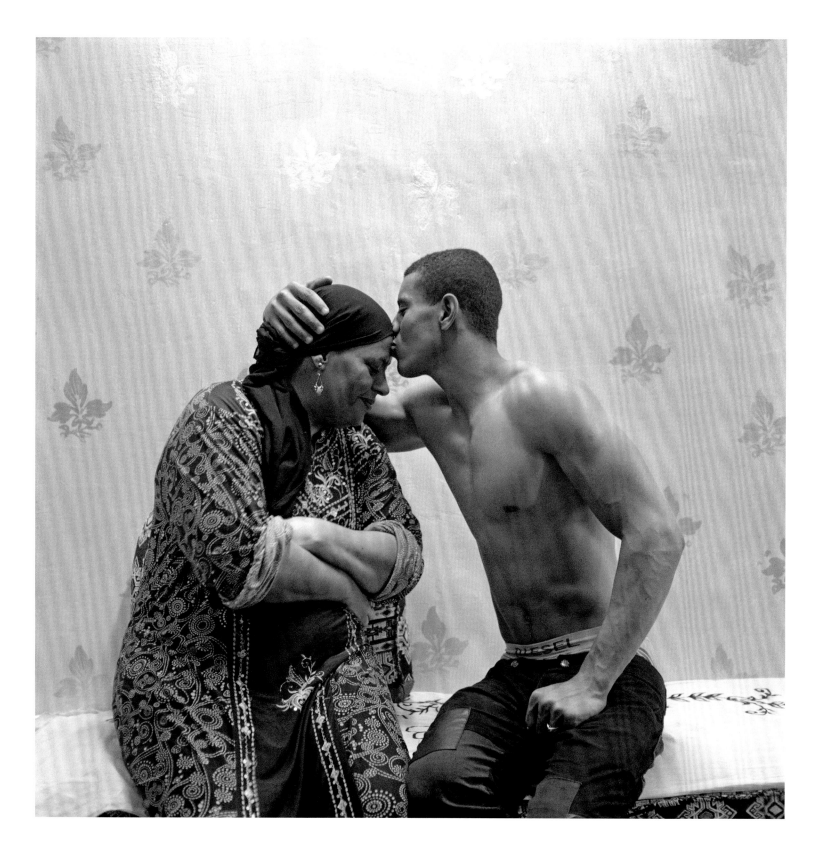

'The idea for the series had been in the back of my mind for a long time. I wanted to explore the link between mothers and sons because of the strength of my own love for my mother. It is intensely personal work.'

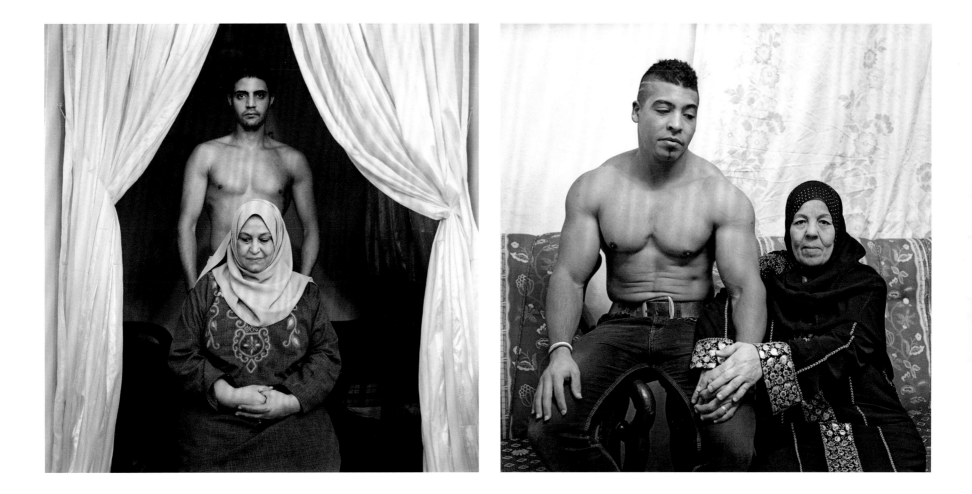

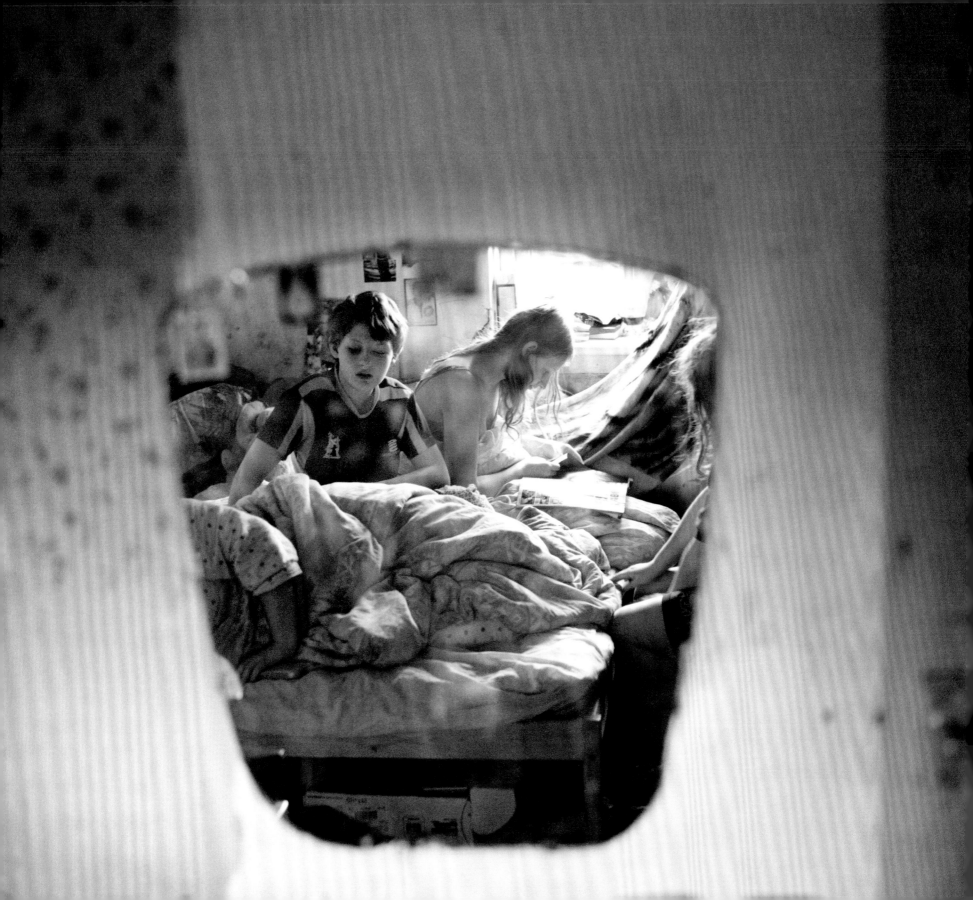

LIZ HINGLEY

born 1985, England

A hard-hitting but affectionate portrait of a family living in poverty within one of the world's richest economies

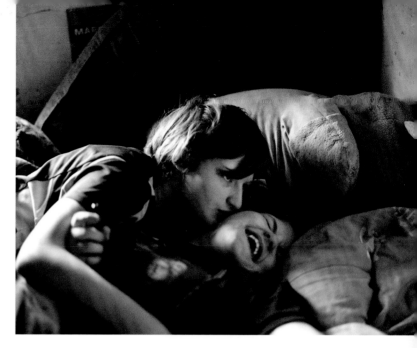

In the autumn of 2010, the international charity Save The Children commissioned photographer Liz Hingley to document the effects of poverty on children living in the UK. She knew right away that she wanted to find her own family, rather than be assigned one, and soon met Michelle, the eldest of seven children living with their parents in a three-bedroom council house in the industrial city of Wolverhampton.

'When I walked through the door of their home, I knew it would be easy to make the kind of images the charity would want. The scene fit all the stereotypes: unemployed Dad sitting on the sofa, frozen food stored outside, TV blaring. But then I started talking to Gary, the eldest son, and had to question my assumptions. He was working at the computer studying for an animation degree. He didn't have money, but he clearly had aspiration.'

Save The Children collected the photos they needed for their campaign a few months later, but by then Hingley felt too deeply involved with the family to pull away. 'I had fulfilled the brief to tell a story about deprivation, but I knew there was another story; a more optimistic one, about the love that holds a family together, even in difficult circumstances. To do justice to the Joneses I decided I would photograph for at least a year. In the end I stayed more than two years, until Michelle moved out to start a family of her own.'

When spring came, Hingley began to let more light into her photographs.

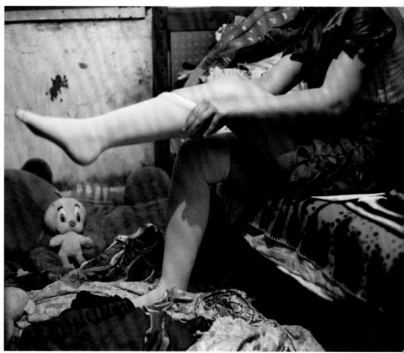

Still contending with the difficulties of shooting in a dark and cramped terraced house, she placed more emphasis on windows and outside spaces. The photographs also began to feel more affectionate, as she discovered how much the Joneses cherished their home and the memories they had created there. She was struck by their ability to create their own private worlds within the small communal space, describing a typical scene in the living room involving someone with their headphones on, someone on the phone, someone watching TV and someone playing a game. But she was even more struck by the everyday rituals that kept the family so tight as a social unit: 'My overriding memory is how close they all are to one another.'

The Joneses didn't have a family photo album when Hingley met them, but she gave them all cameras and they quickly started to document themselves. She was also there to celebrate numerous birthdays and other events. 'Between us all, we created thousands of photographs over the two years. Not surprisingly, the pictures they are fond of are different from the ones Save The Children were interested in, and also from the ones I value most. But the fact that they mean different things to all the different people involved is part of what makes me feel most proud of this project.'

OPPOSITE Waking up in the Girls' Room
TOP RIGHT Sisters and the Teddy Bear
ABOVE RIGHT Halloween Costume

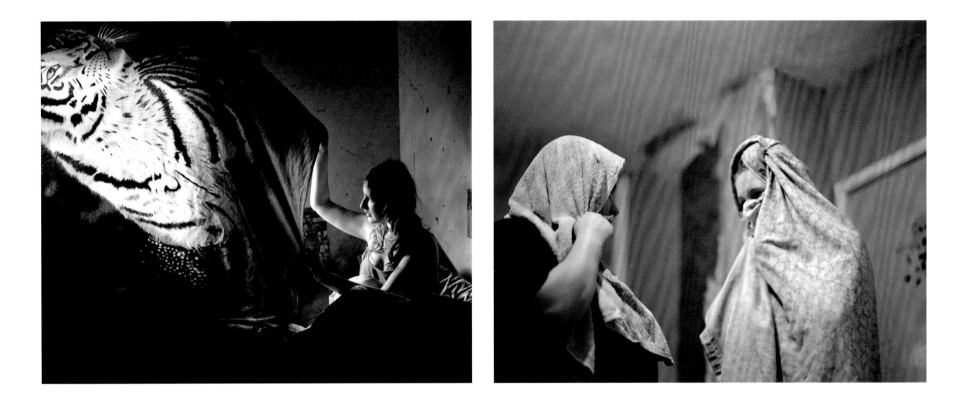

'The project started as a commission to document the effects of poverty,

but I quickly realized I didn't want to take the kind of pictures the

sponsoring charity expected. I do photography to celebrate human life

in difficult circumstances.'

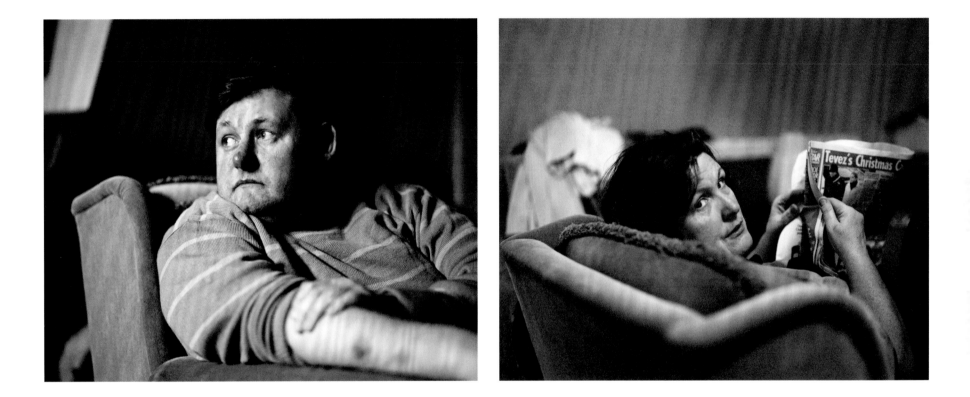

OPPOSITE LEFT The Tiger Curtain
OPPOSITE RIGHT Wet Hair
ABOVE LEFT Dad ABOVE RIGHT Mum

'The Joneses are a close family and the house is very precious to them. They even refused the offer of a larger house because over the years they had built up such fond memories of living in those five rooms together.'

LEFT Dressing Up
OPPOSITE The Cat

BIRTE KAUFMANN

born 1981, Germany

The Travellers: *Ireland's biggest minority group, looking for a new identity within Western society in the 21st century*

It is hard enough to understand one's own family, but to understand a family whose lifestyle, social structures and traditions are vastly different from one's own takes a rare degree of empathy. That is the task that Birte Kaufmann set herself when she started photographing an extended family of Irish travellers in several counties in eastern Ireland.

'Where I grew up in Germany, there were Roma camps twice a year. I was fascinated by these people who came and then left. But everyone always told me, "It's a parallel world. You'll never get an insight into it."'

Undeterred, Kaufmann went back and forth between different travelling places in Ireland, including halting sites and road camps, every day for three weeks. Eventually the travellers let her stay overnight in her VW camper van. She has now stayed with them on and off for more than four years. Although they often move their camps, Irish traveller families tend to stay in the same local area so they can keep their children at school. They know that if their children don't attend school regularly they are in danger of being taken into the care system.

'It has taken a long time to earn their trust,' Kaufmann admits. 'Their constant confrontation with prejudice means they are understandably wary of outsiders. Illiteracy also keeps them on the margins of society. But over the years the family has developed genuine affection for me. They've started to teach me their language, Gammon, which has helped me understand their values much better.'

Gender roles are very traditional in the travelling community. At first Kaufmann was only able to talk to the women. 'If I approached the men, they would say, "The women are over there. Go and join them." Every year I go with the family to a big horse fair, but it was only after three years that the men of the family would speak to me in public. When another traveller asked why they were talking to me, they answered, "She is a friend." That meant so much to me.'

Irish travellers marry young and usually have a lot of children. It has been one of the most marked points of difference between Kaufmann and her subjects. 'When I first met the family, they'd say to me, "You're still young, you have plenty of time." Now they are much more insistent: "Birte, you have to start building your own family!"'

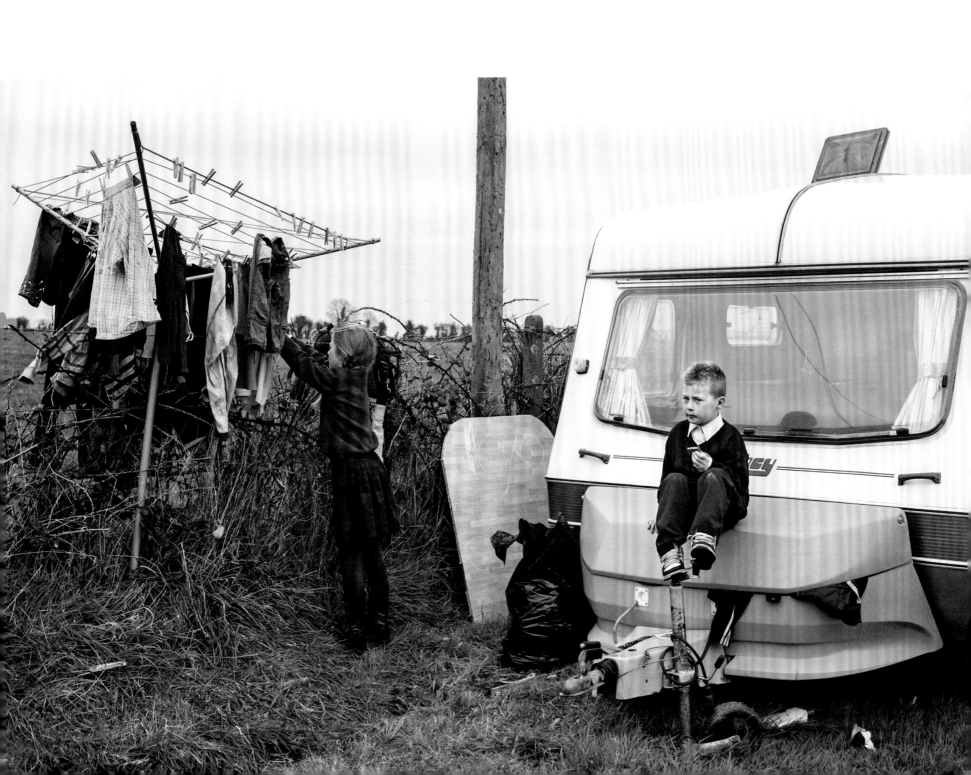

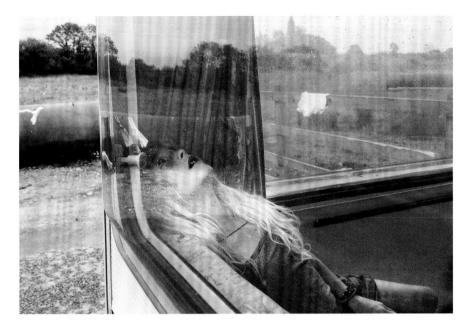

'For me it was really important to focus on daily life and the situations I experienced there, not on the spectacular traveller events that only happen every year or two.'

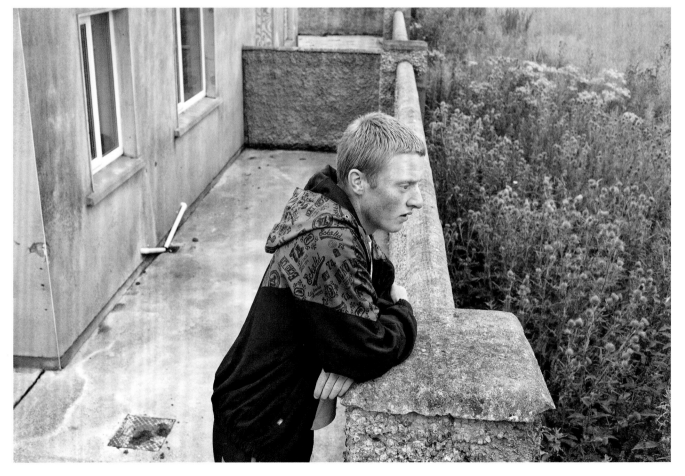

'At the end of one of my recent visits, the travellers said, "OK, we'll let you go back to your German family, but don't forget your Irish family. You have two now, you know!"'

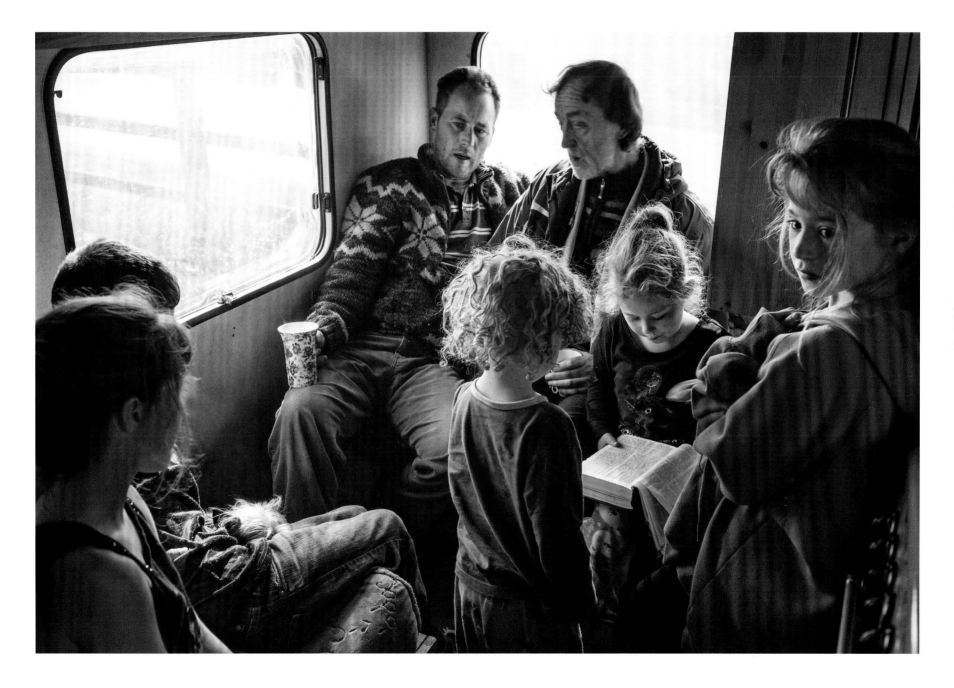

ABOVE Lim family (London, Marine Parade)
OPPOSITE Goh family (Bellevue, Bedok)
OVERLEAF LEFT Leong family (Paris, Thomson)
OVERLEAF RIGHT Lim family (Connecticut, Telok Kurau)

JOHN CLANG

born 1973, Singapore; lives in USA

Being Together: *a series that utilizes modern technology to create a hybrid of real and virtual family portraiture*

Born Ang Choon Leng, John Clang acquired his moniker when, while doing national service in Singapore, he was given a name badge that read C L Ang. Now resident in New York, he conducts disparate and intelligently constructed explorations of issues around identity, memory and longing. His project *Being Together* shows how modern technology is able to bring together families, which, like his own, are spread all over the world.

'I had been focusing on projects based on my own family for years,' he reports, 'and decided to do my family portrait in a manner that reflects our circumstances.' He has gone on to create multiple family portraits that use Skype to make live recordings then project them across continents. 'All the photography sessions are done live, so the families can see how the process works, but they may not wrap their minds around how the final image will look. Some burst into tears on seeing the images. It's quite emotional.'

In our fast-paced world, it can be difficult to arrange sittings, and Clang notes that disputes occasionally mean that shoots have to be cancelled. 'There's a lot of tension within a family dynamic,' he affirms. 'It's a little sad to see how family is not just separated by diaspora; it's affected by our hectic lifestyle as well. The core, though, is about a moment when all family members come together to be frozen in time in a photograph. I like this moment to be something they can reflect on when they look at the image.'

'This work documents our condition of new wave diaspora:

Singaporean families of various races and ethnicities grappling

with the same predicament of separation through time and space.'

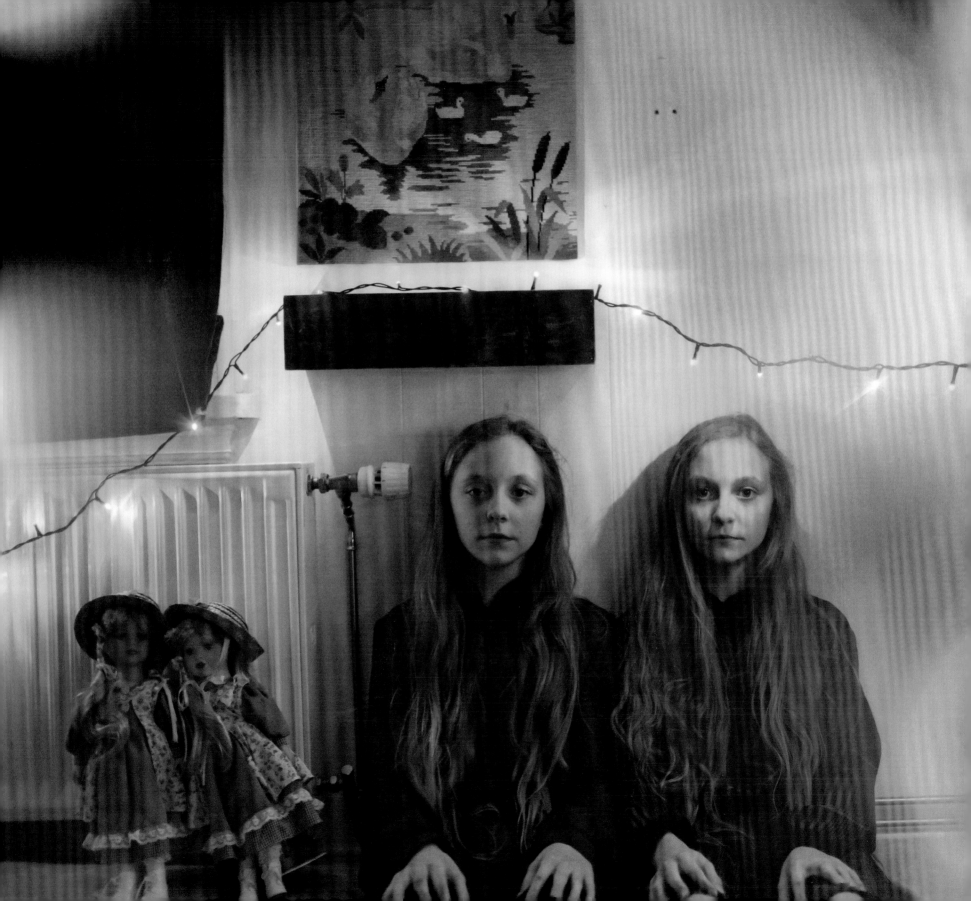

ARIKO INAOKA

born 1975, Japan

Magical-looking images of Erna and Hrefna, identical ballet-dancing twins from Iceland

Dramatic and unspoiled landscapes initially drew Japanese photographer Ariko Inaoka to Iceland, but it was there that she also found her muses in Erna and Hrefna, identical twins with a passion for ballet and horses, and – according to Inaoka – an almost telepathic bond.

'In 2006, I was in Iceland for a commercial assignment,' recalls Inaoka. 'My Icelandic friend was helping me to cast models for the shoot, and she saw Erna and Hrefna at a swimming pool and invited them over for an audition. They were nine years old at that point.'

Since 2009, Inaoka has visited the girls every year. 'I am going back this summer for the seventh visit and will spend about twenty days with them. I see them almost every day. I mostly come up with locations, scenes and fashion ideas, but once the photo shoot starts it goes with a spontaneous flow and it becomes a collaboration: sometimes the girls or their parents give me ideas, too.

'I often get ideas for locations and clothes from what they do and wear in their everyday life. During the summer holiday they take horse riding lessons, and they also take ballet classes almost every day, so I came up with the idea of photographing them in their ballet clothes, with horses. While I was photographing, the idea of them standing behind the horse came to me and I asked them to do ballet poses. It was magical that the horse collaborated with us by lifting one leg.'

Inaoka appreciates the twins' facility as photographic subjects. 'Because they practise ballet they know how to hold themselves in front of a camera naturally. They are also very mature and confident, but at the same time very modest.'

Inaoka, who studied Taoism, makes much play in her work of the dualistic forces and bonds that seem to enwrap Erna and Hrefna. Identical twins make for bewitching design pairings, but the photographer also senses a particularly unusual bond between the girls.

'I have known them closely for six years now, but I've almost never seen them fight or be mean to each other. There is amazing peace and harmony between them. When I ask them questions they often answer together, talking in sentences back and forth between them. They have said they cannot think about living separately from each other. They told me they sometimes have the same dreams.'

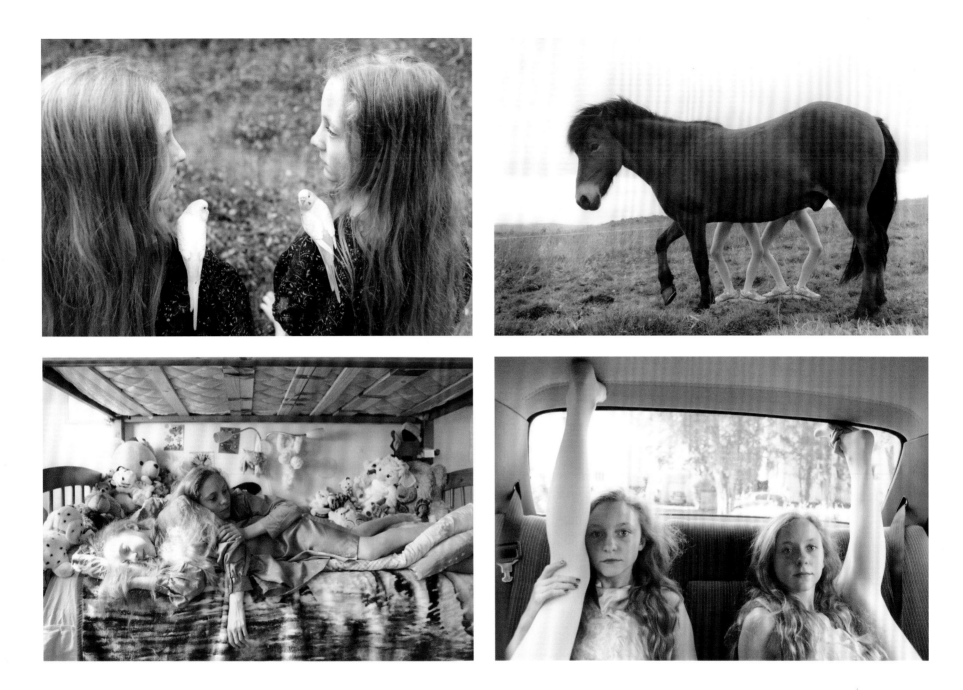

'When I started this project I had an idea to find other twins in

other places to photograph, but I could not find any other twins

who are as strongly connected as Erna and Hrefna.'

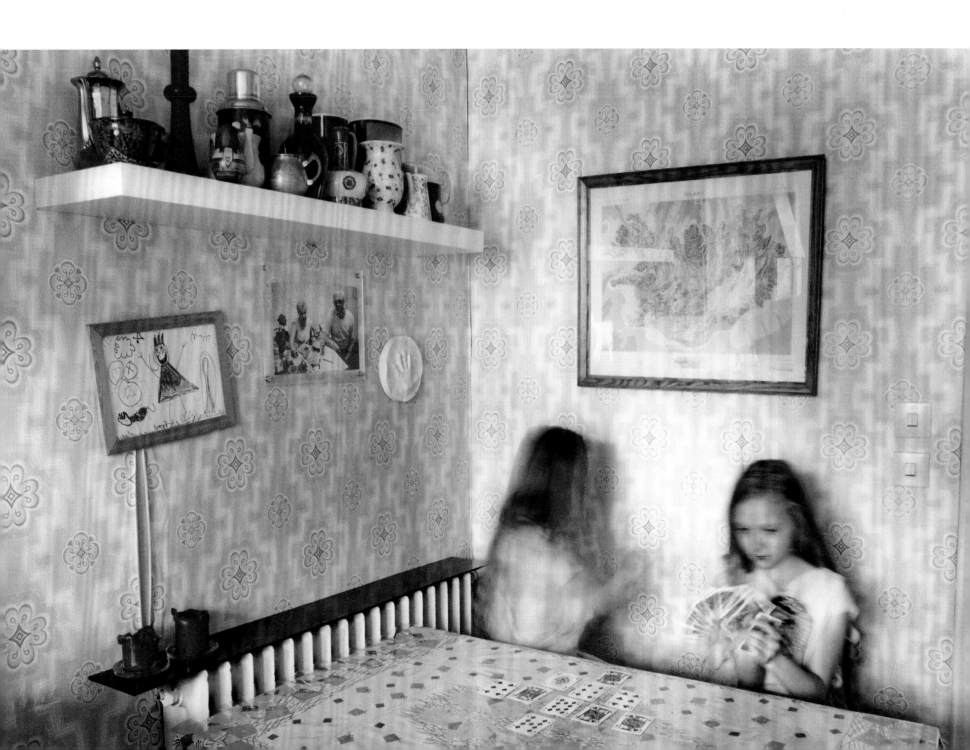

MAJA DANIELS

born 1985, Sweden; lives in England

Mady and Monette: *a touching portrait of the enigmatic lives of two identical twins in Paris*

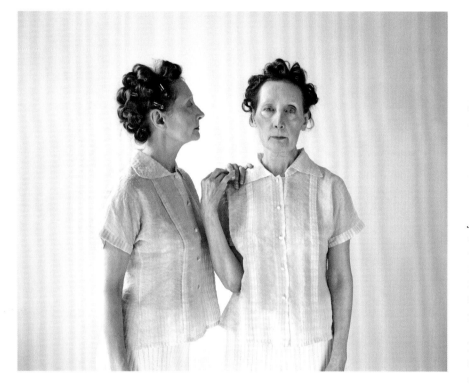

'I hear people say things like, "Ooh, twins at that age", as if being a twin was something you grow out of.'

Mady and Monette Malroux live identical lives. They wear the same clothes, eat the same food, finish one another's sentences and seem to have almost synchronized body language. Neither has married or had children. Their deep companionship invites us to rethink conventional ideas about finding our 'other half'.

When they were younger, Mady and Monette worked together as dance-hall performers. Later they appeared in films, including *Amélie* and *Paris, je t'aime*, and they have also worked as models. Increasingly it is their everyday life that has become their main performance, and the streets of Paris – rich in references to fashion, film and art – offer a perfect backdrop for their extraordinary double act.

Swedish photographer Maja Daniels first noticed the twins when she moved to Paris in 2005, but she didn't begin photographing them until 2010. 'I used to see them shopping at my local fruit and vegetable market. They were so strange and so beautiful, I almost wondered if they were real. It took time to convince them to work with me, and it was two years before they let me photograph them at home. They are very public figures – instantly recognizable to many Parisians – but they are also very private.'

Daniels's photographs are sometimes staged, sometimes candid. It is not always possible to distinguish between the two, but Mady and Monette's life is like that: performance and reality have become inseparable. 'They enjoy the attention they attract. They see themselves as putting on a show for those of us they call "singular" people, and they enjoy the way they make us think differently about individuality, identity and intimacy.

'At first I was spellbound by their seamlessness and my early photographs focused on that. Over the years, as I've got to know them better and the trust between us has deepened, my photographs have become less formal. Now they come to me with suggestions for photographs and I think of them as co-authors of the project. Recently I have also found myself taking more individual photographs of each twin. This can make them appear more vulnerable than when they are shown as a unit, so I always show the individual portraits as a pair. It's not for me to try and separate two people who have chosen to live their lives so closely together.'

ABOVE In Curlers, 2010
OPPOSITE On Street, 2013

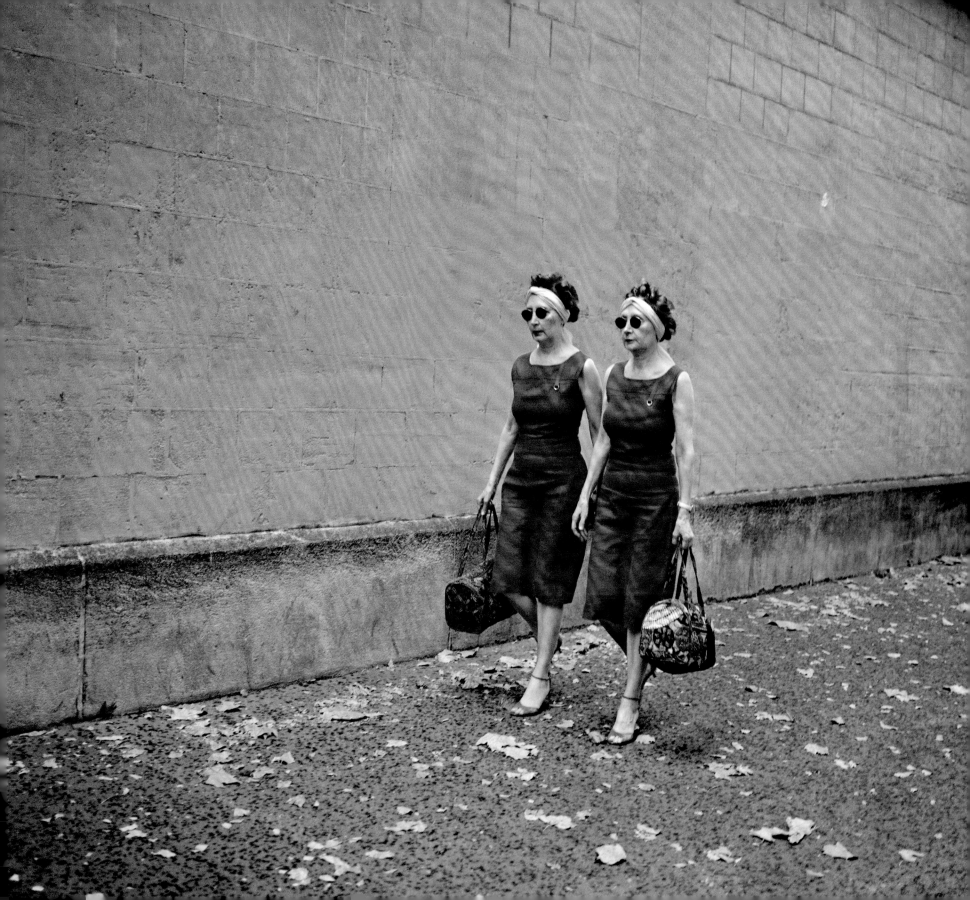

ABOVE Rue des Partants, 2010

'People often ask me how they are different, as if that might provide a clue to understanding them. My role is to let their vision of themselves speak for itself.'

ABOVE At Home Part 01, 2013
OPPOSITE At Home Part 02, 2013

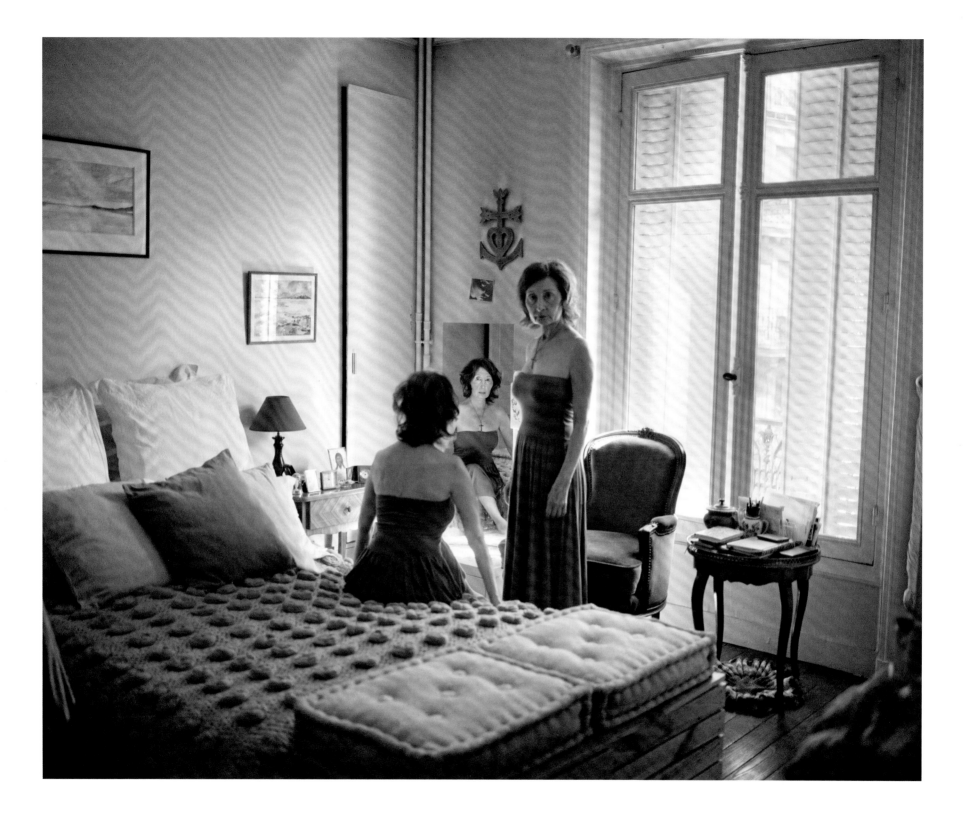

DAVID MAGNUSSON

born 1983, Sweden

*Compelling portraits of fathers
and daughters engaged in the
Purity movement in America*

'Purity' is the name given to a striking series of portraits taken of teenage American girls and their fathers, who have taken part in a quasi-religious ceremony called a Purity Ball, in which the girls pledge to remain virgins until they are married. These events take place in many US states, including Louisiana, Colorado and Arizona. In return for their daughter's vow, each father makes a pledge to protect her chastity, and occasionally rings are exchanged to symbolize the promise. The project forced David Magnusson – a Swedish photographer from a culture in which attitudes towards premarital sex are totally different – to re-think many of his initial beliefs.

As he has stated: 'When I first heard about the Purity Balls I imagined angry American fathers sitting on their porches with shotguns in their laps, terrified of anything that could hurt their daughters or their family's honour. But, as I learnt more, I understood that the fathers, like all parents, simply wanted to protect the ones that they love – in the best way they knew how. It was also often the girls themselves that had taken the initiative to attend the ceremonies. They had made their decisions out of their own conviction and faith, in many cases with fathers who didn't know what a Purity Ball was before being invited by their daughters.'

Magnusson chose to photograph the pairs in the clothes they had worn during their ceremony. The families and photographer then decided together on a location close to the family home.

'To me, *Purity* is about how we are shaped by the society

in which we grow up and how we interpret the world through

the values we incorporate as our own.'

'I wanted the backgrounds to tell a story both about the parts of the US where the Purity Balls were taking place and the surroundings of the families I'd met, but they also had to work visually, being free from unnecessary distractions, so you could focus on the relationship between the girls and their fathers.'

Magnusson told each pair that he wanted to see their relationship in the light of their lifestyle choices. 'We tried different options, which is necessary to get a dynamic in the session, but I never wanted to direct the small details of how they held each other, as I wanted to leave room for the story of their individual relationship to be told through the small details of their interaction.'

Magnusson also interviewed the participants, though his intent was never to present any conclusions or answers in his work. 'I'm simply presenting individuals, leaving the viewer free to reflect on their own values in their reactions to the portraits. My prejudices have definitely been challenged. It can be easy to have strong opinions of the ceremonies, but, once you start meeting the people actually participating in them, it becomes abundantly clear that they are all individuals with complex personal reasons for the decisions they have made.'

'I wanted to create portraits so beautiful that the girls and their fathers could be proud of the pictures in the same way they are proud of their decisions.'

'Someone from a

different background

might see an entirely

different story

in the very same

photographs.'

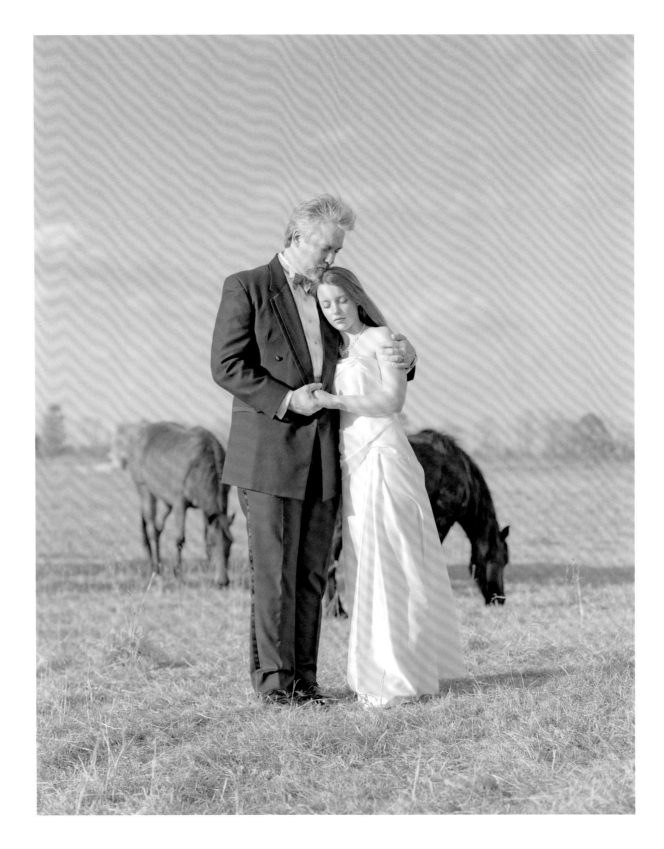

DITA PEPE

born 1973, Czech Republic

Staged self-portraits, posing the question of how differently our lives could have turned out

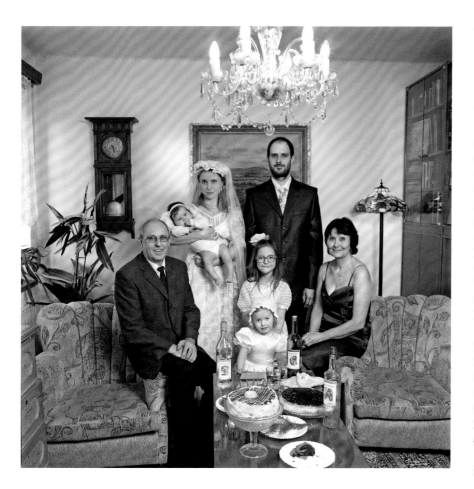

What would we be like if we had been born into a different family? Or had children with a different partner? Czech photographer Dita Pepe has built her career on posing such riddles. Her witty but also unsettling self-portraits show her partnered to a series of wildly different spouses: in one, she is the demure wife of a cold executive, in another the much younger partner of a talented musician. She has been rich and poor, an Arab and a Jew, a housewife and a hippie, a dancer and a dominatrix. In every photograph, she seems utterly convincing in her role, surrounded by the people she apparently loves and the things she apparently owns. But it is all a charade.

'All of us adapt in relation to the people we share our lives with. When I look back, if things had been just slightly different I could have ended up being someone completely different from who I am now. Reflecting on that has made me deeply curious about other people's lives.'

Pepe has involved her own family in her project, but she mainly works with others. 'To make the portraits, I go to see people in their homes,' she explains. 'We talk about the project, and that tends to lead to a conversation about their values and way of life. They show me around their house; I try on their clothes, use their belongings, and try to copy their body language and facial expressions. I usually let them choose where the shot happens, then they pose while I set it up. Only at the very last minute do we swap places.'

Pepe's self-portraits invite us to reflect on the mores of family photography: how family members arrange themselves around one another, where they want to pose, what possessions they value. Pepe also invites us to consider how easily we make assumptions about the internal dynamics of family just by looking at a photograph. Who sits, who stands, who holds the baby, who holds the purse strings? We easily, but not always accurately, set about interpreting these things. Pepe's staged portraits make us think again.

'What would it be like if I had been born somewhere else, in a different

way, to other parents? What would I be like today, what would my life be

like, and who would I live with?'

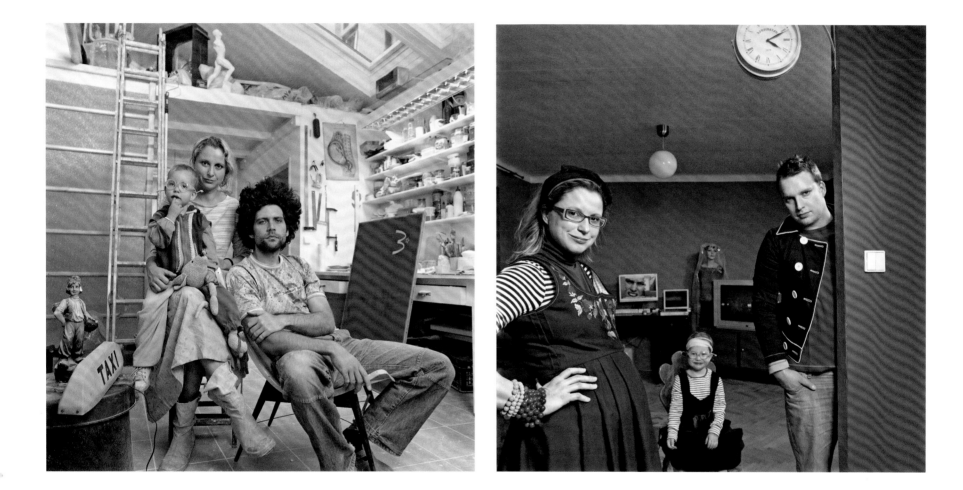

'That's the illusion of photography: that to some extent you always

see what you want to see, and if you want to see that we look similar,

then you will.'

'What I learned about Vinny and David's brotherly

relationship intrigued me, and I knew that in order

to document Vinny's life I had to include David.'

ISADORA KOSOFSKY

born 1993, USA

Immersive study of the lives and incarcerations of teenage brothers Vinny and David

One of the traits that can bedevil young photographers, particularly those with a hunger for immediate recognition, is an unwillingness to devote enough commitment to the subjects they are exploring. An under-investment in time and effort rarely leads to satisfying projects or fruitful careers. Californian photographer Isadora Kosofsky may only be 21, but she has shown that total immersion in a project and getting as close as possible to a subject for as long as possible is the surest route to achieving a powerful body of work.

Vinny and David is a study of two brothers, their experiences of incarceration, and the way in which their family bond has remained strong throughout their interactions with the penal system. Kosofsky found herself interested in juvenile justice after delinquency among a group of her friends resulted in police intervention. 'I began to envision a photography project about young people in prison,' she recalls. 'After three years of submitting requests, at the age of 18, I was granted permission to photograph in a few juvenile detention facilities.' She soon realized, however, that by photographing her subjects only in a prison setting she would be unable to convey their lives and life stories fully. 'The penal atmosphere confined their identities to a label of incarceration, negating my humanistic intent.'

When she met Vinny in the booking section of a juvenile detention centre in New Mexico, she felt an immediate connection. Vinny, in turn, confided his story, speaking extensively of his love for his mother, Eve, and older brother, David. 'I was taken aback by his wisdom and maturity,' admits Kosofsky. She approached his mother in Juvenile Court, then a few days later went to the family apartment. 'David opened the door, but immediately shut it, telling me I wasn't allowed inside. He assumed I was a social worker, and was worried that I could be someone who could cause instability for the family.' It would take many months before David felt comfortable in her presence. 'He had an intense fear of abandonment, thinking I would take pictures of him and then never return.' It was not until two years into the project that he turned to her and said, 'You may leave us, but you always come back.'

Kosofsky's empathy with her subjects and the trust she has generated by spending countless hours in their company over many years shine through in her portraits of these troubled young men, whose affection and support for each other is highly touching. 'Both Vinny and David struggle to fill the holes in their hearts. Their relationship is a unique comfort to each of them. Their closeness resembles the intimacy that every person yearns for within their family.'

OPPOSITE Vinny, 14, and David, 20, in Albuquerque, New Mexico **TOP** Vinny with his sister, Elycia **ABOVE** A portrait of Vinny then aged 8, David aged 13, and their brother Michael, aged 3

'When I saw Vinny, I felt an immediate connection. I experienced

a familiar, yet unfamiliar feeling one gets with the subjects

that eventually become the focus of long-term projects.'

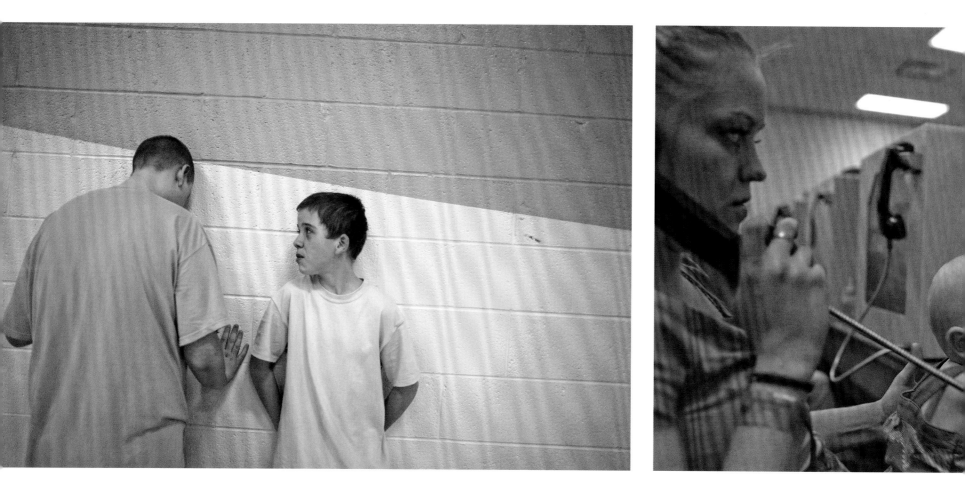

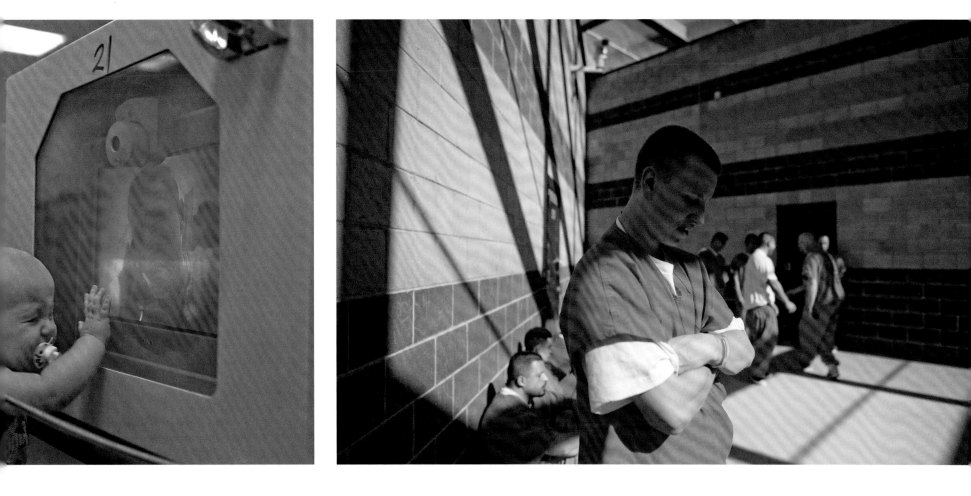

LEFT Vinny with another youth in the gym of
the detention centre **CENTRE** David's fiancée
Felicia, with their 10-month-old daughter
Lily, communicating through video visitation
RIGHT David at the county jail in Albuquerque

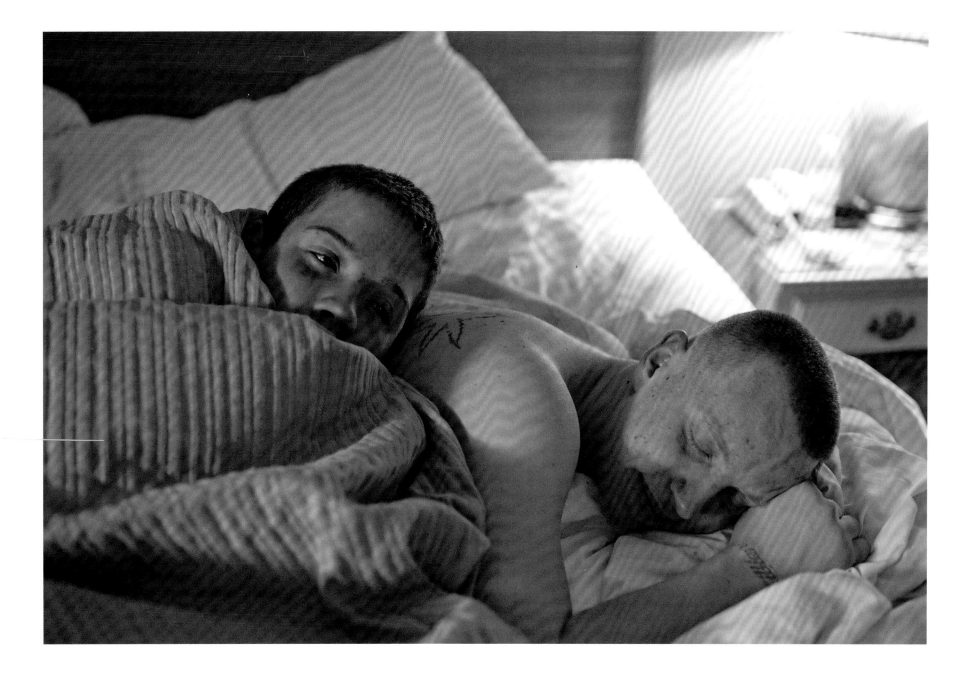

'Vinny describes David as a father figure, and David views

Vinny as the only person who appreciates him.'

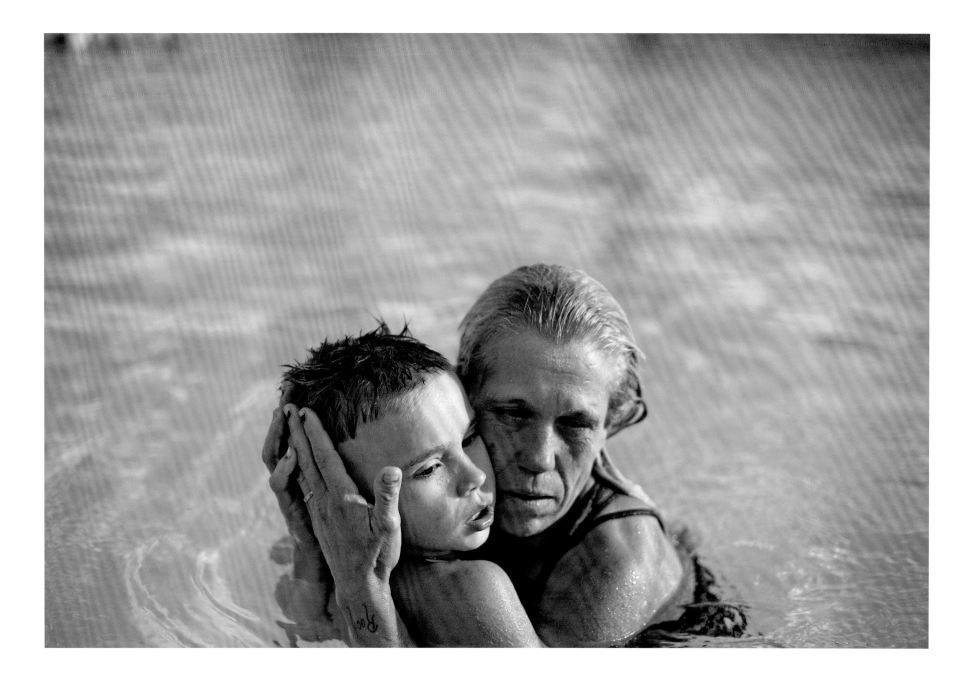

OPPOSITE Vinny, aged 15, and David,
21, after spending the day together
ABOVE Eve holding her youngest son,
Michael, in the pool

JONATHAN TORGOVNIK

born 1969, Israel; lives in South Africa

Two AIDS-related African stories powerfully told by one of today's leading concerned photographers

In 2006, Jonathan Torgovnik was working for *Newsweek* magazine on a story about the 25th anniversary of the AIDS epidemic. While in Rwanda he interviewed Margaret Mukacyaka, who had contracted HIV from being repeatedly raped during the 2004 genocide. 'It was really the most horrific interview I had ever done,' he recalls. 'The level of sexual violence and brutality she endured, how she was held captive and her family killed, is unimaginable, indescribable.'

Mukacyaka had also become pregnant. Torgovnik discovered that there are an estimated 20,000 children born of the multiple rapes that took place during the 100-day genocide. Often referred to as 'children of bad memories' or 'little killers', these offspring, and their mothers, are among the most persecuted and ostracized citizens in the country. Torgovnik committed to telling their story.

'Over the course of three years, I travelled to Rwanda several times to photograph, interview and uncover more details of the heinous crimes committed against the mothers of these children.' Scarred by the combined physical and psychological burdens of of rape, HIV and having a child born of militiamen who in many cases were also responsible for killing their entire families, many of the women had never previously spoken about their experiences.

For Torgovnik, whose own grandfather had been murdered by the Nazis, telling this story has felt essential and urgent. 'I felt so many parallels between the collective consciousness of the Rwandan people and the Jewish people who had gone through the Holocaust. The trauma of genocide is not something you can erase. It's so big that it haunts you your whole life. It's the same thing I observed growing up among survivors of the Holocaust.' Torgovnik has used the money raised from showing his *Intended Consequences* photographs to found an NGO that supports secondary school education for children born of rape during the Rwandan genocide.

In 2012, he published *A Generation Lost*, in which he told the story of the South African grandmothers caring for an estimated 2 million children who have been orphaned by AIDS. Most are living in urban townships, their poverty exacerbated by the absence of the bread-winning middle generation. These grandmothers are often struggling to protect their grandchildren from alcohol abuse, poverty and crime, as well as the risks of them, too, contracting HIV/AIDS. Torgovnik's tender portraits show the grandmothers as towers of emotional strength, able to draw on deep reserves of love, as they raise their grandchildren while dealing with the grief of losing their own children.

'Deep in my heart, I love my kid. But I am
not sure she will ever accept and love me.'

Marie

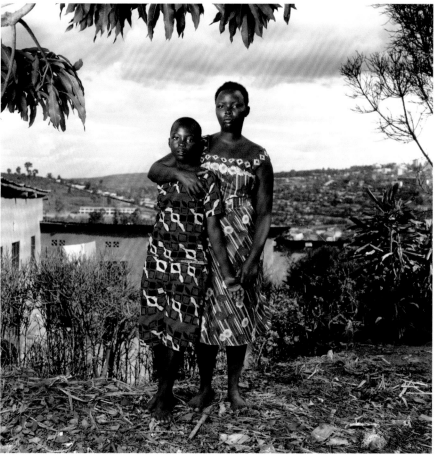

'I don't love this child. Whenever I look
at this child, the memories of rape return.'

Philomena

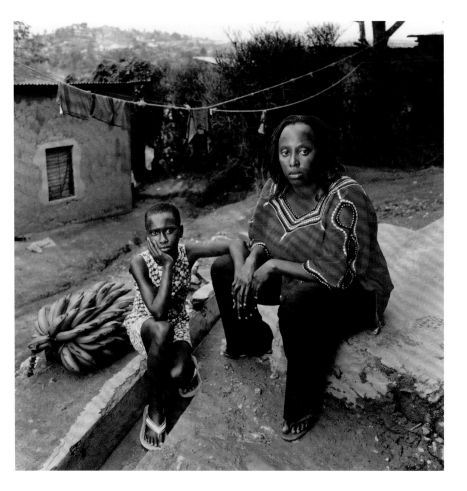

ANNALISA BRAMBILLA

born 1981, Italy

An emotionally charged portrait of the day-to-day life of a British family, made while the photographer was working as their au pair

Italian photographer Annalisa Brambilla met the Habib-Robinson family when she was living in London in 2011. They were near neighbours and, after selling her a camera at the local market, father Matt asked if she might be available for occasional babysitting. After a few months of irregular work, she moved in with them as an au pair.

'I had already begun photographing their daily life,' recalls Brambilla, 'and I knew that if I was able to live with them, I'd gain a much more intimate perspective. It was a very collaborative project from the start, with Matt and Shaila committed to supporting my photography.'

Shaila echoes the sentiment: 'From the moment we met it was honest and easy, as if we had known each other all our lives. Very few people you meet make you feel this way.'

Brambilla had recently finished a Master's in photojournalism and was drawn by the emotional intensity and unfathomability of the Habib-Robinson family dynamics. Matt and Shaila are the parents of Sofia, Zain, Raeef and Ibrahim. Zain is eight years old and was diagnosed autistic at the age of two. Zain, Raeef and Ibrahim all suffer from complex dietary intolerances that affect their behaviour and mean they must follow a strict diet.

'I learned that family life with autism is coloured by endless shades of love and pain, urge and patience, intimacy and also loneliness. I saw close up how every day is a constant struggle and discovery – through passion and despair, togetherness and isolation. Everyone in the family finds ways to create their own time and space.'

It was Raeef who suggested a title for the work: 'My Star Wars Family'. 'He is mad about *Star Wars*,' Brambilla explains, 'and it often seems to me as if the Habib-Robinsons are living in a universe where good and bad forces are in constant battle. The internal resources they have to call on simply to keep going – to have patience and love and hope for one another in the face of the chaotic demands of daily life – are remarkable. I came to have so much love and so much respect for them all.'

'How would the family describe their

day-to-day life? "Chaos, mayhem,

dreams, truth and love."'

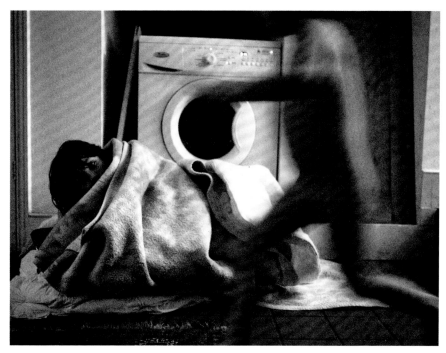

JOHAN BÄVMAN

born 1982, Sweden

Witty portraits of stay-at-home dads that suggest many find the generous paternity leave allowance in Sweden a mixed blessing

No other country offers such generous paternity leave as Sweden. In an effort to promote gender equality, new fathers must take at least 60 days off work when their child is born, and either partner can then take the full 18-month parental leave period. The reality is that only a small handful of fathers take up the opportunity to become the primary care-giver in a family. Johan Bävman was one of them.

'I began making the series while I was home with my own young son,' he reports. 'I was surprised by just how few other men I encountered who had made the same decision, and also by how little of the social activity literature around caring for a newborn seemed designed for men. So I set out to find other stay-at-home dads and to present them as role models. I didn't want to show Super-Dads. I wanted to show ordinary dads who found parenting exhausting and often frustrating, but who also felt their decision to spend more time with their children was a worthwhile one.'

Bävman found his first models through the local children's day care centre where he took his son. As word spread about his project, fathers he didn't know started to get in touch to ask if they could be part of the series. 'Some already saw themselves as role models; most just wanted some kind of recognition.'

Bävman noted that middle-class men with academic backgrounds seemed to find it easier to take extended paternity leave. 'For some of those

from other backgrounds, it was a much harder decision. I photographed one Arab dad, whose female relatives had clearly been very disappointed by his decision to step into what they considered female territory.'

Bävman's photos pull no punches about the banality of much childcare. The lighting may be resonant of fashion photography, but there is no glamour to changing nappies, dressing up as a pirate, or trying to do the hoovering with a baby strapped to one's back. 'I didn't find it glamorous,' says the photographer. 'But I do think that being able to stay at home helps you understand your partner and perhaps have a better relationship. And you certainly get to know your children better as they grow up. I hope my son will find it easier to share his life with me and to come to me for advice because of the quality of time we spent together in the early years.'

OPPOSITE Urban Nordh, 32 years old, civil engineer; on leave with his son Holger for ten months **RIGHT** Johan Ekengård, 38 years old, product developer at Sandvik: sharing parental leave equally with his partner for their children Ebbe (7), Tyra (5) and Stina (1); both took approximately nine months of leave with each child

'In Sweden, we like to pat ourselves on the back and say, "We are by far the most equal country in terms of parental leave." The truth is not quite so simple.'

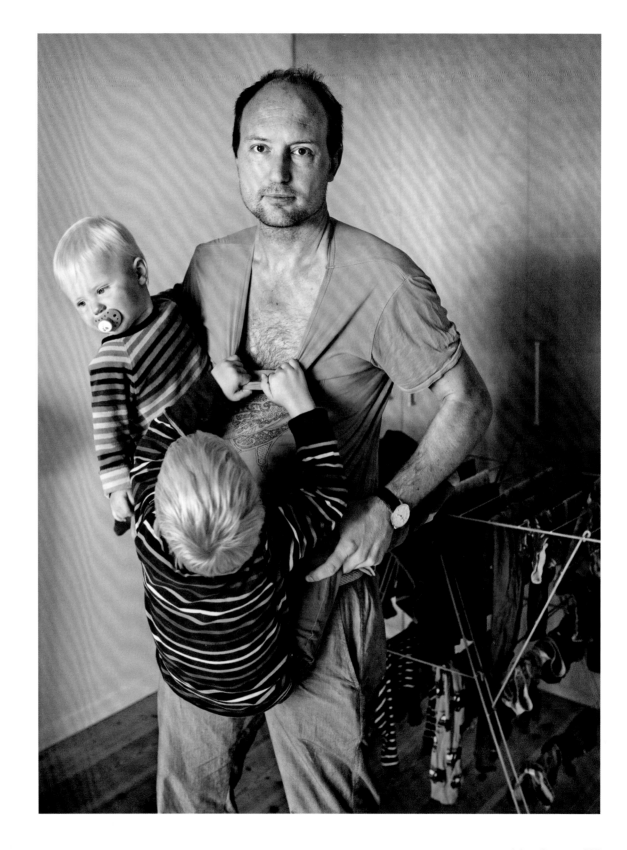

OPPOSITE Ola Larsson, 41 years old, buyer; on leave with his son Gustav for eight months RIGHT Alfred Nerhagen, 38 years old, landscape architect; on leave with his children Zack (4) and Mira (1½) for nine months each

LUCIA HERRERO

born 1976, Spain

A playful look at the tribal behaviour of contemporary Spanish families

Where better to observe families virtually stripped bare than on the beach? Over two summers Spanish photographer Lucia Herrero documented hundreds of middle-class families as they soaked up the sea and sun along her native coastline. 'The beach is the ultimate place to study people, observing the interactions within and between families and friends,' Herrero explains. 'The fight for a patch of space in the sand, and the need to defend one's territory for the day, seem to bring out almost primitive behaviour.'

Herrero was making the work at what turned out to be a curious time. 'The economic downturn meant that many Spanish families were suffering from a deep identity crisis, and still are. While I was shooting and talking to people, it became clear that many were struggling to survive and support one another in the face of the recession.'

In making *Tribes*, Herrero was inspired by 19th- and early 20th-century studio portraits taken by anthropologists studying native people around the world. The families in such photographs are shown wearing traditional costumes, holding prized possessions and looking straight to camera. Herrero re-created the studio look on the beach by shooting into the sun using a 1000-watt strobe flash light. Her modern tribes, in contrast, are dressed in bikinis and trunks, sit on loungers or under sun umbrellas, and proudly show off their buckets, spades, coolboxes and surfboards.

'The lighting and the theatricality add an element of fantasy to
portraits of real people in natural surroundings. I call this
form of social photography "Antropología Fantástica".'

'It's about that picture that we all have of a "tribe"

that stays in our collective memory.'

PAT POPE

born 1969, England

*A series in which ordinary families
get a rock star make-over*

You need a sense of humour to
commission one of Pat Pope's
Alt.Family Portraits. Even the most
congenial family can end up looking
like the cast of a TV drama. Arranged
in a dark space, and backlit to dramatic
effect, Pope's sitters are styled with a
heavy dose of gothic glamour and
a gentle touch of menace.

Pope's early career was as a music
photographer. He photographed David
Bowie and Jarvis Cocker, Radiohead
and Suede, among many others. 'Then
the work dried up and there was no
more travelling around the world
staying in hotels with everything paid
for! So I left London and moved home
to the countryside, and turned my hand
to wedding and family portraiture to
make ends meet.'

The idea for his *Alt.Family Portraits*
came from photographing local rock
bands. They often asked for the kind
of moody group shot beloved by
musicians, but rarely had the budget
to enable it. Pope found a way to
create the effect without the need for
hundreds of spotlights and a large
supporting crew. He would compose
a shot with all the band members
present, marking out the exact
positions of their feet, then photograph

each member of the band one by one
before assembling the separate images
into a final composite in Photoshop.

'It turned out to be a great strategy
for working with families. Kids find
it hard to keep still for long, and it's
almost impossible to get everyone to
follow the same instructions at the
same time. This way, I get to work one
to one with each family member, until
I have a final shot they are happy with.'

The photograph of the Lampitt
family was one of the first in the series,
and is still one of Pope's favourites.
'There's a strange look that results from
it being a composite of individual shots,
all separately lit. It feels a bit awkward
and also slightly surreal.' Dad Brett
Lampitt has described it as a cross
between a formal Victorian portrait
and a poster for *Six Feet Under*. 'I love it
because it's not always a bed of roses in
our house and we're not all smiling all
of the time. So this is a portrait in the
true sense of the word.'

OPPOSITE The Lampitt family

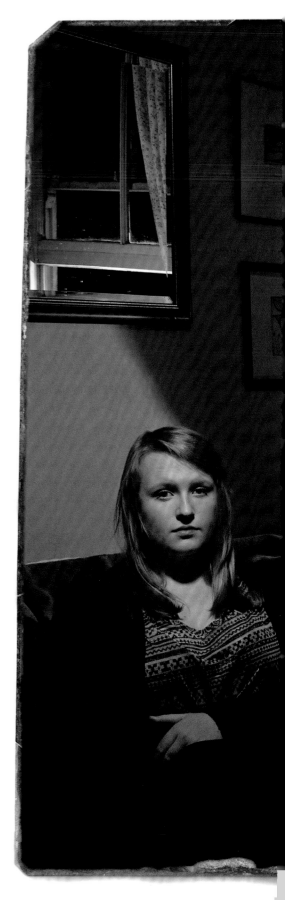

ABOVE The Acason family
OPPOSITE The Skinny family

'The idea is to get as far away from the conventional high-street family

portrait as possible. I don't let people smile. I tell them to look blank.'

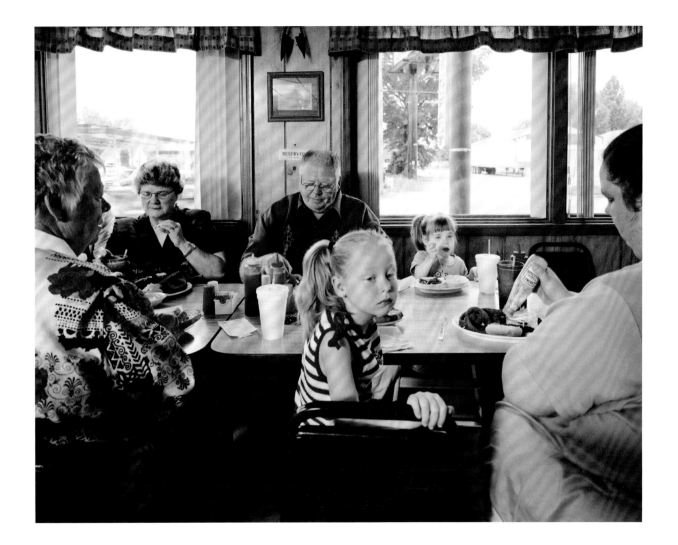

A photographer joins families at mealtimes, capturing profound moments of recognition and connection in everyday circumstances

Douglas Adesko is a commercial photographer from New York who always has a short list of personal projects on the go, which he undertakes when he is travelling between assignments throughout America. He has been shooting his project *Family Meals* for several years now.

'After our daughter was born, I was suddenly taking a lot of pictures around the house, documenting our everyday life,' he recalls. 'I guess I kind of got hooked on photographing these little domestic moments, and I wanted to do a broader project capturing some of the things I was liking about my own family pictures.'

In recording everyday interactions, Adesko's eventual focus on mealtimes was somewhat accidental. 'As I started the project, the first challenge was finding situations in which everyone was together in a photographable space. Using the dinner table was an obvious solution to the problem.'

As the project progressed, Adesko realized that he liked the repetition in his images. 'I think that seeing the same theme repeated in a variety of iterations gives the images a meaning that they don't really have standing alone.'

He continues: 'There was a point fairly early on in the project when I was looking through a bunch of the pictures and I just felt a really strong sense of a kind of connection between all of the people I had photographed. Since that point, fostering that feeling has really been what the project has been about for me.'

Nonetheless the diversity of families and homes in Adesko's project is one of its strengths, and it begs the question: how does he find subjects to photograph? 'They are mostly strangers,' he replies. 'One of the really fun things about doing a project like this is the opportunity to put myself in unexpected situations. Asking strangers to let you into their homes is a great way to do this. I find people lots of different ways: often I literally just drive around neighbourhoods and ask people in their front yards. It's always a little uncomfortable asking people to participate, and it always surprises me a little bit when they agree. The trust that they show me by letting me into their homes to take pictures makes it really easy for me to like them all.'

Lately, Adesko has begun making audio recordings to accompany his photographs. 'I feel like the recordings of the dinner table conversations, together with the ambient household noises, provide a really intimate view of what is going on. You learn a lot more about the people from hearing what they have to say, and I like the way the things you learn from listening to the audio often play against the assumptions you might make after just seeing the pictures.'

'It is good to be around people with different

lifestyles and different values, and it just deepens

my understanding of how human beings are to spend

time around them.'

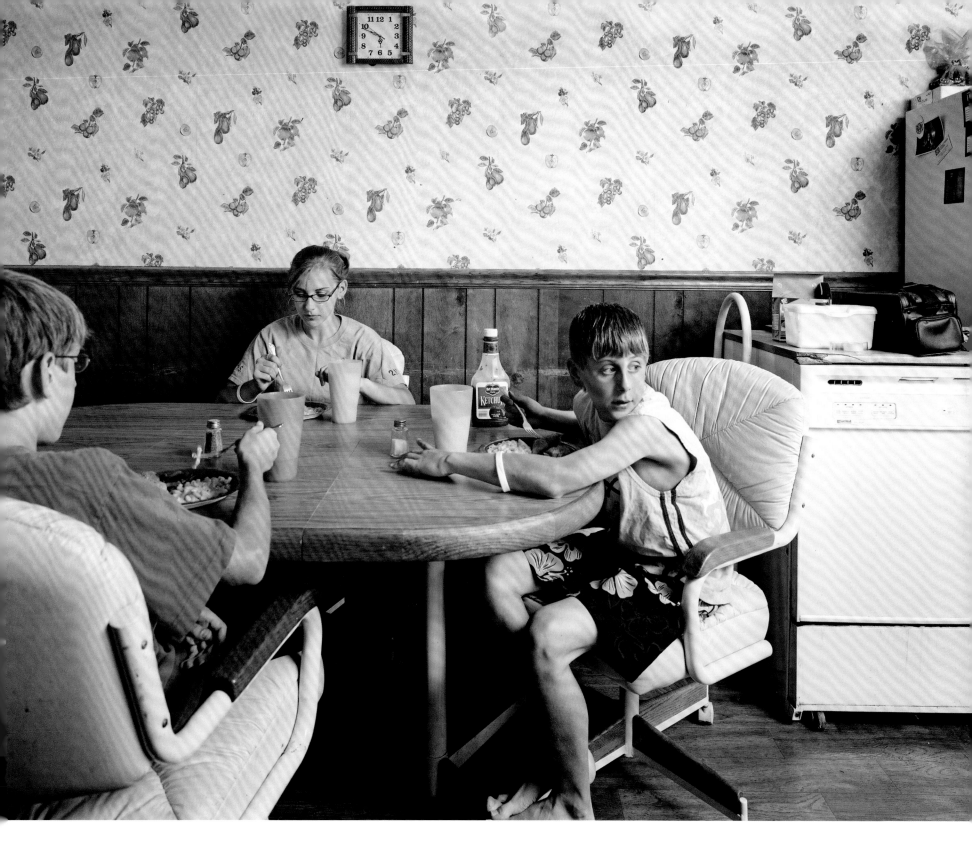

STEPHANIE SINCLAIR

born 1973, USA

A photographic record of the unique connection shared by Krista and Tatiana Hogan, and by the rest of their close-knit family

To say that every family is unique is a glib truism. However, as can be seen in this series of pictures by photojournalist Stephanie Sinclair, it is immediately apparent that the Hogan family from British Columbia, Canada, really do constitute a special household and a scientific marvel. Their daughters Tatiana and Krista Hogan, born in 2006, are the only twins in Canada to be conjoined at the head.

'I was assigned this fascinating project by *The New York Times Magazine*,' recalls Stephanie. 'I accepted immediately because it was a rare opportunity to spend time with such an interesting, unique family. I met the Hogans at their home and spent several days documenting their daily lives. I found them to be a very normal family facing a very abnormal situation. I was impressed with their almost immediate commitment and acceptance of the twins the way they were. Even with the help of a large, close-knit, extended family, the decision couldn't have been an easy one, as the family struggled financially already.'

Tatiana and Krista were given a 20% chance of survival at birth but their resilience, which Sinclair captures in her photographs, has surprised many, and these engaging little girls have appeared on television shows and in newspaper articles. Although they both have a fully structured brain, there is a bridge of tissue between them that enables the girls to see the world through each other's eyes and to taste and feel what the other is experiencing.

'Tatiana and Krista are both so sweet, but have very different personalities,' reports Sinclair. 'Tatiana is very affectionate and gives lots of hugs and kisses to her mother. Krista laughs more easily. But most of all their experience is one of intense compromise. We are all joined to different people in our lives – significant others, family members, friends – and each of these relationships requires a degree of give and take, but none of us have to compromise with every life decision in the way conjoined twins do. Their forced interdependence requires constant negotiation.'

Sinclair describes one example of the twins' enforced sharing of senses. 'I remember dining with them at a restaurant and Tatiana did not want a certain condiment on her food ... because whatever Krista would eat Tatiana would also taste. What ensued was a surreal twist on the typical sibling spat. Tatiana used their attachment to physically prevent Krista from eating the sandwich by dragging herself under the table, which of course brought Krista's head under the table, too. This moment of disharmony only served to highlight the degree to which the two individuals must live nearly every other moment of their lives with extraordinary connection and compromise, which can be beautiful to witness.'

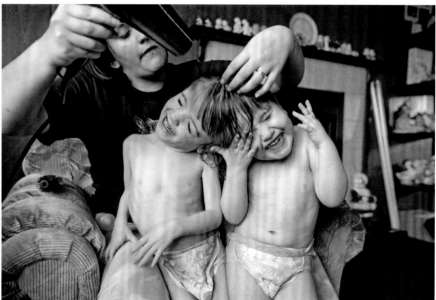

'I wanted to show ordinary people. Show them in their environment and at home; the connection. Because China is a place that is changing.'

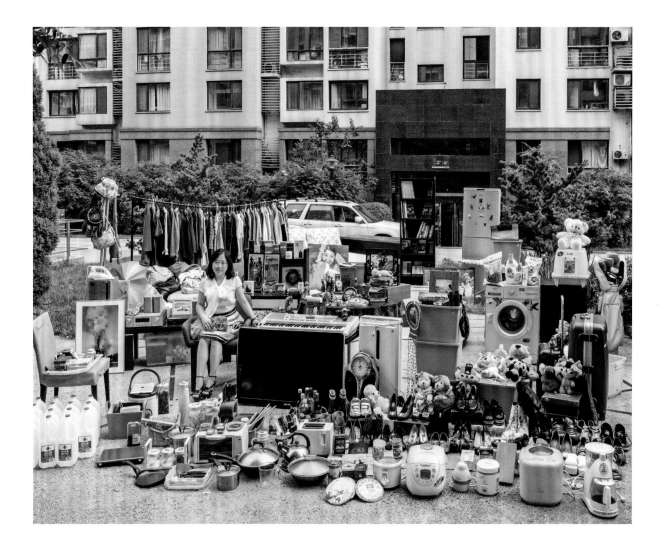

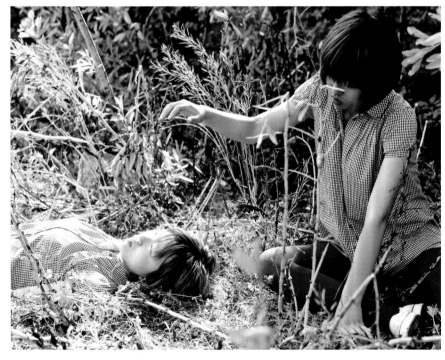

FAN SHI SAN
born 1983, China

*Melancholic composites exploring
the loneliness of China's one-child
generation*

Between 1978 and 2015 the People's
Republic of China applied a population
control measure to married urban
couples known as the 'one-child policy'.
Fan Shi San's photographic series
Two of Us explores the impact of this
ruling on the identity of his generation.

'Nearly every child born in urban
China after 1980, myself included,
is an only child. We are the loneliest
generation in China's history. Many of
us entertained ourselves by integrating
alter-egos into our lives as a substitute
for the siblings we never had. I created
an imaginary friend. I even gave him
a name: "Tree".'

Fan's wistful double-exposures
show the same young person in two
different poses. The effect suggests an
imaginary twin. But these siblings never
seem able to communicate, so the
impression is always one of isolation.

Fan started uploading his
photographs to Douban, a Chinese
social networking site, in 2010. They
immediately struck a chord. Several
young people approached him, asking
if they could model for the series.
One girl wrote: 'I am always talking
to myself, as if I am two people at the
same time. I know so many others who
feel the same. It's as if my heart has
been split; as if I am both weak and
strong, boy and girl, self-conscious
and self-obsessed.'

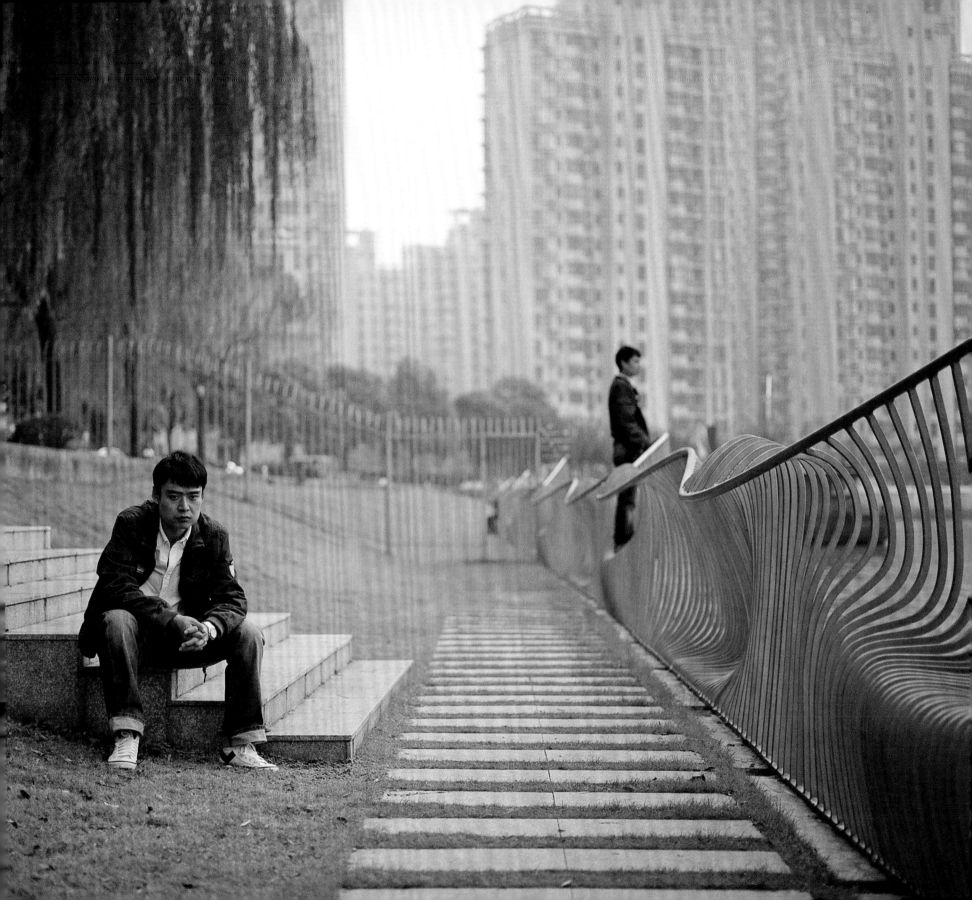

'My imaginary friend sits on my chair, on my bed; he stands right across from me.'

Fan Shi San **231**

'Ideally there will come a point where the

viewer makes no distinction between looking at

an image of a gay family or a straight family.'

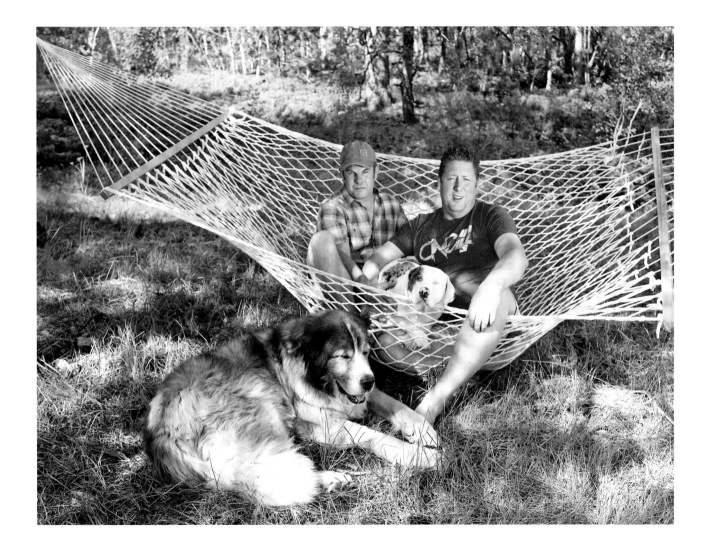

ALIX SMITH
born 1978, USA

A series of colour portraits of same-sex American families, drawing on the classical history of art portraiture

New Yorker Alix Smith was brought up in a privileged Upper East Side household, but, as she was discovering her own sexuality as a gay woman, she realized that what interested her were not the trappings of wealth but the ways in which people expressed their identity through belongings, dress and body language. On becoming a photographer she decided to use her camera to examine how people project an image of themselves in everyday life.

In her most recent project, *States of Union*, Smith has created a series of formal portraits of gay American families in which each posed image resembles a famous painting in art history. 'In these portraits I broaden the idea of family to include social units not generally recognized by society at large. "Family", in *States of Union*, may be as few as two individuals who are in a committed relationship and live as a social unit. These units may include pets and may have biological, fostered or adopted children.'

Smith aims to universalize the idea of family to be inclusive of a marginalized population. 'Gay unions have not been acknowledged in the ledgers of history. Through *States of Union*, same-sex families will be able to claim their place in history and within the centuries-old legacy of portraiture.... By drawing upon classical images, the tropes historically used to promote heterosexual family units are reappropriated and reinvented to serve a more expanded view of family. In so doing, the viewer recognizes

something familiar about the images, including their artistic references, feeling a kinship with families that might otherwise look and feel unrecognizable.'

Through carefully placed props and selectively chosen attire, each photograph is loaded with visual information. One family have used a photograph of their own to add extra meaning. 'In Pennsylvania, birth parents who put their children up for adoption have nine months to change their minds. The first child this couple adopted lived with them for eight and a half months. When her biological father learned that his daughter had been adopted by a gay couple, he exercised his right to revoke the adoption.' Smith notes that, in her portrait, one of the fathers wears a cufflink bearing a photograph of his lost daughter – a reminder of the part of his family denied to him because he was gay.

The project is undoubtedly timely, given the recent legalization of same-sex marriage in the US, but, even as recognition for gay families is enshrined in legal statute, Smith realizes that there is more to be done to address the deficit of imagery of gay families in popular culture.

'The very act of sitting for a formal family portrait

serves as an acknowledgment to the individuals

themselves that they are, indeed, a family.'

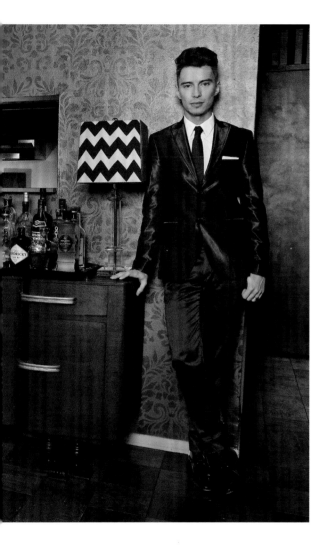

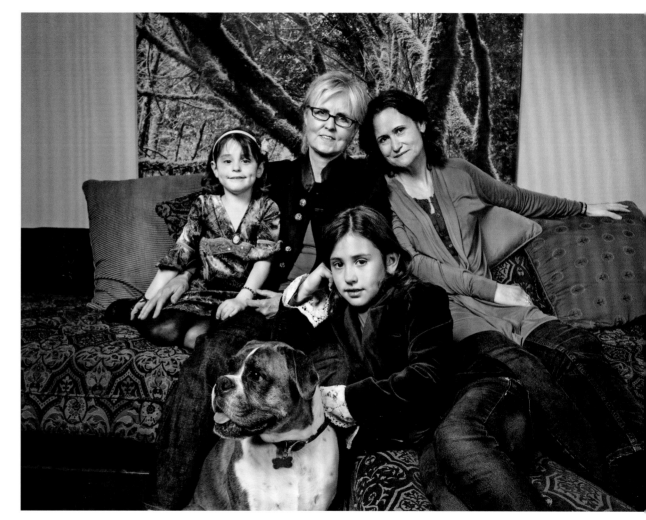

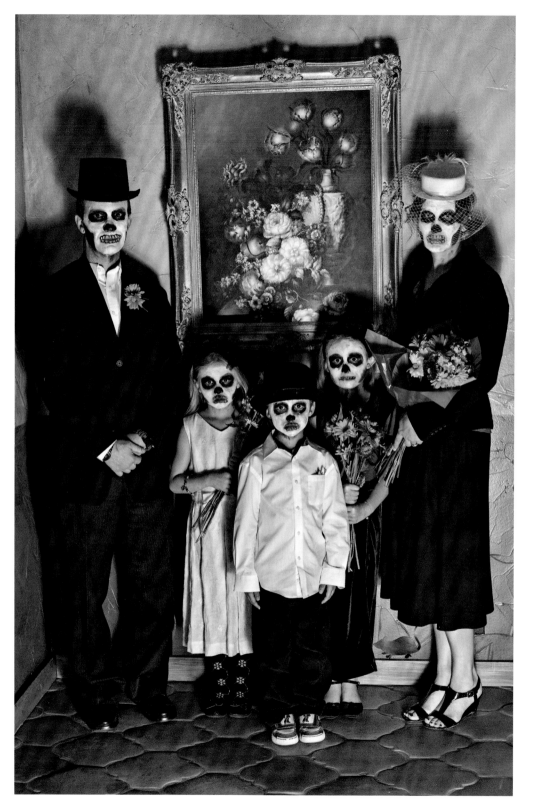

'I think all families are

creepy in a way.'

Diane Arbus

LEFT 'Fischer. Texas.
2010. Family poses
during a wedding
rehearsal.' Photograph
by Bill McCullough.

Notes

All quotations by photographers or other sources are taken from personal correspondence with the authors, with the exception of those noted below.

IS MY FAMILY NORMAL?

Andrew Solomon: quotation on p. 6 from the photographer's 'Love, no matter what' TED Talk, 2013.

Martin Parr: quotation on p. 7 from 'Martin Parr: how to take better holiday photographs', *Guardian*, 24 August 2010.

Aleks Krotoski: 'We live in an increasingly transient world' on p. 9 from 'Is the internet really killing family life?', *Guardian*, 26 December 2010; 'We mean the same thing to one another' and 'We don't have to be co-present' from Libertine, 'Untangling the web with Aleks Krotoski', by Debbi Evans: liberti. ne/editions/untangling-the-web-with-aleks-krotoski/.

Val Williams: quotation on p. 9 from *Who's Looking At the Family* exhibition catalogue, Barbican Art Gallery, 1994, p. 13.

Doug Block: 'I had a lot of questions' on p. 10 from 112weddingsmovie.com; 'Weddings aren't just about one couple' from '11.2 things I've learnt from filming 112 weddings', *Independent*, 6 June 2014; and 'Happy ever after' from interview with Laura Jane MacBeth, '8 things I learned from filming 112 weddings', *The Telegraph*, 10 June 2014.

Cheryl Haggard: quotation on p. 11 from 'An Expression of Thanks', Now I Lay Me Down To Sleep blog; 'Photographs are one of the most precious' from 'Services for Families', Now I Lay Me Down To Sleep.

Operation Photo Rescue: quotation on p. 13 from operationphotorescue.org.

Munemasa Takahashi: quotation on p. 13 from interview with Elisa Curtis, 'Lost & Found: Salvaging Snapshots in Japan', *New Yorker*, 19 March 2012.

Neil Burton: quotation on p. 13 from 'The Meaning of Nostalgia', *Psychology Today*, 26 November 2014.

Andrew Solomon: quotation on p. 13 from *Far From the Tree: Parents, Children and the Search for Identity* (Vintage, 2014).

THIS IS MY LIFE

Alain Laboile: p. 19 from 'Europe Week: Alain Laboile' by Aline Smithson, http://lenscratch.com/2012/11/europe-week-alain-laboile/; p. 23 from 'La Famille' by Alain Laboile, https://www.lensculture.com/articles/alain-laboile-la-famille.

Timothy Archibald: quotations on pp. 34 and 39 from www.timothyarchibald.com.

Pete Pin: p. 43 from the Artist's Statement.

Elina Brotherus: pp. 69 and 73 from the Artist's Statement.

Christopher Capozziello: pp. 74 and 75 from www.chriscappy.com; pp. 76, 77 and 78 from *The Distance Between Us* (Edition Lammerhuber, 2013).

Matt Eich: p. 81 from 'The Eye of Matt Eich' by Abigail Smithson, http://thephotographerdiscloses.com/2013/09/20/the-eye-of-matt-eich/.

Martine Fougeron: p. 88 from the Artist's Statement.

Motoyuki Daifu: p. 93 comprises the Artist's Statement.

Trent Parke: p. 98 from 'Family by Trent Parke', http://www.magnumphotos.com/C.aspx?VP3=SearchResult&ALID=2K1HRGMKYDF.

Tim Roda: pp. 108, 109 and 112 drawn from the Artist's Statement.

Nadia Sablin: p. 114 'As a child I had little understanding or empathy for my aunts...' from a conversation with photographer Ashley Kauschinger, http://www.lightleaked.com/2013/02/nadia-sablin_25.html.

Phillip Toledano: p. 123 from www.thereluctantfather.com.

Sian Davey: p. 129 'I was deeply shocked...' and 'On reflection...' from www.siandavey.com.

MAY I COME IN?

Patrick Willocq: p. 149 from text produced for 'Arles: Les Rencontres de la Photographie, 2015', www.rencontres-arles.com.

Dita Pepe: p. 187 from 'Self-Portraits' film, http://www.bara-dita.com/en/book-dita--self-portraits-special-edition.php.

Jonathan Torgovnik: pp. 196 and 197 from *Intended Consequences: Rwandan Children Born of Rape* (Aperture, 2009).

Pat Pope: p. 212 'I love it because it's not always a bed of roses in our house' from 'How to Stage a Family Portrait, HBO Style' by Fiona McWilliam, http://www.theguardian.com/artanddesign/shortcuts/2014/jul/13/family-portrait-bowie-radiohead-pat-pope.

Huang Qingjun: p. 227 from 'Portraits of China's People (and Their Possessions)' by Didi Kirsten Tatlow, *The New York Times*, 7 September 2012.

Alix Smith: p. 234 from 'Traditional Families – Who Also Happen To Be Gay' by David Rosenberg, www.slate.com.

Every effort has been made to locate copyright holders of photographs.

Acknowledgments

This book would not have been possible without the courage and trust of our contributing photographers and the families whose lives they have shared with us. We were offered privileged access to the private lives of so many families across the world and we thank each of them for being an integral part of this book.

For commissioning this title, guiding the authors towards the most interesting themes, and designing so many stunning pages we thank Johanna Neurath at Thames & Hudson. Her equanimity and expertise have been of immense value to us. Her colleague, Jenny Wilson, has been a most patient and diligent editor of our texts, and her advice has always been judicious. In addition, we are most grateful to Andrew Mitchelson for his assistance with picture research.

The authors would also like to thank their own families who have provided years of support and insight into how rich family life can be. Thanks for giving us the space, time and encouragement to be the curious people we are.

Index